CONTENTS

Introduction		1
Maps	The Mediterranean region	2
	Egypt and the Near East	3
E J Peltenburg	Early faience: recent studies, origins and relations with glass.	5
J E Reade	Field observations of glass and glazed materials.	31
M S Tite, M Bimson, M R Cowell	The technology of Egyptian Blue.	39
A Caubet and A Kaczmarczyk	Bronze Age faience from Ras Shamra (Ugarit).	47
K P Foster	Composition of colours in Minoan faience.	57
S Mazzoni	Faience in Ebla during Middle Bronze II.	65
P B Vandiver and W D Kingery	Manufacture of an Eighteenth Dynasty faience chalice.	79
P E McGovern	Silicate industries of Late Bronze-Early Iron Age Palestine: technological interaction between Egypt and the Levant.	91
G Hölbl	Typology of form and material in classifying small Aegyptiaca in the Mediterranean during Archaic times.	115
M S Tite, M Bimson, I C Freestone	The scientific examination of Pre-Hellenistic faience from Rhodes.	127
B Kleinmann	Technological studies of Medieval and later Persian faience: possible successors to the faience of antiquity.	133
V E S Webb	Aegean glass: continuity or discontinuity.	145
M Cable and J W Smedley	The replication of an opaque red glass from Nimrud.	151
M Bimson	Opaque red glass: a review of previous studies.	165
I C Freestone	Composition and microstructure of early opaque red glass.	173

INTRODUCTION

This volume is based on the proceedings of a symposium on *Early Vitreous Materials* held in the British Museum on the 2nd and 3rd of November 1984, at the combined initiative of the Research Laboratory of the British Museum and Dr E J Peltenburg of the University of Edinburgh. Of the papers presented at the symposium only three do not appear here.

Our main objectives in convening this symposium were to bring together scientists and archaeologists who were interested in early silicate technology, to exchange information and perhaps to throw some light onto the problems associated with the development of these esoteric materials. At the same time we hoped that the projected symposium would encourage cooperation between scientists and archaeologists, and the success of the meeting can be measured in terms of the scientific contribution included in, or appended to, a number of the more typologically-oriented papers. In analysing these papers we were suprised to find that, while interest in the potential of scientific techniques was buoyant in the field of faience studies, active interest in the analysis of early glass was restricted to just a few individuals. Furthermore, the fact that the great majority of extant analyses of ancient glass remains unpublished and therefore inaccessible to most workers, is likely to continue to inhibit the development of scientific studies of ancient glass for some time. Thus readers will find that glass is under-represented in this volume relative to its importance, and it is clearly a material to which new work should be directed.

Secondarily, we hoped to bring some order into the variety of terms which have been adopted by archaeologists over the last one hundred and fifty years to describe these ill defined and poorly understood materials. Although at the time of the symposium it was not clear that a consensus had been achieved, in practice it now appears that in spite of their dubious etymological ancestry the term 'faience' will continue to be used to describe a material consisting of a glazed body of sintered quartz, while 'frit' will be used to describe an unglazed sintered body. 'Egyptian blue' will continue to be used for frit bodies and pigments based upon synthetic copper calcium silicate irrespective of where they were produced. It is noticeable that several authors have dropped the qualifying term 'Egyptian' before faience, chiefly - one suspects - in the cause of brevity but also perhaps influenced by the opinion that it was to a certain extent misleading. It is an indication of the narrow specialization of modern scholarship, that there is felt to be no risk that some readers may be interested in both types of 'faience' and may assume because they have the same name that they are technically similar.

With the exception of Peltenburg's comprehensive review of the origins of faience and glass-making which we have placed at the beginning of the volume, the sequence of papers is, broadly speaking, chronological, with glazed materials preceding glass. We would like to express our thanks to the authors for the quality of their contributions and for their patience in awaiting publication. Many of our colleagues in the British Museum have lent invaluable help, especially Julian Reade of the Department of Western Asiatic Antiquities. We have received much editorial and clerical assistance from Ben Bayliss and Julie Bevan and finally we must record that the importance of the written contributions by Michael Tite, Keeper of the Research Laboratory, is only a partial reflection of his total contribution to the success of the meeting, and we are grateful both for his advice and for his practical assistance.

Mavis Bimson and Ian Freestone

EARLY FAIENCE: RECENT STUDIES, ORIGINS AND RELATIONS WITH GLASS

E J Peltenburg

Department of Archaeology,
University of Edinburgh,
19 George Square, Edinburgh EH8 9LD

Abstract

This review seeks to establish the main developments in research on early faience and glass since the seminal papers of Beck and Stone (1936) and Stone and Thomas (1956). Following a discussion of the contributions made by typological, analytical and structural approaches to faience studies, the relationship between the faience industry and the development of early glass manufacture in Western Asia is discussed. Finally the influence of metallurgical practices on early glassmaking techniques is considered.

Keywords: FAIENCE, GLASS, GLAZE, METAL, SYRIA, MESOPOTAMIA, EGYPT, ANATOLIA, ANALYSIS.

Introduction

In seeking to review studies of a substance which is often misidentified or identified only with difficulty, whose ancient name or names is a source of heated controversy and whose modern name, faience, is an acknowledged misnomer compounded by a bewildering variety of multi-lingual equations, I am forcibly reminded of Tweedledee's challenge: 'Contrariwise, if it was so, it might be; and if it were so, it would be; but as it isn't, it ain't. That's logic'.

The etymology of the word is well known, but I think there are still genuine lessons to be learnt from it. The modern word for the material which has been characterized in our pre-conference hand-out as well as elsewhere on numerous occasions is, of course, derived from the popular medieval tin-glazed Maiolica products of Faenza in Italy. It only gained wide currency in the French language however during the late sixteenth century when craftsmen from Faenza took their knowledge of 'terre blanche' to Lyons and other centres in France (Lane 1948, 8-9). It was this French term for the 'porzellena di Faenza' that was thereafter generally applied to all fine-glazed pottery and, by extension, during the nineteenth century to ancient finely glazed objects. Most of these were of crushed quartz rather than clay however, and although some may feel that the Iranian 'sugar stone' (Allan 1973, 115) or 'stone paste' (Wulff, Wulff and Koch 1968, 107) might have been more appropriate, the fact is that this material has not been made in English-speaking countries at least in recent times

and hence there is no precise English word for it. 'Faience' therefore is at best an established approximation and surely a better one than 'porcelain', another term frequently used in the past for the same material.

Initially it was applied to objects found in Egypt or Egyptian objects found abroad (e.g. Renan 1864, 488) and even when artefacts of visibly similar appearance were found in Asia and other areas the word often retained an unwelcome adjective, 'Egyptian' (e.g. Noble 1969, Bray and Trump 1970, 85). The term 'Egyptian faience' not unnaturally biased several studies of the material (e.g. Unger 1957) and it was not until Beck and Stone's study in 1936 and Stone and Thomas' classic paper of 1956 in which its widespread occurrence and possible Asiatic precedence was clearly stated, that the non-committal term 'faience' became firmly established in the English language. Here I think we have a demonstration of how the growth of our knowledge can affect terminology, a demonstration that should be salutary in considering the term 'Egyptian blue'. This is particularly relevant to a wider appreciation of ancient vitreous materials, for while specialists might concede that 'Egyptian blue' was frequently made outside Egypt, non-specialists are confronted by an obscure term which conditions their thinking about provenance. Vandiver (1983b, 241) has argued that it, as well as similar reds and whites, is but one of a number of sintered bodies which she would therefore call blue or red or white frit. Unfortunately this term has a specific meaning in glass and glaze-making which conflicts with its use for finished objects, but it does have several merits.

I have already referred to Stone and Thomas' seminal 1956 paper and it seems a suitable bench mark from which to assess recent developments in faience studies. The aim of their paper was to confirm and elaborate on the general conclusion reached in an earlier survey (Beck and Stone 1936) 'that an Egyptian origin was the most likely for a number of the faience beads' in Bronze Age Britain, but in so doing they ranged over many matters that are still of unresolved concern today. This then was primarily a source study paper in which a solution was sought by means of the combination of two methods, an approach that was standard, especially in studies of metal objects. The first was a traditional typological examination of British and comparable beads, the second a spectrographic analysis. Analyses of faience had of course been carried out before but this was the first time to my knowledge that this particular technique was adopted and also the first time that the explicit aim of the analysis was to sustain or otherwise the argument for a particular source. In what follows I shall deal with these two approaches first, selecting only a few of the more important works for citation, and then touch on other avenues of investigation before turning to Asiatic topics for reasons which I hope will become clear. Although it will be obvious from certain sections, I should emphasize here that I claim no expertise in technological fields.

Typological studies

Few subsequent investigations of faience combined the typological and analytical methods in the manner of Stone and Thomas primarily because most were not designed as source studies and because Stone's typological work has not been improved upon. One exception to this state of affairs is the work of Harding (1971) and Harding and Warren (1973) on Central European Bronze Age beads. Otherwise, in-depth typological studies have tended to eschew analyses, even to assist in grouping types, and they have largely been carried out on an art historical basis. Such approaches, moreover, do not lend themselves to the definition of attribute states favoured in more

recent refinements to typological work (e.g. Clarke 1968), but the often worn condition of faience precludes systematic application of these new methodologies. In addition the work has been piecemeal, so it is still rare, for example, to be able to obtain a general conspectus of prevalent types in a single region during a given time. One can but look with envy at catalogues of major collections of ancient glass (e.g. Harden 1981) or Müller-Karpe's *Prähistorische Bronzefunde* series. That is not to decry the invaluable typological studies and few syntheses hitherto published, but merely to emphasize the fledgling status of the subject at present. Thus, to return to Stone and Thomas (1956) and their single Abydos bead that figures so prominently in the exotic origin argument for some British beads, it is remarkable that we still do not have a basic typological survey of contemporary beads from Egypt, the Levant or Greece. Foster's survey of Aegean faience (1979) is a start in the right direction, but it is not comprehensive (cf. the ring, quoit and segmented beads from Profitis Elias: Rudolf 1973).

No thorough typological study of fifth - third millennia BC faience has yet appeared and so in this unsatisfactory state of affairs there are many more questions than answers concerning the origins (see below) of these early pyrotechnological achievements. This is obviously warranted, not least because of the seemingly isolated expertise shown in modelling and combinations of faience with precious metals that took place in Mesopotamia (Watelin 1934, Pl.XXXI, 7) and Egypt (Verner 1984). Moorey has made a most useful beginning in the important field of integrating evidence for the latter aspect in Mesopotamia (1982).

We are much better off for the second millennium BC, a period that witnessed the zenith of ancient faience production in terms of quantity, quality and distribution. Sagona has presented anew the Middle Bronze II vessels from Palestine which she concludes 'developed independently from contemporary Egyptian industries' (1980) and Mazzoni the Middle and Late Bronze Age anthropomorphic vessels from Syria and elsewhere in Western Asia (1979/80). Representational faience in the form of female face pendants of the second half of the second millennium BC is the subject of several studies, by Parrot (1969), Kühne (1974) and Peltenburg (1977). Crownover (1964) has issued a preliminary statement on the important material from Tell al-Rimah in Iraq and Caubet on the well-dated assemblage from Late Bronze II Meskéné-Emar, Syria (1982).

For the East Mediterranean we now have several studies of Late Bronze - Early Iron Age faience from Cyprus where, because of its location amidst the proliferation of faience ateliers, there is an intriguing interplay of styles derived from many parts of the ancient world (e.g. Åström 1967, Caubet and Lagarce 1972, Peltenburg 1972, 1974). Particularly indispensible is Foster's synthesis of Aegean faience (1979).

By comparison, the rich material from second millennium Egypt remains largely unaffected by rigorous typological scrutiny, unlike the kindred substance glass (cf. Nolte 1968). Riefstahl has collected some outstanding pieces in her treatment of Brooklyn's holdings (1968) and Strauss has examined a certain class of New Kingdom bowl (1974), but beyond that not much headway can be reported. Tait's masterly survey of the Egyptian relief chalice (1963), although including some New Kingdom material, properly belongs to the first millennium BC.

Faience production abated in Western Asia and Egypt in the early first millennium except perhaps in Western Iran and this decline is reflected in the paucity of reported instances from the area. However Von Bissing some time ago pointed to the increasing numbers of faience objects that occurred

in the Mediterranean region during the Orientalizing Period (1941) and this has led to a spate of several excellent recent studies: Clerc et al. (1976), Rathje (1976), Webb (1978), Hölbl (1979). And for the later first millennium we now have Thompson's *Ptolemaic Oinochoai* (1973) and for the following period Grimm's study of Early Imperial vessels (1972).

Compositional studies

Contrary to the rather static methodology that is evident in typological studies, important new techniques are at present often employed in the investigation of the composition of faience and, together with the structural studies mentioned below, these are now providing unprecedented insights into the characteristics of faience in particular and added incentives for the recently increased interest in the subject of ancient pyrotechnology in general. They have not entirely replaced the well-established chemical analyses (cf. Meneret 1957 for the distinction of four types of Elamite-Achaemenid faience; Bulté 1981, and also Kühne 1969c, for the proposal of glass additives in Egyptian New Kingdom faience), but their desirable qualities - non-destructive analysis, speed in dealing with large numbers and complementarity - mean that they will probably become commonplace. As evidence of a change in emphasis one has but to note the growing numbers of reports on the composition of faience which appear before their publication in the more conventional archaeological site reports. Given the frequent tardiness of the latter all the more importance attaches to the inclusion of descriptions, illustrations, or at least the citation of comparable pieces (cf. Pollard and Højlund 1983) if these analyses are to be integrated into relevant studies with different emphases.

One of the results of Neutron Activation and X-Ray Fluorescence (XRF) work bears directly on the tentative conclusions reached by Stone and Thomas with regard to the varieties of Bronze Age European beads. This has suggested that there are significant compositional differences between regional groups, in some cases related to local metal resources (Neuninger and Pittioni 1959, Aspinall et al. 1972, Harding and Warren 1973). Unless we are dealing with itinerant faience-workers like our craftsmen from Faenza mentioned above, these results suggest that innovation or faience invention took place amongst metal-using communities on a number of occasions. Such conclusions pose serious questions of the out-and-out diffusionist interpretations of the distribution pattern of faience. Thus the view, most clearly formulated by Lucas, that it seems extremely unlikely that such an extraordinarily complex material as faience can possibly have been invented at more than one place (in Stone and Thomas 1956, 39) is made less secure or at least may require modification. Among the many questions that come to mind as a result of these findings, three may be mentioned here. First, just how complex is 'extraordinarily complex', particularly within metal-using communities?. Second, to what extent can we be confident that it could 'have been manufactured and developed only by communities that had reached a fairly high level of civilization' (Stone and Thomas 1956, 36). Without entering into the question of what constitutes 'civilization', the interesting probability to emerge is that faience-making attracted the skills of quite different kinds of societies and that it was capability in general pyrotechnics as well as the desire for portable, shiny products which fostered innovation. Third, concerns the argument that because it could only have been invented once we have a *prima facie* case for diffusion 'uncomplicated by numerous secondary areas of manufacture'. The mechanism for this diffusion was regarded simply as trade and commerce (Stone and Thomas 1956) or, with more circumspection, spread and dissemination (Foster 1979, 22-31). In reality

no one explanation is likely to suffice for the first appearance of a series of faience in a particular area and an important consequence of these compositional studies is that they have perhaps begun to undermine simplistic and unilateral solutions to the distribution of early faience.

There are also studies which now make use of quite varied analytical techniques. Thus Foster and Kaczmarczyk employed XRF and Atomic Absorption Spectrometry to isolate, amongst other things, what may be an Egyptian-derived colourant in Minoan faience (1983). The fact that it is now recognized as essential to employ a battery of techniques to achieve thoroughness and to answer specific queries not only underlines the growing complexity of the subject but more important it points to possibilities for answering new kinds of questions. XRF in particular has great potential in this field, as McKerrell (1972) and others recognized some time ago, but the type and quality of conclusions reached are neither all-embracing nor without constraints. Kaczmarczyk and Hedges have outlined many of these limitations (1983, 10-19) and even severer strictures have been voiced with respect to the distorting effects of weathering on analytical results (Hedges 1976, 210; Tite, Freestone and Bimson 1983, 27). Even if these deficiencies could be overcome and precise and accurate results were obtained we would still have to contend with the problems of the extent to which all faience-workers rigidly adhered to traditions, to formulae and to sources of raw materials, to the role of glass ingot trade (cf. Oppenheim 1973 and Cooney 1976, 1445-50, 1466 for possible examples, but note Cooney 1981) and to fluctuation even within a single firing batch, matters that affect characterization as well as source studies. The problem becomes especially acute when faience-working centres proliferate and there is a growth of internationalism in the Near East and Mediterranean regions in the second millennium BC, for example. North of the Alps and West of Greece however, where prehistoric faience is much rarer, these problems may be ameliorated, hence a readier acceptance of the discrete patterns of faience constituents from these areas. But, in general, XRF analyses, if reliable, have revealed such considerable variation and complexity that, as in the case of metal analyses, their use for provenance studies remains a debatable issue. It would seem from Kaczmarczyk and Hedges' (1983) pioneering analyses of 1102 examples of Egyptian faience (a number which demonstrates the potential of XRF and the impending need for regular statistical treatments) that the most convincing conclusions regarding regional and sometimes local compositional traits must be derived from the averages of large groups rather than single, or indeed a few, objects which can skew compositional profiles because of anomalous, minor fluctuations.

Structural studies

Since 1956 there has also been an upsurge in the deployment of another analytical tool, one which I propose to call 'structural studies'. To some extent Stone and Thomas were already able to divide their material into two structural groups, true and glassy faience, and Lucas of course had long before proposed several others (1962, 161-7), but these require amendment (cf. Kaczmarczyk and Hedges 1983, 185-220) and we now possess yet others that reflect our much better understanding of the material. These more recently acquired insights into structure have been gained from unexpected quarters, those of 'replication' and 'ethno-technological' investigations. As in all synthesizing experiments, to achieve a similar product as the ancient exemplar is not to prove that this is the way in which the exemplar was in fact made. This and the startling novelty of efflorescence rather than dipping or application as a means of glazing is perhaps why there was scant attention paid to the work of Binns *et al*. (1932) until Noble presented it to a wider audience (1969). Still, Noble only showed that

faience of the same appearance could be achieved by this method and it is mainly through the surface and microstructural investigations of Vandiver (1983a) and Tite and his colleagues (1983) that enhanced credibility is being given to the technique. Distinctive characteristics of core, interface and surface glaze of objects produced by efflorescence can now be inventoried on the basis of modern reproductions which are closely comparable to some Egyptian faience (Table 1).

About the same time as Noble introduced this method for general reconsideration, Kiefer and Allibert proposed another self-glazing technique for Egyptian faience whereby glaze was formed as a result of the cementation of a faience core buried inside a matrix of glazing powder (1971). Their studies were initially vindicated from the quite unexpected quarter of modern faience production in Qom, Iran (Wulff, Wulff and Koch 1968) and more recently by the same examination of the structural characteristics of ancient and modern faience just mentioned.

These latter investigations further confirmed the co-existence of applied glaze techniques so that now we have three quite different glaze formation methods verified for Egyptian faience. As shown in Table 1 some indication of the method employed may be obtained from visual inspection and so there are new and important advantages for the non-specialist. But the poor preservation of many samples, it must be said, and other factors render this a hazardous procedure and recourse to the use of the electron microprobe and scanning electron microscope would seem to be necessary to attain an acceptable measure of certainty.

Table 1. Glaze formation characteristics on faience (see Vandiver 1983a; A-39, Tite, Freestone, Bimson 1983)

TECHNIQUE	BODY	INTERFACE (Glass and quartz phase)	GLAZE
APPLICATION*	Little interstitial glass	Not well defined	Thick. Could retain stand marks. All over cover unless intentionally curbed. Can have drip and flow lines. No drying marks.
EFFLORESCENCE+	Much interstitial glass	Narrow, well defined, depending on flux and temperature.	Could retain stand marks. Drying marks: none on unturned drying surface; cracks; decrease in thickness at edge. Thinner on concave surfaces.
CEMENTATION	Little interstitial glass	Thick, well defined	Thin. No stand marks. All over cover unless intentionally curbed. No drying marks.

* Probably dipped into glaze solution though application by pouring over body, brushing onto body and as a dry powder (cf. Wulff 1966, Vandiver 1983a) are also possible.

+ Most effective for fine grained bodies. Note variations possible, e.g. Lucas Variant A (Lucas 1962).

It is perhaps too soon to assess the potential of these developments for source studies even though it is obvious that they appreciably extend our knowledge of the intricacies and diversity of ancient pyrotechnology. If it could be shown, for example, that the rather esoteric self-glazing procedures were known primarily in Egypt, then their appearance elsewhere would require explanation. There are, moreover, apparent constraints in reaching definitive statements about glaze formation techniques. Thus Tite, Freestone and Bimson (1983) found it difficult to ascertain the precise method in three of four examples of Egyptian faience. And last, a more general problem is raised by the use of these notably different techniques to produce typologically similar objects from at least the Middle Kingdom (Vandiver 1983a, A-2,3), even to the extent that all three methods were used on the same object. Such variation may be due to the persistence of practices established at different times, but if this is the case, then in the current state of our knowledge such a multiplicity of workshop practices will raise more problems than it solves with regard to provenance.

The upshot of these recent advances in the study of Egyptian faience is that there is now ample scope for the search for correlations between elemental analyses, glaze formation processes and types and styles of objects as well as their distribution and chronological definition.

Philological studies

The inexplicit nature of ancient Near Eastern texts with regard to vitreous materials in general let alone faience in particular continues to bedevil our understanding of this promising body of evidence (Oppenheim et al. 1970, Muhly 1972). In spite of a recent attempt to identify not one but three types of faience in the richest of our sources, the cuneiform texts (Foster 1979, 15-21), the case is still open as to what exactly is being referred to. Brill's hyper-cautious statement still seems apt in revealing the real state of our ignorance: -

> 'it cannot be said without some reservation that the materials referred to *must* be glass. There is just enough ambiguity in the identifications and chemical details as gleaned from the translations that the possibility cannot be entirely ruled out that the final products might instead have been some form of faience, Egyptian blue, or similar materials, instead of true glasses' (Oppenheim et al. 1970, 107).

Studies of Western Asiatic faience

The above selective outline of recent studies shows that the major contributions to our understanding of the history and nature of ancient faience derive from Egypt or Egyptianising products. This is due to its fame, good preservation, accessibility and variety. Such is the high quality of these studies that they threaten to distort an overall assessment of the subject and so I should like to turn to two key issues alluded to by Stone (Stone and Thomas 1956) in reference to Asiatic faience, namely the beginnings of its production and its relationship with early glass.

Questions of identification and the earliest Asiatic faience

In his survey of the records of early finds, Stone lighted on a single seal or discoid pendant from Arpachiyah which by implication comes from Halaf

levels (Stone and Thomas 1956, 41). The other finds quoted from this site belong to subsequent Ubaid graves however and so it was felt that the evidence for a Halaf Period occurrence was equivocal. Several summaries of the history of faience have been similarly and quite properly chary of the chronological evidence and they have concluded that a fourth millennium BC date is likely for its Asiatic beginning (e.g. Kaczmarczyk and Hedges 1983, 282). But in concentrating on beads Stone overlooked or failed to mention Mallowan's clear statements with regard to a vessel in an undoubted Halaf context. Thus, from TT6 or TT7, comes a frit bowl. Another is ascribed to the Halaf Period on the unsound criterion of absolute depth, though here it should be pointed out that the three Ubaid graves, the only later features evidently found in the area of this object, did not penetrate to the same level (Mallowan and Rose 1935, 97, 175, Pl.XIX, 9). Other published Arpachiyah vitreous items include glazed steatite and glazed ring beads from Ubaid graves 4, 23, 25, 27 and 31, and frit, glazed white steatite and 'bitumen inlaid with discs of vitreous paste' from unspecified periods, either Halaf or Ubaid (Mallowan and Rose 1935). Uncalibrated radiocarbon dates for the Halaf are no later than the mid-fifth millennium BC (Hijara *et al.* 1980) and hence we may be reasonably certain of the precocious development of vitreous materials in North Mesopotamia in the first half of the fifth millennium BC.

There may even be earlier instances. Thus, there is a fluted faience bead from Layer 2a of the seventh - sixth millennia BC site of Tell-i-Mushki in southwest Iran (Fukai 1973, 65,73 Pls.XL 1.1, LV 35), but unfortunately it comes from a part of the essentially single-period site where there is at least one intrusive burial pit (Pl.XLVI, Section 1-11). There is also a series of even earlier disc and cylindrical beads from Pre-Pottery Neolithic B as well as Pottery Neolithic A Jericho, but these are described as glazed frit, an ambiguous term (Kenyon and Holland 1983, 789-791).

But what exactly are these early Arpachiyah materials? Stone presumed that by frit Mallowan meant faience, a not unlikely assumption. Others have followed suit, yet none seem to have been able to inspect the materials in question and Mallowan, it may be noted, does make the distinction between frit and glazed frit (1935,39,92-3). Even if they could be inspected however, such is the registration and storage conditions of some Arpachiyah finds that it would be difficult to correlate them with their precise stratigraphic position unless they could be matched in the publication. For example, one box of Arpachiyah objects in Birmingham Museum and Art Gallery contains a flat unmarked sherd-like object and a nugget of material that conforms to descriptions of 'Egyptian' blue, but the box is marked 'TT6' and an enclosed card states 'ALL DUMP from Trench D'. XRD analysis kindly carried out at short notice in the Research Laboratory of the British Museum however showed that both were azurite and so presumably used as pigments. This basic test demonstrates the need for the analysis of many kinds of vitreous materials if we are to be certain of identifications. The fact that the Halaf pieces have not been so analysed is worrying therefore and while we may be prepared to accept that Mallowan recovered some vitreous materials from Halaf contexts the question of their nature and whether faience was included remains unresolved.

This confusion of terminology which so vexes our studies has not improved much in the nearly thirty years since Stone was driven to exasperation by conflicting and inconsistent reports (Stone and Thomas 1956, 43-4). But these are really not surprising given the diversity of vitreous materials, their often disintegrated state and the differing priorities of frequently underfinanced excavators for whom specialists are not readily available. However, there is no room for complacency in this matter because important conclusions are being reached on the basis of misidentifications and for

related reasons. Two cautionary tales may be used to illustrate this point.

In the recent volumes of the Ur Excavations it was quite rightly decided to adhere as closely as possible to Woolley's original texts and hence his terminology. Presumably because he was so convinced by the Gulkishar tablet, which was purported to be a seventeenth century BC pottery glazing recipe (cf. Woolley 1955, 300), he was well satisfied to have the corroboration of examples of Kassite Period glazed pottery, whether ultimately from North or South Mesopotamia. Such pieces are reported in the relevant volume of the Ur Excavations (Woolley 1965, 97-8), despite the fact that the vessels are of faience (Peltenburg 1968, 161-2). Thus, as published, they lend support to Stone's general remark concerning Western Asiatic faience: 'it would seem that except for Syria little attention was paid to the manufacture of the material during the second millennium in comparison with that of Egypt and the Aegean' (1956, 49), whereas in reality, as may be verified in Reuther's publication of the faience from Babylon for example (1926), the situation was quite different. The mistake also has intra-Mesopotamian repercussions since it appears that Babylonia was reluctant to adopt the glazing of pottery which, as finds from Nuzi demonstrate (see below), was such a flourishing industry in the North. Reports of a few second millennium pieces of glazed pottery from Nippur as well as undoubted examples of Babylonian shapes from Sa'ad IV on Falaika (though this site is outside Babylonia proper) may mean that limited essays into this technique were attempted (Table 3), but the Ur evidence cannot be used to support such Babylonian experimentation or for trade in glazed pottery with the North. Although Babylonia is known to have been conservative during the Kassite Period, this is unlikely to have been the entire reason for the belated appearance of glazed pottery in the South. The fourteenth - twelfth centuries BC palace at Dur Kurigalzu, after all, was decorated with novel, high quality mosaic glass (von Saldern 1970).

The second instance may be characterized as a case of technological determinism. It would seem to stem from Andrae's fundamental study of Assyrian glazed pottery (1925). There he concluded that the earliest examples occurred in the reign of Adad-nirari I, ca. 1307-1275 BC, and that the main production followed only in the first millennium BC. Although an over-simplification, faience was believed to be diagnostic of the second and glazed pottery of the first millennium BC. In the later publication of the tombs and graves from Ashur, Haller apparently used Andrae's chronological scheme in order to date those graves for which there was otherwise inadequate dating evidence (1954). Thus, while not denying the existence of glazed pottery in the second millennium, its presence became a criterion by which certain graves were assigned to the Neo-Assyrian Period (Haller 1954, 13 ff). There is however incontrovertible evidence that such pottery was much more common in second millennium contexts than allowed for both at Ashur (Haller 1954, tombs 37, 51 and several graves) and at other North Mesopotamian and North Syrian sites (Table 3). The history of Mesopotamian vitreous materials therefore consists of significant technological overlaps and regional variation rather than one of unilineal development.

Faience and glass

It is generally acknowledged that true glass developed out of a background of faience-working (e.g. Oppenheim 1973, 262) and that this is likely to have occurred in North Mesopotamia - North Syria during the sixteenth - fifteenth centuries BC when core-formed glass vessels appear (Barag 1962). One can but agree with Stone who stated that 'the techniques involved in the development of faience were strictly antecedent to the subsequent

development of true glass' (1956, 37). And Vandiver's conceptual observation that application glazing rather than the other types of glazing foreshadowed the development of glass (1983a, A-136) seems particularly apposite in view of the likelihood that this technique was the favoured one for Western Asiatic faience vessels. The implication then in many of these statements is of a causal relationship between faience-working and the start of core-formed glass production. In the absence of specific proof this development has had to be visualized in a general manner. Thus, Goldstein's notion that glass evolved from tinkering by faience manufacturers (1979, 24-7). Such descriptions emphasize how little we know of the processes involved. We are far better informed on the questions of when and where glass appeared. Granted that archaeology is unlikely to reveal each of the first steps in this discovery process, there still is a need to look more closely at the alleged faience-glass equation and, in trying to address the questions of how and why, to account for the change in its specifically pyrotechnical and historical contexts.

Had glass been developed in an exclusive faience-working tradition then it could be reasoned that the breakthrough is likely to have taken place during a time of increased tempo in the production of faience, particularly of larger scale works such as vessels. These vessels moreover should also carry polychrome glazes in view of the appearance of an impressive array of colours on the earliest glass vessels (Barag 1970, Vandiver 1983b). Leaving aside the polychromy of the rather *sui generis* Minoan faience industry (Foster and Kaczmarczyk 1982) and confining ourselves to the area of the advent of glass vessels, one is struck however by the relatively low numbers of preceding faience vessels and the absence of polychromy. They are conspicuous by their absence in the relevant Middle Bronze Age levels of such sites as Tell Brak, Chagar Bazar, Tell al-Rimah and Mari for example, the first three within, the last on the edge of what was to become the centre of the distribution of core-formed glass vessels. The prevailing model for the emergence of glass would lead us to expect the opposite so this sparse occurrence pattern requires detailed examination.

Alalakh in North Syria has some of the earliest known glass vessels which, according to Gates' recent study of the chronology of the site (1981), may be attributed to the sixteenth century BC. If Woolley's statement concerning the Level VII incidence of polychrome glass beads could only be verified (1955, 269), then Alalakh also possesses the earliest instances of glass polychromy. This would be highly significant since, as argued here, polychromy seems to be an integral component of the technological revolution that brought about the establishment of glassworking industries. The lengthy sequence of levels at Alalakh might have been helpful in determining if a preceding Middle Bronze Age surge in faience-working took place had there been more substantial exposures of pre-level VII deposits. As it is, we cannot assess if the four vessels from Level VII represent a preparatory quickening of pace (Woolley 1955, 297). With the exception of the hand bowl (Fig.1) which, like its parallel from Ugarit (Fig.1) confirms the well-known presence of certain Egyptian customs in Syria at this time, the others show no special deviation from the black and blue glazing traditions that were well established in North Syria and perhaps Central Anatolia from the end of the third millennium BC (Fig.1; Peltenburg 1968, 124-137; van Loon 1969, 67 top). The Middle Bronze II occurrence of modelled (Mazzoni 1979-80) and incised (Matthiae 1979,Fig 64) vessels are novelties which attest to the liveliness of the North Syrian faience industry, but they are still firmly within established parameters of working in glazed quartz frit. There are no published developments in faience production from this area therefore which overtly presage the emergence of glass.

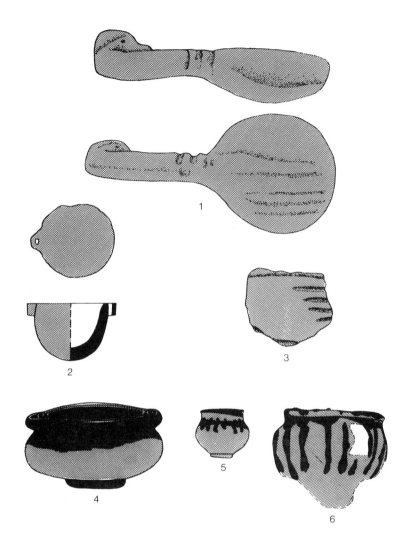

Fig.1 Middle Bronze Age faience vessels from Ugarit (1,4,5), Alishar Huyuk (2,6) and Alalakh (3) in N.Syria and Anatolia. Not to scale.

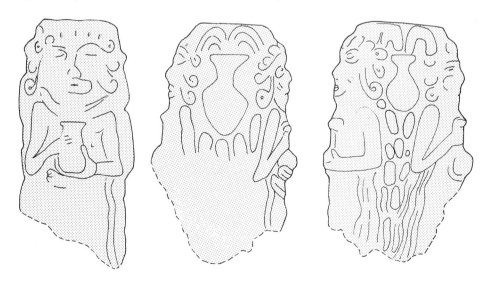

Fig.2 Fragment of monochrome blue glazed faience vessel depicting in high relief figures holding vases with flowing water. Ht. 0.094m. From Tello. T. 92. AO 15345.

Mesopotamia has yielded documentary evidence for such a challenging assortment of vitreous materials referrable in its initial phase to South Mesopotamia ca.2000 BC according to Oppenheim (1970), that one might expect that it was this area which possessed the most conducive technological environment for sustained glass production. Turning once again to the evidence of faience however we can observe that while there was a continuous tradition of vessel-making there is little archaeological evidence for critical advances in the period leading up to ca.1600-1500 BC. The most remarkable achievements of South Mesopotamian faience-workers seems to have been representational vessels, but the early second millennium examples (e.g. Fig.2) show no great technical superiority over extant pieces of the much earlier Early Dynastic III period (Watelin 1934, Pl.XXXI 7). Indeed, outside Susa (Peltenburg 1968, 114) it is difficult to isolate very securely dated pieces of the period. The attribution of several from Ur to this time (Woolley loc. cit. and Mallowan 1976, 183-4) should be treated with reserve. The polychrome face pendants or 'masks' from this site for example are undoubtedly much later (Peltenburg 1977). There are however reports of the addition to the existing repertoire of the new glaze colours red and yellow here as well as in North Mesopotamia (Andrae 1925, 61; Moorey 1982, 35). These are noteworthy since they figured prominently in the new glass technology and so it would be useful to have them checked particularly because of colour alterations due to the harsh effects of post-depositional agencies in these regions. Secondary, reduction burning, it should be remembered, can reduce CuO to red cuprite (Cu_2O) and it may be relevant that no distinct metal oxide could be found in the yellows of pre-Eighteenth Dynasty Egyptian faience (Kaczmarczyk and Hedges 1983, 146).

Thus, while the poor quality of our evidence cannot be stressed too strongly, there does not seem to be an observable momentum towards glass production within relevant faience industries. Yet the prolonged recurrence of pre-1500 BC small glass finds, both in Egypt and Western Asia, indicates some familiarity, presumably amongst faience-workers, with glass formation. Reported instances are summarized in Table 2, but before considering the significance of this evidence and its division into two stages certain features of the Table need to be borne in mind. First, there are dating and identification problems, but an effort has been made to exclude more dubious examples, for whatever reasons. Thus the Ur and Ashur pieces of Beck's (1934) and Kühne's (1969a) lists are deleted because of insufficient stratigraphic data (cf. also Woolley and Mallowan 1976, 184 n.3, 205). There may well be others which should be deleted, and yet more to add (e.g. from Iran: Crawford 1975, 12), but the general pattern, it is hoped, will not be altered decisively. Second, the remaining artefacts are mostly regarded as the results of glazing accidents (e.g. Cooney 1960) and they should be considered as examples of the occasional use of rare and curious chance products which, nevertheless, must have raised the latent consciousness of glazers with respect to the possibilities of the substances they were handling. Turning now to the implications of Table 2 we may note again that there is no convincing increase in occurrences either in one place or generally through time. The greater number of finds from Egypt is regarded here as a consequence of better soil conditions, more excavation and more detailed study rather than a reflection of closer familiarity with glass. Recurrent pieces from Tell Asmar in Mesopotamia culminate, apparently, in an early second millennium BC glass bowl, but this evidence is still unique in the region. The identification of a glazer's kiln at the same site and its use for beads and glazed pottery is also unconfirmed (Delacroix and Huot 1972, 58-9).

Table 2. Glass of Stage 1 in the Near East

DATES BC	EGYPT	SYRIA	MESOPOTAMIA	ANATOLIA
1500	▓▓▓▓▓ GLASS	OF	STAGE 2 ▓▓▓▓▓	
1600	● Thebes[2]			
	● Saqqara[10]	● Alalakh[7]		
	● Mostagedda[10]			
1700		● Jericho[13]		
1800				
	□?[12]			
	● Abydos[1]			● Büyükkale[11]
1900	● Armant[1]		□▲ Tell Asmar[5]	
	● Dahshur[2]			
2000	● Deir el Bahari[1]			
	● Sedment[1]			
	● Matmar[1,10]			
2100	● Qau[2,10]			
	● Mostagedda[10]			
2200	● Matmar[1]		□ Tell Asmar[3]	
	● Qau[2]		□ Eridu[4]	
2300			□ Nuzi[9]	
2400	● Gebelein[1]	● Jericho[14]	● Tell Asmar[6]	
	● Abydos[10]			
2500		● Judeidah[8]		

● Bead(s) & pendant(s) ▲ vessel (?) □ miscellaneous

Note: Kühne (1969b, 307) argues for 18th - 17th centuries BC dates for moulded glass figures from Western Asia, but stratified examples come from later deposits (Barag 1970). The example from Ebla, a city which flourished in the 18th - 17th centuries BC but of which little is known thereafter, is unstratified (Davico 1967, 98, Pl.LXVI: 3).

(1) Lucas 1962, 180-1. (2) Beck 1934. (3) Beck 1934; Delougaz, Hill, Lloyd 1967, 246; Moorey 1982, 36. (4) Beck 1934; Garner 1956, 147; Moorey 1982, 36. (5) Delougaz, Hill, Lloyd 1967, 263-4. (6) Delougaz, Hill, Lloyd 1967, 243. (7) Woolley 1955, 269. (8) Braidwood, Braidwood 1960, 341-2, Fig. 258. (9) Starr 1939, 380, 515. (10) Andrews 1981 (11) Boehmer 1972, 175, 1809 (12) Martin 1971 nos. 441, 1198. (13) Kenyon 1960, 351, 368, 406. (14) Kenyon 1960, 171.

Thus neither the history of faience nor the history of earliest glass can be shown to lead in a series of gradual steps in one area to the realization of the potential of glass. Faience-working therefore provided but a general background rather than a direct impetus for glass production which, as has often been stated, appears suddenly.

The long history of glass accidents and the manufacture of 'glass' for subsequent use as glaze on a crushed quartz or other carrier should not be confused with the circumstances in which intentional and continued production of glass is recognizable. The former may be termed Stage 1, a pre-adaptive stage characterized by the very infrequent and irregular use of glass, the distinct properties of which may not have been discerned by users as exceptional until perhaps the appearance of some glass scarabs in Egypt and a vessel in northern Babylonia (Table 2, nos.12 and 5). The latter, from Tell Asmar, remains unpublished but whatever the techniques employed to make the vessel, its isolation, like that of the scarabs, suggests that the incipient glass technology had not yet been fully exploited. Stage 2 (Table 3) may be defined as that period in the history of glass in which its individual properties have first been realized and the products exhibit characteristics unique to glass-working. It was then used for luxury items, primarily polychrome core-formed vessels and 'jewellery', especially in temples and palaces. Stage 2 appears suddenly in several regions and it involves from the outset a diversity of specialised techniques such as fusing, marvering, trailing and the incorporation of different metal oxides for new colours. This rapid emergence of a 'working glass' industry ca.1600 BC has analogies with critical junctures in the history of other crafts and it may be helpful to pursue one of these, the metal iron, briefly here. It too existed for a prolonged time before it was established as the predominant metal for practical purposes (Snodgrass 1982). This shift was also sudden and is diagnosed in the archaeological record by the appearance of new techniques and a much increased number of limited types of iron artefacts. What is more relevant for our purposes however is the consensus view that some critical historical element is responsible for the adoption of iron as the working metal. Now, it seems hardly likely that the crucial motive for its adoption, that is a severe shortage of rare raw materials (i.e. tin for bronze), figured in the inception of working glass. Quite the contrary given the diversity of metal oxides necessary for the many associated colours in the earliest glasses. But the more general point concerning change from a position of relative homeostasis to active production is that particular historical circumstances are the mainspring and it is this aspect that deserves closer investigation than has hitherto been applied to the case of glass. In other words, while long term experimentation in both cases provides an essential pre-adaptive phase within respective crafts it is the predisposition of society that is the essential factor in the dynamics of invention.

Can we determine the circumstances that attended the beginning of glass production? Unfortunately, precious little is known of the historical situation in North Syria - North Mesopotamia in the seventeenth - sixteenth centuries BC. In broad outline it seems that Mursilis' raid on Babylon precipitated a power vacuum in this part of the world which rapidly saw the crystallization of a poorly understood but effective Hurri-Mitanni symbiosis (Otten 1966). This may in part have already proved a political and cultural reality before the raid for there is ample evidence of increasing Hurrian onomastica then (Kupper 1973). The earliest reference to the Mitanni is somewhat later, during the reign of Thutmosis I (Brunner 1956). This group is generally regarded as a recently intrusive and politically dominant partner in a heterogeneous mixture, one which seems to be founded on novel political institutions.

In terms of material culture this sometimes manifested itself in adaptations of existing traditions. Such amalgamations have led to controversies concerning the very existence of a truly independent Hurrian-Mitanni art for example, but for our purposes the development of the cylinder seal at this time may be taken as indicative of one trend. First, the idea of the cylinder seal was enthusiastically continued and expanded in these regions. Second, the prevalent material, stone, was largely abandoned in favour of another medium, faience. Third, selections were made from existing Mesopotamian and Syrian compositions, adapted and added to in such a way that distinctively new designs were created (Buchanan 1966, 179-185). Prior to this period glyptic art in Mesopotamia had been relatively static so these discontinuities are all the more notable. It is perhaps in this conducive environment of modification to established practices that the growth of working glass may be placed. Such an historical context has the merit of accounting for the distribution and chronology of the first polychrome core vessels and of providing some answer to the niggling question of why, when for ca.1000 years at least there were so many instances of accidental or crude glass, the 'discovery' did not happen earlier. Although too sweeping, Oppenheim's conclusion that changes in 'technical know-how .. are due to impulses from outside, in other words, they are released by information originating in other cultures' would seem to be appropriate in this case (1973, 265).

So, to state that glass-working developed from faience-working is an oversimplification that fails to treat the complex historical processes that were the more immediate causes of its emergence. And there is even some evidence that faience-working may have played no more than a minor role in the establishment of glass-working. We have already remarked how there was no compatible upsurge in faience vessel-making prior to the onset of glass and indeed the paucity of such vessels early in Stage 2 at Nuzi, for

Table 3. Western Asiatic Stage 2 core-formed glass vessels (▲) and glazed pottery (●).

DATES B.C.	N. SYRIA	N. MESOPOTAMIA	S. MESOPOTAMIA/GULF	ANATOLIA
1300		●Tell Billa[2]	●Nippur[9]	
		▲●Ashur[3] ▲● Tell Brak[6]	●Sa'ad wa-Sa'aid[10]	▲Büyükkale[12]
1400		▲●Nuzi[4] ▲Chagar Bazar[7]	▲Ur[11]	▲Norsun Tepe[13]
		▲●Tell al Rimah[5] ▲●Tell al-Fakhar[8]		
1500				
	▲●Alalakh[1]			
1600				

(1) Woolley 1955, 299; Barag 1970, 150-3. (2) Unpublished glazed pottery in Iraq Museum and Philadelphia. (3) Barag 1970, 141-5 and see above. (4) Starr 1939, 391-3; Barag 1970, 135-141; Vandiver 1983b. (5) Carter 1967, 286; Barag 1970, 145. (6) Unpublished glazed pottery, Institute of Archaeology, London; Barag 1970, 146. (7) Barag 1970, 146. (8) Mahmoud 1970. (9) Gibson 1975, 64, Fig.46.220337; Gibson et al. 1978, 81, 85, but probably not the horse figures, p.14. (10) Pollard and Hojlund 1983. (11) Barag 1970, 147 (12) Boehmer 1972, 174-5.1802. (13) Hauptmann 1974, 93.

example, suggests that faience vessel production played an insignificant role in these developments (cf.Vandiver 1983b). Instead there seems to have taken place a much more thorough-going and enthusiastic conversion of extant practices than we can trace in the glyptics. Not only were glazes applied in an unprecedented manner to removable cores to make glass, but leaving aside the unconnected material from India (Marshall 1931, 366, 578, 581, 692-3) they were also applied for the first time to a common core type, namely pottery (Peltenburg 1968, 12-63). That this significant departure constitutes one more facet of the same technological revolution is clear from technical, typological, chronological and distributional evidence. Thus, unlike the thin glazes on faience, those on pottery have a thickness approaching the walls of glass vessels, a factor which not only helps to account for the distinctive crazing of early pottery glazes, but, more importantly, also indicates a closer affinity to glass vessel-making practices. Indeed, it has been suggested that it was not until some mastery of the mechanical properties of glass was gained, and hence an awareness of controlling its composition in order to overcome differing coefficients of glaze and carrier expansions, that glazed pottery became consistently possible (Hedges 1982, 102). With regard to typology, it is remarkable that the earliest glazed pottery vessels are primarily handleless flasks, identical with the most characteristic early glass vessel shape (Fig.3). As shown in Table 3 they occur together at the same time and on the same sites as far apart as 750km in North Syria and North Mesopotamia. This singularly close association, sometimes in the same graves as at Ashur or same temple as at Nuzi, is partly due to the fact that the objects probably originate from the same or allied workshops. Taken together, these relationships demonstrate that the technological revolution which took place comprised not an isolated shift but a completely new approach to existing practices, one which was bound to have ramifications in several directions. No such correlations exist between glass and faience vessels.

Metallurgy and early glassmaking

Of particular interest in this context is the relationship that the new glass-workers and glazers had with metalworkers. It is generally agreed that the metal oxides used as colourants for glazes often approximate to the proportions known in contemporary bronze industries, so suggesting, for example, that glazers often used scale (McKerrell 1972, Kaczmarczyk and Hedges 1983, 90, 274). It is also clear from the combination of vitreous materials with gold appliqué (e.g. Verner 1984) and with bronze (by resins? fusion?: Delougaz, Hill and Lloyd 1967, 115, 132) that faience-workers and metallurgists commonly acted in concert. But several aspects of the first glass vessels make explicit a much closer relationship between metallurgic and vitric traditions than seen previously. This is most obviously evident from glass-makers' knowledge of the colouring properties of not just copper for blue, but a host of metal oxides: calcium antimonate for white, lead antimonate for yellow, copper for blue, cuprite and iron oxide for red, and iron plus sulphur for black/brown (Vandiver 1983b, 245). It is also demonstrated by the use of copper-containing metal rods in the manufacture of some of the earliest glass beads, from Nuzi (Vandiver 1983b, 242). Other metal-related glass-working techniques require further investigation. Thus it may be that there are decisive differences in the production of faience and glass which link the latter more closely to metal-working. In contrast to faience-workers who formed their glaze essentially in a cold state, that is by efflorescence, cementation or application as powder or in solution, glass as an independent substance involved a hot technology in which heated canes were wound round a core or the hot glass was applied to it with a dip stick or cores were immersed into the viscous batch. Whatever the method, hot working the glass in a molten state both for body

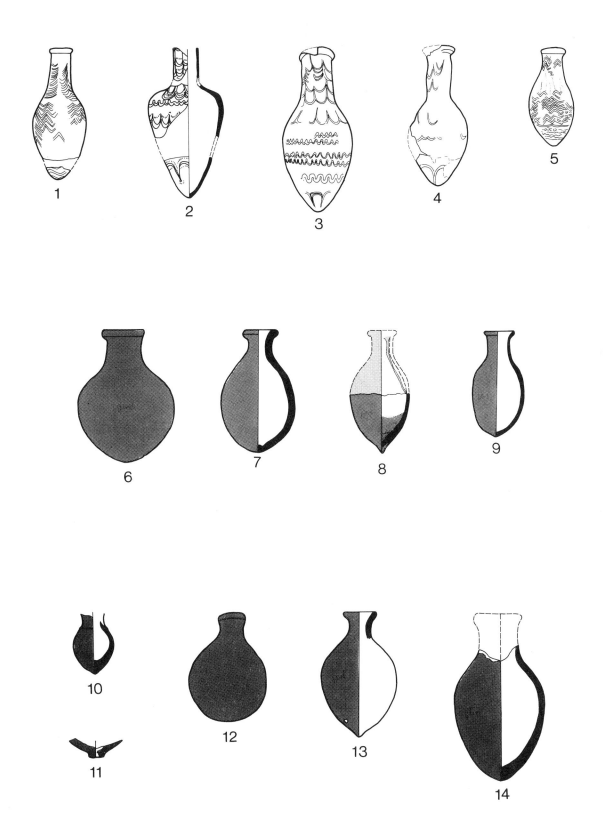

Fig.3 Stage 2 glass (1-5) and contemporary glazed pottery (6-14) flasks from Alalakh (1,6,7), Nuzi (2,8-11), Ashur (3,12), Tell al Rimah (4), Ur (5), Tell Billa (13) and Tell al-Fakhar (14) in N. Syria and Mesopotamia. Not to scale.

forming and decoration is much more akin to metal than faience working. Scapova has persuasively shown how glass may be regarded as an adaptation of non-ferrous metalwork technology, but the described analogies are limited to mould-produced objects (1981). These comprise but a minority of the earliest glasses. They include, for example, female figurine plaques (Barag 1970, 188-9) and probably mosaic glass bowls (von Saldern 1970, 206). In contrast, the majority are beads and vessels which are formed around non-adhering disposable cores. While faience-workers were probably familiar with such a practice in the manufacture of beads (many in fact were drilled), there were nonetheless critical differences since the quartz body is packed around the core in a cold state whereas in glass-working the core or armature would have to be heat-resistant to receive the molten glass. Metalworkers however had been employing precisely this technology for centuries in the production of socketed tools for example and, generally speaking, in the concepts entailed in 'cire perdue' casting. In order to make hollow castings a false core, often made of refractory clay and used in conjunction with a piece mould, was necessary. Once the molten metal had solidified the core was extracted, but in the case of our glass flasks with their constricted necks it would have to be soft in order to be scraped out. Vandiver has recently also noted the existence of a parting layer between core and glass beads (1983b) and this is very reminiscent of the dressing or facing applied to moulds, in this case to ensure a good surface to the casting.

These relationships between glass and metalworking are unlikely to be fortuitous and so it may be that a different organization of crafts which allowed for a more integrated transfer of technology than hitherto was responsible for the character of the observed changes. The Hurri-Mitanni were by no means unique in combining metals with other materials to fashion objects but, as Tushratta's gifts to Egypt show, they were very interested in these amalgamations and in novelties such as iron (Knudtzon 1915, 131-269). Presumably certain glazers and metalworkers laboured to satisfy the requirements of a new elite who in the Amarna letters repeatedly refer to colourful objects of conspicuous display and it is they therefore who ultimately may have provided the stimulus and encouragement for the creation of such dazzling products.

The posited inter-relationship of glass and metalworkers, like the general proposal concerning the historical context of the development of working glass, is an hypothesis that, it should be realised, at present rests on all too slender a foundation. There are after all few Hurrian or Mitannian terms in the earliest glass texts, many of which are supposedly several centuries earlier than the period under discussion (Oppenheim 1970, 18,83). Whatever the exact nature of the vitreous materials mentioned, these texts also refer to numerous colours from which we may infer prior Babylonian knowledge of the colouring properties of certain metal oxides. The admittedly scanty archaeological evidence however is at odds with the textual, if the latter in fact refers to glass. Assuming its date and identification is correct, the dramatically early Larsa Period glass vessel from Tell Asmar (Table 2) would certainly be the oldest known, but its isolation in the archaeological record suggests that it was a precocious instance of glass-making rather than proof of the existence at that time of the new craft in South Mesopotamia.

The other main candidate for the region in which glass originated is North Syria, first suggested by Petrie with characteristic perception (1925 col.187) and more recently favoured with additional evidence by Oppenheim (1973). This Amorite area was once dismissed as being too backward for the promotion of such a sophisticated technology (e.g. Muhly 1972), but recent discoveries reveal an excellence in the minor arts and in metallurgy which

certainly means that a favourable milieu existed here. There are however no reports of glass in contexts such as Palace G or the Tomb of the Princess at Tell Mardikh-Ebla (Matthiae 1979, 1980) where we might expect to find it, had a glass industry been established in North Syria prior to the period discussed here. The occurrence of 'glass paste' (Pinnock 1984, 74-5) however should alert us once again to the patchiness of our records and to the persisting confusion in current terminology for vitreous materials.

Acknowledgements

I am grateful to Dr M Tite and M Bimson who respectively suggested and undertook the analysis of azurite from Tell Arpachiyah and to P Watson of the City Museums and Art Gallery, Birmingham, for so speedily enabling this analysis to take place. Dr T Watkins thoughtfully drew my attention to 'glazed frit' beads from Jericho. The following kindly permitted the inclusion of unpublished material: P Parr, Institute of Archaeology, London: Chagar Bazar glazed pottery; Trustees of the British Museum: Fig.3.7; the University Museum, Philadelphia: Fig.3.13; Professor Frank Moore Cross, Director, Harvard Semitic Museum: Fig.3.8,11; A Caubet, Musee du Louvre: Fig.2.

References

Allan J (1973). Abu'l-Qasim's treatise on ceramics. Iran XI, 111-120

Andrae W (1925). Coloured ceramics from Assur. London

Andrews C (1981). Jewellery from the earliest times to the Seventeenth Dynasty. In Catalogue of Egyptian antiquities in the British Museum VI.1. London

Aspinall A, Warren S E, Crummett J G and Newton R G (1972). Neutron activation analysis of faience beads. Archaeometry 14, 27-40

Åström L (1967). Studies on the arts and crafts of the Late Cypriot Bronze Age. Lund

Barag D (1962). Mesopotamian glass vessels of the second millennium BC. Journal of Glass Studies 4, 8-27

Barag D (1970). Mesopotamian core-formed glass vessels (1500-500 BC). In Glass and glassmaking in ancient Mesopotamia Oppenheim et al., 131-201

Barag D (1985). Catalogue of Western Asiatic glass in the British Museum. London

Beck H (1934). Glass before 1500 BC. Ancient Egypt, 7-21

Beck H and Stone J (1936). Faience beads of the British Bronze Age. Archaeologia 85, 203-52

Binns C, Klem M and Mott H (1932). An experiment in Egyptian blue glaze. Journal of the American Ceramic Society 15, 271-2

Boehmer R (1972). Die Kleinfunde von Bŏgazköy. Wissenschaftliche Veroffentlichung der Deutschen Orient-Gesellschaft 87. Berlin

Braidwood R and Braidwood L (1960). Excavations in the Plain of Antioch I: The earlier assemblages. Oriental Institute Publications 61. Chicago

Bray W and Trump D (1970). A Dictionary of archaeology. London

Brunner H (1956). Mitanni in einum ägyptischen Text vor oder um 1500. Mitteilungen der Institut fur Orientforschung 4, 323-7

Buchanan B (1966). Catalogue of Ancient Near Eastern seals in the Ashmolean Museum 1: Cylinder seals. Oxford

Bulté J (1981). Catalogue des Collections Égyptiennes du Musée National de Céramique a Sèvres. Paris

Carter T (1967). Tell al-Rimah. The Campaigns of 1965 and 1966. Archaeology 20, 282-9

Caubet A (1982) Faience et verre. In Meskéné-Emar, Dix ans de travaux 1972-1982 D Beyer ed., 111-114. Paris

Caubet A and Lagarce E (1972). Vases en faience de Chypre. Report of the Department of Antiquities, Cyprus, 113-128

Clarke D (1968). Analytical archaeology. London

Clerc G et al. (1976). Fouilles de Kition II: Objets Égyptiens et Égyptisants. Nicosia

Cooney J (1960). Glass sculpture in ancient Egypt. Journal of Glass Studies 2, 11-43

Cooney J (1976). Catalogue of Egyptian antiquities in the British Museum IV Glass. London

Cooney J (1981). Notes on Egyptian glass. In Studies in Ancient Egypt, the Aegean, and the Sudan Simpson W and Davis W eds., 31-3. Boston

Crawford H (1975). Geoy Tepe 1903. Iranica Antiqua XI, 1-28

Crownover D (1964). Some frit from Northern Mesopotamia. Expedition 7, 43-44

Davico A (1967). Missione archaeologica Italiana in Siria, Campagna 1966. Roma

Delacroix G and Huot J-L (1972). Les fours dits 'de potier' dans l'Orient Ancien. Syria 44, 35-95

Delougaz P, Hill H and Lloyd S (1967). Private houses and graves in the Diyala Region. Oriental Institute Publications 88. Chicago

Foster K (1979). Aegean faience of the Bronze Age. London

Foster K and Kaczmarczyk A (1982). X-Ray fluorescence analysis of some Minoan faience. Archaeometry 24, 143-157

Fukai S et al. (1973). Marv-Dasht III. The Excavation of Tell-i-Mushki. Tokio

Garner H (1956). An early piece of glass from Eridu. Iraq 18, 147-9

Gates M-H (1981). Alalakh Levels VI and V: A Chronological Reassessment. Syro-Mesopotamian Studies 4

Gibson M (1975). Excavations at Nippur, Eleventh Season. Oriental Institute of Communications 22. Chicago

Gibson M et al. (1978). Excavations at Nippur, Twelfth Season. Oriental Institute of Communications 23. Chicago

Goldstein S (1979). Pre-Roman and Early Roman glass in the Corning Museum of Glass. Corning

Grimm C (1972). Two early Imperial faience vessels from Egypt. Misc. Wilbouriana, 71-100

Haller A (1954). Die Gräber und Grüfte von Assur. Wissenschaftliche Veroffentlichung der Deutschen Orient-Gesellschaft 65. Berlin

Harden D (1981). Catalogue of Greek and Roman glass in the British Museum I: Core and rod-formed vessels and pendants and Mycenaean cast objects. London

Harding A (1971). The earliest glass in Europe. Archeologické Rozhledy 23, 188-200

Harding A and Warren S (1973). Early Bronze Age faience beads from Central Europe. Antiquity 47 64-6

Hauptmann H (1974). Die Grabungen auf dem Norsun-Tepe 1971. Turk Tarih Kurumu Yarinlare 93

Hedges R (1976). Pre-Islamic glazes in Mesopotamia-Nippur. Archaeometry 18, 209-238

Hedges R (1982). Early glazed pottery and faience in Mesopotamia. In Early pyrotechnology, Wertime T and Wertime S eds., 93-103. Washington, Smithsonian Institution

Hedges R and Moorey P (1975). Pre-Islamic ceramic glazes at Kish and Nineveh in Iraq. Archaeometry 17, 25-43

Hijara I et al. (1980). Arpachiyah 1976. Iraq 42, 131-154

Hölbl G (1979). Beziehungen der Ägyptischen Kultur zu Altitalien. Leiden

Kaczmarczyk A and Hedges R (1983). Ancient Egyptian faience. Warminster, Aris and Phillips

Kenyon K (1960). Excavations at Jericho I. London

Kenyon K and Holland T (1983). Jericho V. London

Kiefer C and Allibert A (1971). Pharaonic blue ceramics: The process of self-glazing. Archaeology 24, 107-17

Knudtzon J (1915). Die El-Amarna Tafeln. Leipzig

Kühne H (1969a). Glas. Reallexikon der Assyriologie und vorderasiatische Archäologie 3, 410-427

Kühne H (1969b). Bemerkungen zu einigen Glasreliefs des 2. Jahrtausends v Chr aus Syrien und Palästina. Zeitschrift fur Assyriologie und vorderasiatische Archäologie 25, 299 - 318

Kühne H (1974). Rätselhafte Masken-zur Frage ihrer Herkunft und Deutung. Baghdader Mitteilungen 7, 101-10

Kühne K (1969c). Zur Kenntnis silikatischer Werkstoffe und der Technologie ihrer Herstellung im 2. Jahrtausend vor unserer Zeitrechnung (Abh.Deut.Akad.d.Wiss. zu Berlin). Berlin

Kupper J-R (1973.) North Mesopotamia and Syria. In Cambridge Ancient History (3rd ed) Edwards I E S et al., II.1, 1-41

Lane A (1948). French faience. London

Lucas A and Harris S (1962). Ancient Egyptian materials and industries. London

Mahmoud J (1970). Tell Al-Fakhar, Report on the first season's excavation. Sumer 26, 109-126

Mallowan M and Rose J (1935). Excavations at Tall Arpachiyah 1933. Iraq 2, 1-178

Marshall Sir J (1931). Mohenjo-daro and the Indus Civilization, I-III. London

Martin G (1971). Egyptian administrative and private-name seals. Oxford

Matthiae P (1979). Scavi a Tell Mardikh-Ebla 1978: rapporto sommario. Studi Eblaiti I, 129-184

Matthiae P (1980). Ebla. London

Mazzoni S (1979-80). Essai d'interpretation des vases plastiques dans la Syrie du Bronze Moyen et Recent. Annales archeologiques arabes syriennes 29-30, 237-252

McGovern P (1980). Ornamental and amuletic jewellery of Late Bronze Age Palestine: An archaeological study. Ann Arbor

McKerrell H (1972). On the origins of British faience beads and some aspects of the Wessex-Mycenae relationship Proceedings of the Prehistoric Society 38, 286-301

Meneret J (1957). Untersuchung der alten Fayencen auf Kieselsaüerbasis ohne Glas-und Tonbinding. Keramische Zeitschrift 9, 166-170

Moorey P (1982). The archaeological evidence for metallurgy and related technologies in Mesopotamia c.5500-2100 BC. Iraq 44, 13-38

Moorey P (1985). Materials and manufacture in Ancient Mesopotamia: The evidence of archaeology and art. Metals and metalwork, glazed materials and glass British Archaeological Report International Series 237. Oxford

Muhly J (1972). Review of Oppenheim et al. 1970. *Journal of Cuneiform Studies* 24, 178-182

Neuninger H and Pittioni R (1959). Woher stammen die blauen Glasperlen der Urnenfeldkultur. *Archaeologia Austriaca* 25, 52-66

Noble J (1969). The technique of Egyptian faience. *American Journal of Archaeology* 73, 435-439

Nolte B (1968). *Die Glasgefasse im Alten Ägypten* Müncher Ägyptologische Studien 14. Berlin

Oppenheim A (1973). Towards a history of glass in the Ancient Near East. *Journal of the American Oriental Society* 93, 259-66

Oppenheim, Brill R H, Barag D and von Saldern A (1970). *Glass and glassmaking in Ancient Mesopotamia*. Corning NY, Corning Museum of Glass

Otten H (1966). Hethiten, Hurriter und Mitanni. In *Fischer Weltgeschichte* 3, 128-177

Parrot A (1969). De la Mediterranée à l'Iran: Masques Énigmatiques. In *Ugaritica* VI, C Schaeffer ed., 409-18. Paris

Peltenburg E (1968). *Western Asiatic glazed vessels of the second millennium BC* (Unpublished PhD thesis, University of Birmingham)

Peltenburg E (1972). On the classification of faience vases from Late Bronze Age Cyprus. *Acts of the First International Congress of Cypriot Studies A'*, 129-36. Nicosia

Peltenburg E (1974). The Glazed Vases in V Karageorghis et al. *Excavations at Kition* I, 106-144. Nicosia

Peltenburg E (1977). A faience from Hala Sultan Tekke and second millennium BC Western Asiatic pendants depicting females. In *Hala Sultan Tekke 3* Åström P et al., eds, 177-200. Studies in Mediterranean Archaeology XLV: 3

Petrie W (1925). Ancient Egyptians. In *Descriptive sociology, or groups of sociological facts*, Spencer H ed, London

Pinnock F (1984). Trésors de la nécropole royale. *Histoire et archéologie* 83, 70-77

Pollard A and Højlund F (1983). High-magnesium glazed sherds from Bronze Age tells on Falaika, Kuwait. *Archaeometry* 25, 196-200

Rathje A (1976). A group of Phoenician faience perfume flasks. *Levant* 8, 96-106

Renan E (1864). *Mission de Phénicie*. Paris

Reuther O (1926). *Merkes, Die Innenstadt von Babylon*. Wissenschaftliche Veroffentlichung der Deutschen Orient-Gesellschaft 47. Leipzig

Riefstahl E (1968). *Ancient Egyptian glass and glazes in the Brooklyn Museum*. New York

Rudolph W (1973). Die Nekropole am Prophitis Elias bei Tiryns. In Tiryns VI 8-56. Mainz am Rhein

Sagona C (1980). Middle Bronze Faience Vessels from Palestine. Zeitschrift der Deutschen Palasteins Verein 96, 101-120

Scapova J (1981). Origine de la Verrerie. Annales du 8e Congrès International d'Etude Historique du Verre, 21-34

Schaeffer C (1938). Les Fouilles de Ras Shamra-Ugarit. Neuvième campagne (printemps 1937). Rapport Sommaire Syria 193-255, 313-334

Snodgrass A (1982). Cyprus and the beginnings of iron technology in the Eastern Mediterranean. In Early Metallurgy in Cyprus, 4000-500 BC Muhly J, Maddin R and Karageorghis V eds., 285-295. Nicosia

Starr R (1939). Nuzi. Cambridge, Mass.

Stone J and Thomas C (1956). The use and distribution of faience in the Ancient East and Prehistoric Europe. Proceedings of the Prehistoric Society 22, 37-84

Strauss E (1974). Die Nunschale - Eine Gefassegruppe des Neuen Reiches Munchner Ägyptologische Studien 30. Munich

Tait G (1963). The Egyptian Relief Chalice. Journal of Egyptian Archaeology 49, 93-139

Tite M, Freestone I and Bimson M (1983). Egyptian faience: an investigation of the methods of production. Archaeometry 25, 17-27

Thompson D (1973). Ptolemaic oinochoai and portraits in faience. Oxford

Unger E (1957). Fayence. Reallexikon der Assyriologie und vorderasiatische Archaologie 3, 29-31

Vandiver P (1983a). Egyptian faience technology. In Ancient Egyptian Faience Kaczmarczyk and Hedges, Appendix 1-144

Vandiver P (1983b). Glass technology at the mid-second-millennium BC Hurrian site of Nuzi. Journal of Glass Studies 25, 239-247

van Loon M (1969). New sites in the Euphrates Valley. Archaeology 22, 65-70

Verner M (1984). Excavations at Abusir. Zeitschrift für Ägyptische Sprache, 70-78

Von Bissing F (1941). Zeit und Herkunft der in Cerveteri gefundenen Gefässe aus ägyptischer Fayence und Glasiertem Ton. Sitzungsberichte der Bayerischen Akademie der Wissenschaften (Phil Hist Abt) II 7 1-117

Von Saldern A (1970). Other Mesopotamian glass vessels (1500-600 BC). In Glass and glassmaking in Ancient Mesopotamia Oppenheim et al., 203-228

Watelin C (1934). Excavations at Kish IV. Paris

Webb V (1978). Archaic Greek faience. Warminster, Aris and Phillips

Woolley C (1955). *Alalakh*. Oxford

Woolley C (1965). *Ur Excavations VIII. The Kassite Period and the Period of the Assyrian Kings*. London

Woolley C and Mallowan M (1976). *Ur Excavations VII. The Old Babylonian Period*. London

Wulff H (1966). *The traditional crafts of Persia*. Cambridge, Mass.

Wulff H, Wulff H and Koch L (1968). Egyptian faience: A possible survival in Iran. *Archaeology* 21, 98-107

FIELD OBSERVATIONS OF GLASS AND GLAZED MATERIALS

Julian Reade

Department of Western Asiatic Antiquities,
British Museum, London WC1B BDG

Abstract

This paper mainly contains observations made by an archaeologist in the field in Northern Mesopotamia. Appearances suggest significant technical variation in contemporary objects from a single site. For instance, the quality of some Nimrud glazed bricks (about 845 BC) varied according to the importance of the positions they occupied; the evidence for this is liable to be concealed by subsequent deterioration. The body of glazed faience vessels from Tell Taya (about 2300 BC) varies greatly, sometimes having a superficial resemblance to terracotta and even to glass. Local workshop variation as well as regional variation needs to be taken into account, but may not be fully reflected in the range of samples made available for analysis.

Keywords: IRAQ, NIMRUD, TELL TAYA, BRICK, GLAZE, FAIENCE, MESOPOTAMIA, TELL AL-RIMAH, TELL BRAK

As an archaeologist I have had many opportunities to handle and assess the 'early vitreous materials' of Western Asia; not simply in museums, or indirectly in excavation reports where things are not always what they seem, but in the field at Tell Taya, Tell al-Rimah and Nimrud, northern Mesopotamian sites primarily of the third, second, and first millennia BC respectively. Any observations I have been able to make relate to macroscopic features, and are obviously no substitute for technical studies, but I hope some of them may be helpful or suggestive to some specialists who are obliged to work with limited and possibly unrepresentative samples.

First, there is a general point that has to be stressed. Factors such as political disunity, economic constraints, variable access to raw materials, and professional reluctance to hand technical information to potential competitors, are liable to militate against the development of unilinear traditions in the manufacture of vitreous goods. This was true recently in Western Asia, and must often have been true in antiquity.

The degree of variation within one period can readily be seen by inspecting Assyrian glazed clay bricks and tiles of the ninth to seventh centuries BC. They are all manifestly inferior to Babylonian bricks of the sixth century BC, even though the latter were buried in conditions that are normally less favourable for the preservation of glaze. Yet, among the Assyrian bricks,

even among those which were apparently made at about the same time as one another for a single public building, we may encounter what seem to be significant technical distinctions.

My examples are taken from the arsenal at Nimrud, built in the 840s, which had two kinds of glazed brick decoration: large picture panels which were placed in special positions, one at least being above an important doorway (Reade 1963; colour reproduction in Dayton 1978, plate 24); and strips, decorated with rows of rosettes, which ran along the battlements (Oates 1962, 8-9, plate Vc; colour in Dayton 1978, plate 23). The main picture panel definitely dates to the reign of the king who founded the arsenal; it is most likely that the battlement strips do also. Both lots will have been commissioned officially, possibly from state workshops, and both were found buried in comparable conditions. Yet the quality of the panel bricks, at least at the time of excavation, was superior to that of the battlement ones. The background blue was darker and richer, the white and yellow clearer; the method of dividing colours had been more efficient. I cannot quantify these differences, as our samples never reached their destination, and they can be explained as the result of different practical applications of what was essentially one technique of production. My point is that either kind of brick, studied in isolation, might have given a somewhat misleading impression of the technical standards of the time.

There is a further problem with this particular group of material. The glaze layer on Assyrian bricks is bubbly and friable, and tends to flake away before or after excavation, leaving little more than a matt powdery residue of colour; this is one reason why old publications sometimes refer to 'painted bricks' rather than glazed ones. The blue, which forms the main background colour on panels and strips alike, is especially vulnerable; green suffers badly too; yellow suffers a little; and only white and black seem relatively stable. The incautious application of consolidants such as polyvinyl acetate, which was widely used at Nimrud, may make matters worse rather than better. Add to this some loss of colour through dehydration after exposure to air on excavation, a process visible with some Nimrud glazed bricks though it is nothing like as dramatic as it is with glass objects of the second millennium BC, and the result is an unduly low estimate of Assyrian expertise in glaze technology.

Thus one writer (Dayton 1978) not unreasonably deduced from a study of the large Nimrud panel as now displayed in the Iraq Museum, and from microscopic examination of one battlement brick, that 'the glaze on all these Assyrian bricks was very close to the point of failure, and their life under normal climatic conditions in Iraq could not have been long, which explains why they have only survived in such fragmentary condition'. In reality, however, it is most probable that the large glazed panel in question, and many of the rosette battlement bricks, survived in good condition, mounted in the open air in highly exposed positions where there could have been no structural protection, for some 230 years until the sack of Nimrud. The adhesion of the glaze was adequate for that period of exposure.

Perhaps there was additional protection in the form of a polish or varnish. I have no specific evidence for this suggestion, but we have a comparable problem with painted or partly painted stone sculptures which decorated the exterior of Assyrian palaces. The stone is gypsum and soluble in water, as becomes abundantly clear when it is left exposed to the elements nowadays. The only explanation readily available for its fine state of preservation in many instances is that in antiquity it did have a protective coating. If stone was given a protective coating, so might glazed bricks have been. On the other hand, the glaze on bricks is broadly similar to that on contemporary glazed pottery vessels, and their supreme advantage over

unglazed vessels was surely not that they were pretty but that they were impermeable.

While field experience may sometimes be helpful, however, in considering samples of glass and glazed materials, the archaeologist can also go seriously astray. This is not merely a semantic problem, such as the indiscriminate use of the word 'frit'. For instance, the first time I encountered decayed amber in northern Iraq, a light-brown flaking powdery substance, I was inclined to suppose that it might be glass: decayed glass of 1400-1200 BC can look somewhat like this. Fortunately, on that occasion, I had a visitor who was familiar with amber from Scandinavian excavations and was able to identify mine, but I cannot help wondering how often comparable mistakes are made. Certainly I am aware of circumstances in which ancient glass has lain in museums unrecognised for years, and there is always a danger of misconceptions, based on wrong identifications or negative evidence, becoming current. Here then, with appropriate reservations, I should like to draw attention to some odd features of the glazed quartz-frit faience vessels, dated around 2300 BC, from Tell Taya.

We found parts of several vessels, all with blue or green glaze. The body material of Mesopotamian faience is most commonly white, but our field registers describe the body material of these as white, yellow or pink. When the pink pieces first emerged, it seemed to me (Reade 1968, 244-5) that we were faced with the earliest glazed pottery. The Research Laboratory (1973) looked at one sample, however, by atomic absorption spectroscopy, and discovered that it had a high-quartz body: despite appearances it was faience and not fired clay.

Recently a vessel fragment that appeared to be made of a similar substance, with traces of glaze including a small pool at the bottom inside it, was found in the study collection of the Institute of Archaeology, University of London (Fig.1). It was unpublished, though certainly deriving from 1930s excavations in north-east Syria (e.g. Mallowan 1936), and bears a pencil mark in Mallowan's hand which might read CBA, suggesting Trench A at Chagar Bazar. However that may be, the fragment is part of a pedestal vase, and there are reasonable parallels for the shape, and remoter parallels for the decoration, among pottery from Taya; while the piece remains unique, therefore, a date in the third millennium BC seems almost certain. It has now been studied by the Research Laboratory whose report, with its interesting implications for early methods of faience production in Mesopotamia, is appended to this paper (compare Wulff 1966, 165-7).

Another Taya faience vessel, with the more usual white core, is a beaker (Reade 1971, plate XXVd). Pottery vessels of this shape were common at the time; a characteristic of theirs is that the bases were cut extremely thin and have often split on firing. The base of the faience beaker is also very thin, so thin that it is effectively not ordinary faience but something closely related to glass. The two greenish-blue glazed surface layers merge back-to-back, with no visible white body between. The object is, as it were, by design or mistake, transitional between faience and glass, and the effect must have been observed by the manufacturer.

A feature of one other of the Taya faience vessels is a small patch of green metal filings, presumably copper, which appear to be baked into the exterior glaze (Reade 1973, 165,184 plate LXXVd). Copper was the colouring agent used in the sample studied by the Research Laboratory, but I do not know whether the presence of loose copper filings alone could have resulted in the contents of a kiln turning satisfactorily blue or green. Yet another Taya faience vessel bore the marks of a tripod kiln-setter, a device that was not necessary for unglazed pottery vessels of the same date

which, as one can see from firing marks, rested directly on top of one another in the kiln.

The archaeological horizon from which all these Taya pieces come, in the late third millennium BC, was followed by a phase of discontinuity, with destruction levels and so on, in much of northern Mesopotamia. In the levels of the early second millennium at Taya, as at Tell al-Rimah nearby, faience was conspicuously absent or rare. There is a great contrast with the abundance of faience and glass in levels dated after 1500 BC at Rimah and similar sites such as, most recently, Tell Brak.

Finally, it may seem that the very sporadic available evidence is unlikely to provide, even in broad terms, a reliable picture of the state of the faience and glass industries of ancient Western Asia at different periods. For the areas with which I am most familiar, however, the evidence, albeit sporadic, is consistent. Particular types of object manufactured by roughly comparable techniques turn up with tolerable regularity where and when one expects them, notably in periods of prosperity and political stability, and, on the whole, do not turn up unexpectedly. At the same time we do have to differentiate between areas: the industry developed in different ways in Iran, Mesopotamia, the Levant, and Anatolia, let alone Egypt. We probably have to cope not merely with changing fashions, but with a history of continual invention and re-invention, introduction and re-introduction, development and disappearance of particular technical skills.

Fig. 1 The fragment of a third millennium pedestal vase from north-east Syria. Two-thirds actual size.

Appendix

REPORT ON THE SCIENTIFIC EXAMINATION OF A THIRD MILLENNIUM BC PEDESTAL VASE FROM NORTHERN MESOPOTAMIA

M S Tite

The fragment of a third millennium BC pedestal vase from north-east Syria, (Fig.1) has a pinkish coloured body with much whiter surface layers which, on the walls of the vessel, are of the order of 1mm thick. The fragment was submitted for scientific examination in order to determine (1) whether the body was made from quartz sand or from clay and (2) whether or not a glaze had been applied to the surface.

The SEM examination of a polished section through the outer surface layer and into the body of the pedestal vase showed that it consists of very fine grained quartz sand (Fig.2), the majority of which is less than 20μm (0.02 mm) in diameter. In the surface layer to a depth of 400μm sufficient interstitial glass is present to bond together adjacent faces of the angular quartz grains (Fig.3). Quantitative analysis of the very small areas of glass was not possible but qualitative analysis indicated the presence of the oxides of silicon, sodium, potassium, aluminium, calcium, iron and copper. The fact that alkalis are still present in the glass phase indicates that weathering during burial was not too severe and that the surface layer has not therefore changed significantly since being formed.

Below the surface layer the amount of interstitial glass present is minimal with only occasional filaments, linking adjacent quartz grains, being visible (Fig.4). The hardness of the body is therefore somewhat surprising but must be associated with the very fine texture and consequent close packing of the quartz grains. Mixed with the quartz is a scatter of iron-rich silicate particles also containing oxides of sodium, potassium, aluminium and calcium. The pinkish colour of the body is most probably due to the presence of small amounts of iron oxide whereas, in the surface layers, the iron oxide has dissolved in the glass phase resulting in a paler colour.

In summary, therefore, the pedestal vase has a quartz sand body with a very poorly-developed glaze consisting only of interstitial glass with no continuous surface glaze layer. It is therefore similar in microstructure to faience produced in the laboratory by the direct application of a raw as opposed to a fritted glazing mixture to the surface of a quartz body which was then fired to a low temperature (c.850°C)

References

Bimson M (1973). Analysis of glazed material from Tell Taya. Iraq 35, 183-184

Dayton J (1978). Minerals metals glazing and man. London

Mallowan M E L (1936). The excavations at Tall Chagar Bazar, and an archaeological survey of the Habur region, 1934-5. Iraq 3, 1-86

Oates D (1962). The excavations at Nimrud (Kalhu), 1961. Iraq 24, 1-25

Reade J E (1963). A glazed brick panel from Nimrud. *Iraq* 25, 38-47

Reade J E (1968). Tell Taya (1967): summary report. *Iraq* 30, 234-264

Reade J E (1971). Tell Taya (1968-9): summary report. *Iraq* 33, 87-100

Reade J E (1973). Tell Taya (1972-3): summary report. *Iraq* 35, 155-187

Tite M S and Bimson M (1986). Faience: an investigation of microstructures associated with the different methods of glazing. *Archaeometry* 28, 69-78

Wulff H E (1966). *The traditional crafts of Persia.* Cambridge, Mass.

Fig. 1 The fragment of a third millennium pedestal vase from north-east Syria.

Fig. 2 SEM photomicrograph of section through outer surface layer into the body of the pedestal vase showing the very fine-grained quartz sand with which it is made.

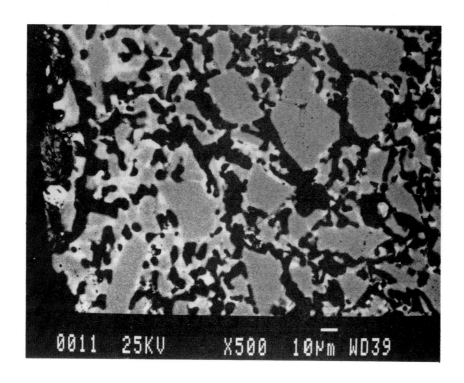

Fig. 3 SEM photomicrograph of section through outer surface layer showing the quartz grains (grey) bonded together by interstitial glass (white).

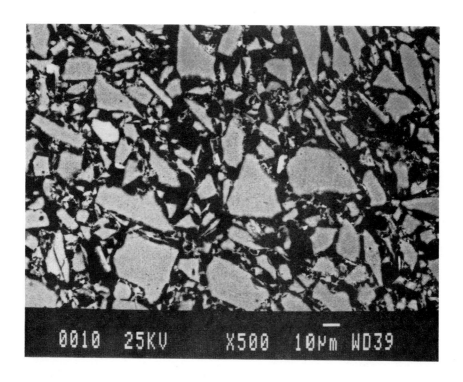

Fig. 4 SEM photomicrograph of section through body showing quartz grains (grey) with only occasional filaments of glass linking adjacent grains. Also visible is a scatter of iron-rich silicate particles (white).

THE TECHNOLOGY OF EGYPTIAN BLUE

M S Tite, M Bimson and M R Cowell
British Museum Research Laboratory,
London WC1B 3DG

Abstract

The chemical composition, microstructure, hardness, and colour of a series of ancient Egyptian Blue samples from Egypt, the Near East and Europe have been investigated using principally atomic absorption spectrophotometry and scanning electron microscopy. Egyptian Blue has been produced in the laboratory by using a range of compositions and firing procedures and has been compared with the ancient material. From these results, information on the techniques used in antiquity to produce Egyptian Blue has been obtained. In particular, it seems probable that a two-stage firing cycle with grinding and moulding to the final shape between the first and second firing was used in the production of small objects.

Keywords: EGYPTIAN BLUE, PIGMENT, MICROSTRUCTURE, HARDNESS, COMPOSITION, SEM, ATOMIC ABSORPTION SPECTROMETRY

Introduction

Egyptian Blue first occurs in Egypt during the third millennium BC and during the subsequent three thousand years its use as a pigment and in the production of small objects such as beads, scarabs, inlays and statuettes spread throughout the Near East, the Eastern Mediterranean and to the limits of the Roman Empire.

Egyptian Blue was not only the first synthetic pigment, it was one of the first materials from antiquity to be examined by modern scientific methods. A small pot containing some of the pigment was found during the 1814 excavations at Pompeii; it caused considerable interest and was examined by several scientists of the day, including Sir Humphrey Davy. In 1889 Fouqué published his analysis, identified the compound as the calcium-copper tetrasilicate $CaCuSi_4O_{10}$ and defined the optical characteristics of the crystals. In the latter part of the nineteenth century, he and several other chemists believed that they had synthesized the pigment. Subsequently, comprehensive series of syntheses were undertaken by Laurie *et al.* (1914) and more recently by Chase (1971), Ullrich (1979), Wiedemann and Bayer (1982) and Tite *et al.* (1984). At the same time, it has been possible to positively identify Egyptian Blue as $CaCuSi_4O_{10}$ and establish that it is the same material as the mineral cuprorivaite which occurs in nature but is very rare and was never worked.

On the basis of this published work, it is now established that Egyptian Blue can be produced by firing a mixture of quartz sand, calcium carbonate and a copper compound, together with a small amount of alkali, at a temperature in the range 900 - 1000°C for several hours. The examination of the microstructure of the material thus produced has established that it consists of an intimate mixture of Egyptian Blue crystals and unreacted quartz, together with varying amounts of glass (Figs. 1 - 4).

At this point it should be emphasised that, in the literature, the term Egyptian Blue is used to describe both the bulk material and the constituent calcium-copper tetrasilicate mineral ($CaCuSi_4O_{10}$) which is the cause of the characteristic blue colour. In this paper, the suffix 'crystal' or 'mineral' will be added when the latter meaning applies.

The aim of the present paper is to present a summary of the information available on the materials and techniques used in the manufacture of the wide range of fabrics (from soft and friable to hard and semivitrified, from coarse to fine textured and from light to dark blue), which are classified as Egyptian Blue. This summary is based primarily on a detailed scientific study of a wide range of samples of ancient Egyptian Blue from Egypt, the Near East and Europe, together with a comprehensive series of laboratory syntheses, undertaken by Tite et al. (1984). In this study, some fifty samples of ancient Egyptian Blue were quantitatively analysed using atomic absorption spectrophotometry and their microstructure was examined in polished section in the scanning electron microscope (SEM).

Composition and raw materials

Elemental analysis of ancient Egyptian Blue samples (Table 1) indicated that the concentrations of the three principal components are typically in the ranges 60 - 70 per cent silica (SiO_2), 7 - 15 per cent calcium oxide (CaO) and 10 - 20 per cent copper oxide (CuO). If the samples consisted entirely of the Egyptian Blue mineral ($CaCuSi_4O_{10}$) then they would contain approximately 64 per cent silica, 15 per cent calcium oxide and 21 per cent copper oxide. It can thus be shown that, in addition to the Egyptian Blue mineral, the ancient samples all contain a varying excess of silica (5 - 40 per cent) which is present as unreacted quartz and in a glass phase, together with smaller excesses of either calcium oxide (1 - 6 per cent) or copper oxide (1 - 8 per cent).

It seems probable that, as is the situation for contemporary glass from Egypt and the Near East, the calcium oxide was introduced into the Egyptian Blue as an impurity in the quartz sand and alkali. In contrast, the copper was, almost certainly, separately introduced in the form of copper ore or filings from copper ingots or from scrap metal. When scrap metal was used, the Egyptian Blue contains small amounts of tin (0.1 per cent), arsenic (0.01 - 0.07 per cent) and lead (0.05 - 0.3 per cent) which reflect, in general terms, their concentrations relative to copper in contemporary copper alloys.

In addition to its three principal components, Egyptian Blue contains varying amounts of alkalis with the sodium oxide content (from less than 0.1 to 4 per cent) normally being greater than the potassium oxide content (from less than 0.1 to 2 per cent). It seems probable that when the total alkali content (Na_2O plus K_2O) is less than about 1 per cent, the alkalis were introduced with the quartz sand as felspars and clay minerals. However, when present in higher concentrations the alkalis almost certainly represent a deliberate addition. The most probable source of the alkalis

is natron, although the residues from evaporated river water or the ashes from desert or sea coast plants could also have been used.

In summary, therefore, the reported compositions are consistent with the description of the manufacture of Egyptian Blue given in the late first century BC by Vitruvius, who states that sand and natron were first powdered together and that copper filings were than added.

Table 1 ANALYSES OF EGYPTIAN BLUE*

Oxide (% wt)	1	2	3	4	5	6	7
SiO_2	65.0	65.0	65.0	63.0	64.5	67.3	63.9
CuO	18.4	15.7	18.1	13.9	13.1	11.4	21.2
CaO	14.0	11.2	10.4	12.2	11.8	7.0	14.9
Na_2O	0.09	0.72	0.03	0.89	1.86	1.63	-
K_2O	0.16	0.22	0.01	0.49	0.66	0.41	-
Al_2O_3	0.4	0.7	0.3	0.8	1.7	1.0	-
FeO	0.37	1.50	0.36	0.89	0.64	0.76	-
MgO	0.62	0.37	0.55	0.78	0.25	0.36	-
SnO_2	0.1	0.1	0.1	0.8	0.1	0.1	-
As_2O_5	0.01	0.02	0.01	0.01	0.01	0.01	-
PbO	0.02	0.13	0.02	0.23	0.05	-	-
Egyptian Blue	86.8	74.1	69.8	65.6	61.8	47.0	100
Excess SiO_2	9.5	17.7	20.4	21.2	25.0	37.3	-
Excess CuO	-	-	3.3	-	-	1.4	-
Excess CaO	1.1	0.3	-	2.4	2.6	-	-

1. BMRL 13714 Nineveh, 9-7th century BC, cylinder fragment
2. BMRL 14121 Malta, 3rd century AD, pigment ball
3. BMRL 13720 Nimrud, 9-7th century BC, curl fragment
4. BMRL 14232 Egypt, c 300 BC, column drum fragment
5. BMRL 14122 Italy, 2nd century AD, mosaic tessera
6. BMRL 14414 Egypt, c 600 BC, figure fragment
7. Egyptian Blue mineral ($CaCuSi_4O_{10}$) - theoretical composition

*See Tite et al (1984) for analytical data for full range of ancient Egyptian Blue studied.

Microstructure, hardness and colour

A primary factor in determining the microstructure developed in Egyptian Blue is its alkali content. In samples with higher alkali contents (greater than about 1 per cent Na_2O plus K_2O), the Egyptian Blue crystals and unreacted quartz are embedded in a glass matrix (Figs. 1 and 2). This glass normally produces long-range interconnection between the other constituents and, in consequence, a harder fabric (greater than 3 Mohs). In contrast, in samples with lower alkali contents (less than about 1 per cent Na_2O plus K_2O), a glass is not normally formed (Figs. 3 and 4). There is, therefore, little or no long-range interconnection between the Egyptian Blue crystals and unreacted quartz and in consequence, the fabric tends to be softer (1 - 2 Mohs). The microstructures of Egyptian Blue can be further classified as coarse- or fine-textured according to the degree of aggregation of the Egyptian Blue crystals. In coarse-textured samples, the Egyptian Blue crystals aggregate to form definite large clusters, some of which adhere to the unreacted quartz (Figs. 1 and 3). In fine-textured samples the Egyptian Blue crystals tend to be smaller, do not form clusters and are more uniformly interspersed between the unreacted quartz grains (Fig. 2 and 4). The grain sizes of the unreacted quartz particles tend to match those of the Egyptian Blue crystals so that this classification additionally provides some measure of the actual physical texture of the samples.

On the basis of direct visual comparison of the body (as opposed to the original surface) Egyptian Blue can be grouped into three broad colour categories: dark blue, light blue and diluted or pale light blue. The change from dark blue to light blue is associated with a decrease in the overall dimensions of the clusters of Egyptian Blue crystals. Thus, samples classified as coarse-textured tend to be dark blue (Figs. 1 and 3) whereas those classified as fine-textured tend to be light blue (Figs. 2 and 4). The distinction in terms of microstructure between undiluted and diluted light blue is less obvious but it appears that the diluted light blue is observed in fine-textured samples when the colour of the Egyptian Blue crystals is effectively masked by the presence of glass. Thus, fine-textured low alkali samples in which there is no obvious glass tend to be undiluted light blue (Fig. 4), whereas fine-textured high alkali samples which contain a significant amount of glass tend to be diluted or pale light blue (Fig. 2).

Laboratory reproduction

Egyptian Blue produced in the laboratory by firing an intimate mixture of quartz, calcium carbonate and malachite (with or without a few per cent of sodium carbonate) at temperatures in the range 900 - 1000°C for up to 27 hours, was invariably coarse-textured. With the high-alkali mixture (3 per cent Na_2O), firing at 900°C for 5 hours was sufficient to produce a significant quantity of the Egyptian Blue mineral, whereas with the low-alkali mixtures (0.3 per cent Na_2O), the higher firing temperature of 1000°C was required. In both cases, however, Egyptian Blue crystals aggregated to form definite clusters irrespective of the original grain sizes of the raw materials.

In order to produce fine-textured Egyptian Blue with isolated Egyptian Blue crystals uniformly interspersed among the unreacted quartz grains, a two-stage firing cycle was necessary. In this, the coarse-textured product of the first firing was ground to a fine powder, thus breaking up the clusters of Egyptian Blue crystals and mixing them more uniformly with the unreacted

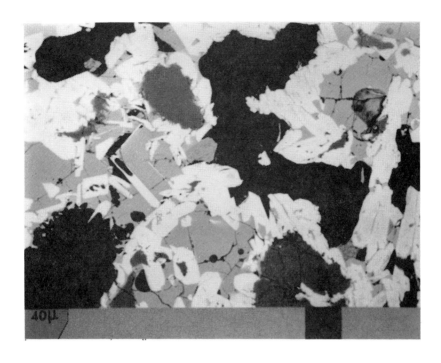

Fig.1 SEM photomicrograph of Egyptian Blue (BMRL 14122: 122 Roman): high alkali, hardness greater than 3 Mohs, coarse texture, dark blue. Clusters of Egyptian Blue crystals (white) and unreacted quartz (dark grey) embedded in glass (light grey).

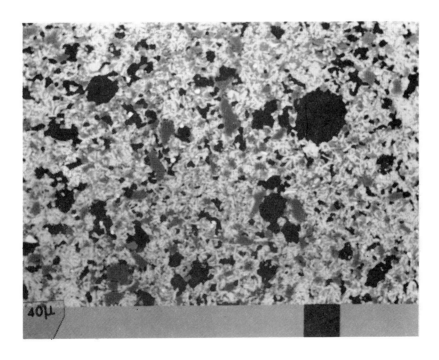

Fig.2 SEM photomicrograph of Egyptian Blue (BMRL 14414: Egypt): high alkali, hardness greater than 3 Mohs, fine texture, diluted light blue. Intimate mixture of Egyptian Blue crystals (white) and unreacted quartz (grey) embedded in glass.

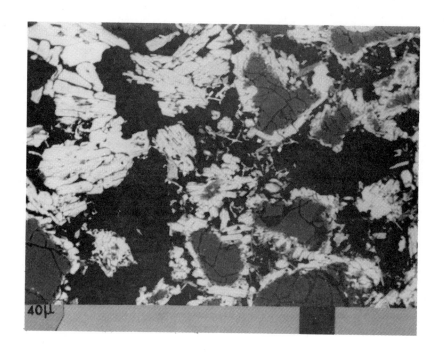

Fig.3 SEM photomicrograph of Egyptian Blue (BMRL 14121: Roman): low alkali, hardness 1 Mohs, coarse texture, dark blue. Clusters of Egyptian Blue crystals (white) and unreacted quartz (grey). No glass phase is present.

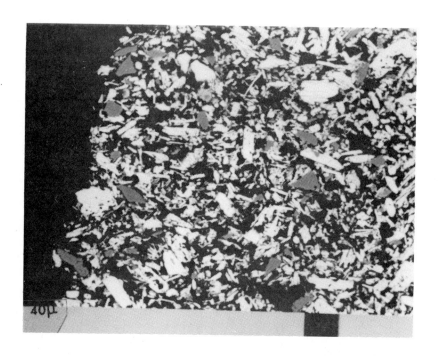

Fig.4 SEM photomicrograph of Egyptian Blue (BMRL 13714: Nineveh): low alkali, hardness 1 Mohs, fine texture, undiluted light blue. Mixture of Egyptian Blue crystals (white) and unreacted quartz (grey). No glass phase present.

quartz. This powder was then dampened with water and reshaped before firing for a second time at a somewhat lower temperature (850 - 950°C) for a shorter time (1 hour). However, even with this procedure, the reproduction of the very fine-textured fabric with small, closely-packed Egyptian Blue crystals embedded in an essentially continuous glass matrix (Fig. 2) was not altogether successful. This failure was most probably because we did not match the amount of grinding between the first and second firing undertaken in antiquity!

Conclusions

The results of scientific examination of Egyptian Blue show that the range of textures, hardnesses and colours observed can be satisfactorily explained in terms of the compositions of the mixtures used and the firing procedures employed.

The common characteristic of the great majority of ancient Egyptian Blue is an excess of silica (5 - 40 per cent) over and above that necessary to produce the Egyptian Blue mineral ($CaCuSi_4O_{10}$) and a much smaller excess of either calcium oxide or copper oxide. Further, its microstructure is characterised by an intimate mixture of Egyptian Blue crystals and unreacted quartz together with varying amounts of glass. The amount of glass present is determined primarily by the alkali content (i.e. Na_2O and K_2O) which varies from less than 0.2 per cent up to about 5 per cent.

From the results of the laboratory reproduction, it seems probable that both single and two-stage firing cycles were employed in the production of ancient Egyptian Blue. A single firing at about 900°C for the high alkali material and at about 1000°C for the low alkali material would normally have been used to produce the coarse-textured fabric with the Egyptian Blue crystals aggregated into definite clusters. This material would tend to be dark blue in colour while its hardness would depend on the amount of interconnecting glass formed and hence on its alkali content. It has been suggested that several firings interspersed with coarse grindings were used even in the production of the coarse-textured Egyptian Blue. Such a procedure should increase the yield of the Egyptian Blue mineral through the exposure of fresh surfaces at which reaction could occur. However, the full range of microstructure observed in the ancient coarse-textured fabrics has been reproduced in the laboratory with a single firing by varying the grain size of the quartz sand. Also, laboratory syntheses have established that a high yield of Egyptian Blue mineral can be obtained from a single firing if long heating times are used. It therefore seems unnecessary to introduce the idea of multiple firings in order to explain the production of coarse-textured Egyptian Blue.

In contrast, a two-stage firing cycle with grinding and moulding to the required shape between the first and second firings would normally have been used to produce the fine-textured fabric with the Egyptian Blue crystals uniformly interspersed among the unreacted quartz grains. The temperature of the second firing typically would have been 850 - 950°C; that is, sufficient to achieve coherence without any significant further reaction between the constituents. The material thus produced would tend to be undiluted light blue in colour and soft if the alkali content, and hence the amount of interconnecting glass, were low. Conversely it would tend to be diluted or pale light blue and hard if the alkali content was high.

It would appear that small objects of Egyptian Blue, which are almost invariably fine-textured, were made using a two-stage firing cycle. A

finely-ground powder would certainly have been necessary when moulding the objects to shape although, as a result of the fine grinding, the colour would have been changed from dark to light blue. Further, the blocks and balls of coarse-textured Egyptian Blue, which are sometimes found, probably represent the material from which objects would have been produced by grinding, moulding and refiring. In addition, the coarse-textured material would have been ground for use as a pigment, a range of blues from dark to light being obtained by grinding to increasingly fine particle size.

Although there are some obvious differences in the alkali contents and firing procedures associated with Egyptian Blue produced in Egypt, the Near East and the Classical World, the number and chronological range of the samples so far examined is insufficient to establish whether they represent genuinely different technological traditions. It is therefore not yet possible to establish, on technological grounds, whether the production of Egyptian Blue represents a single invention that subsequently spread through the Near East or whether parallel inventions occurred independently in different parts of the Near East.

References

Chase W T (1971). Egyptian Blue as a pigment and ceramic material. In Science and Archaeology, R H Brill, ed., 80-90. Cambridge, Mass., MIT Press

Fouqué M F (1889). Sur le bleu egyptien ou vestorien. Bulletin de la Soc. Francaise de Mineralogie 12, 36-38. Paris

Laurie A P, McLintock W F P and Miles F D (1914). Egyptian Blue. Proceedings of the Royal Society A89, 418-429

Tite M S, Bimson M and Cowell M R (1984). Technological examination of Egyptian Blue. In Archaeological Chemistry - III J B Lambert, ed., 215-242. Washington, American Chemical Society

Ullrich D (1979). Agyptisch Blau Bildungsbedingungen und Rekonstruktionsversuch der Antiken Herstellungstechnik. (Unpublished Diploma Thesis, Freien Universitat, Berlin)

Wiedemann H G and Bayer G (1982). The bust of Nefertiti. Analytical Chemistry 54, 619-628

BRONZE AGE FAIENCE FROM RAS SHAMRA (UGARIT)

A.Caubet[1] and A.Kaczmarczyk[2]

1. Département des Antiquités Orientales
 Musée du Louvre, Paris

2. Department of Chemistry,
 Tufts University, Medford, MA.

Abstract

A study collection of Ras Shamra material recently bequeathed to the Louvre by the late Professor C F A Schaeffer has prompted the authors to examine more closely the nature of vitreous objects that have been recovered from Ugarit. Visual examination was accompanied by x-ray spectrometric analysis of selected specimens. Included in the examination were lumps of unglazed blue frit, some of the type commonly called 'Egyptian blue', and objects made of glazed clay and of faience. Chemical analysis has enabled the authors to confirm that while some of the objects suspected of being of Egyptian inspiration or manufacture must have been imported from Egypt most of the finds display a chemical composition significantly different from those of contemporary Egyptian material. Thus the existence of an active local industry involved in the manufacture of these luxury wares may be inferred.

Keywords: FAIENCE, FRIT, RAS SHAMRA, UGARIT, MIDDLE BRONZE AGE, LATE BRONZE AGE, EGYPT

Introduction

After the death of Professor C F A Schaeffer in 1982, his study collection was bequeathed to the Louvre. This included samples from his various digs in Cyprus and Syria: from Minet el Beida and Ras Shamra, ancient Ugarit. The collection covers the entire span of Schaeffer's work since 1929 and therefore represents a better sampling for this important North Syrian coastal site than the choice of works of art hitherto presented to the Museums in Aleppo, Damascus and Paris.

The collection entered the Louvre in 1983, the Ugarit material numbering more than two thousand items. Various research programmes have already been undertaken under the aegis of the Near Eastern Department of the Louvre (A Caubet) and the archaeological mission at Ras Shamra, now headed by M Yon. Several archaeometric studies involving metallurgy, pottery and vitreous materials were undertaken with the cooperation of the Laboratoire de Recherche des Musées de France (C Lahanier and M Menu) and other

laboratories. The present study of vitreous materials from Bronze Age Ugarit, undertaken by the authors, is in its preliminary stages. The results obtained to date merit publication in view of the virtual absence of published analytical data on vitreous materials from this site.

Faience vases and other objects have been recovered at Ras Shamra in Level II (end of Middle Bronze Age) and Level I (Late Bronze Age). Most, but not all, are badly weathered. This fact was taken into consideration when the analytical data were interpreted. With few exceptions, the glazed material consisted of alkaline glazes applied to high silica bodies, i.e. of 'faience' in the manner that the term is applied to Egyptian material (Kaczmarczyk and Hedges 1983). While the study is primarily concerned with glazed material, a few specimens of 'Egyptian blue' were also included.

Glazes and frits were analysed by A Kaczmarczyk, with the aid of the x-ray microfluorescence spectrometers, at the Laboratoire de Recherche des Musées de France and at the Research Laboratory for Archaeology in Oxford. Some of the cores and the frits were also submitted for analysis by means of atomic absorption at the Oxford Laboratory.

Faience types and styles at Ugarit

Middle Bronze Age

Faience vessels show up at Ras Shamra in level II (seventeenth - fifteenth century BC) from tombs of early type with Middle Bronze Age pottery. Comparisons with contemporary material from Alalakh (Woolley 1955), Byblos (Salles 1980, pl.XXI,4) and Palestine (Sagona 1980) raise the question of the date of this production and the place of its manufacture: are these Egyptian imports or egyptianising imitations? Shapes include a series of cosmetic spoons in the form of a human hand holding a cup and with a duck-headed handle (Schaeffer 1938, pl. XXII,2), of a type known at Alalakh (Woolley 1955, 297) but not analysed here; also included are pyxis and bowls. The glazes range from pale blue to green with black linear decorations. Among the analysed objects was a globular bowl with a flaring rim and black dripping bands (AO 15723: Ras Shamra 1932, tomb on the Acropolis; Schaeffer 1939, 26, Fig. 17,I). This is one from a series found in Middle Bronze Age tombs and the shape has close parallels in local pottery types.

Also analysed was a dark blue cosmetic bowl with vertical pierced lugs which lacks a lid; large black drips are still attached to the rim (AO 14802: Ras Shamra 1932, tomb point 83: Schaeffer 1932, pl. XI,3). This box or pyxis appears to be a prototype for a series of pyxis popular during the Late Bronze Age both in Egypt and the Levant.

In both samples the black is obtained by means of manganese oxide mixed with iron oxide, as it is in Egypt, except that the ratio of manganese to iron is significantly higher than in contemporary Middle Kingdom Egyptian black. The presence of barium in association with manganese indicates psilomelane as the mineral source of the manganese. Copper is the sole colourant in blue glaze, accompanied by some iron and lead. The style and the analyses suggest non-Egyptian workshops utilising similar glazing recipes.

Late Bronze Age: Egyptian styles

In Late Bronze Age Ugarit (mainly fourteenth - early twelfth century BC) Egyptian styles, as defined by Peltenburg (1972), are represented mostly by blue glazes with linear black decorations (Peltenburg 'Monochrome') and very few plain blue-grey objects. Inlaid polychrome vessels, so noteworthy in Egypt and Cyprus at the time (Peltenburg 1974, 129), have so far not been found at Ugarit or anywhere else on the Levantine coast.

Blue glazes

The blue glazes with linear black decorations, so dominant in Egypt, account for only about one third of the remains from Ugarit. Shapes and decorations show strong Egyptian features, such as hemispherical bowls with nilotic themes or goblets in the form of a lotus blossom. The glaze may show alternate bands of blue and white. This production is widely considered Egyptian (Strauss 1974, fig.13: an example from Ugarit). Samples from the Louvre include a bowl, with a white glaze on the inside and a blue glaze outside, decorated with a black lotus (?) design (83 AO 35: Minet el Beida, tomb VI, unpublished) and fragments of a blue-glazed rhyton decorated in black with a hunting scene depicting a lion, a bull and a dog (83AO 32: Minet el Beida, tomb VI, unpublished). In the case of the rhyton, the shape, which is of Aegean origin, has been found on faience vessels from Egypt or the Levant and is discussed in connection with the Kition rhyton (Peltenburg 1974, 126), where it is considered egyptianising. The style of the hunting scene has close parallels in another faience vessel from Kition Bamboula (Caubet and Yon 1985). This raises the possibility of a particular workshop active probably in Cyprus or the North Levantine coast, defined by this mixed Egyptian-Aegean style, with a Near-Eastern background. Analyses show, as in the preceding cases of the Middle Bronze Age period, that ferruginous manganese was the black pigment. The ratio of manganese to iron is much higher than that observed in second millennium Egypt. A different recipe is suggested, one richer in iron. The blue and green are coloured by copper derived from bronze, as suggested by the presence of significant amounts of tin. It is suggested that at least some of this egyptianising production is not of Egyptian manufacture. More samples need to be examined to check these early results.

The examples examined above have a white core; however, among the blue-glazed vases, several have a hard, coarse-grained body, of grey or red colour (see below) and a white intermediate layer of high silica content between the body and the glaze. We cite here one example of possible Middle Bronze Age date, a cylindrical goblet (83AO 48: Ras Shamra 1939, east lower city, unpublished); the decoration is incised with a net pattern and black dripping dots are applied on the outer grey-green glaze. The inner glaze is black. Two other examples of this type of body belong to the Late Bronze Age and display a white layer between body and glaze; both display strong Egyptian features: these are a rectangular box (83AO 53: Ras Shamra, no provenance, unpublished) which has an inner and outer blue glaze with black design of triangles and papyri and a footed cup (83AO 141; Ras Shamra, no provenance; unpublished) which has a white design of hanging 'tongues' and lotus blossoms on a pale blue glaze. The manganese : iron ratios in black were higher than in contemporary Egyptian faience; barium was present, in contrast to New Kingdom faience for which a barium-free pyrolusite seems to have been the preferred source of manganese. While bronze-derived copper was the principal pigment in blue, 83AO 53 shows traces of cobalt too. Style and analysis suggest a non-Egyptian manufacture in imitation of the more refined production seen above.

The same blue glaze technique has been applied to a series of figurines depicting a nude goddess, closely related in shape and type to the local terra-cotta figurines (83AO 80, 81, 83, 87: Ras Shamra 1937, unpublished). The manganese : iron ratios in the black glazes are highly variable, suggesting more than one recipe. As in the preceding black glazes, barium accompanies manganese in three out of four cases. In contrast with the preceding cases, the copper used in the blue is free of tin, indicating that pure copper metal or ore was used instead of oxidised bronze scale.

Grey monochrome glazes

Monochrome blue-grey glazes on greyish hard cores (identified as Lucas Variant D and Kaczmarczyk and Hedges 1983, Variant D2) have been used for objects recovered from Ras Shamra: amulets or beads, but not vases. Among the more interesting examples of this type were two model bunches of grapes (AO 14803: Ras Shamra 1931, unpublished; 83AO 148: Ras Shamra, point 531, unpublished) and a bead in the form of a lion's head (AO 1804: Minet el Beida 1931, 16, unpublished). Almost identical model grapes have been recovered from Tell el Amarna and other Egyptian New Kingdom sites; the lion's head shows strong Egyptian features, such as the 'tears' dropping from the inner corner of the eyes. The pigment responsible for the colour was cobalt accompanied by comparable amounts of manganese, iron, nickel and zinc. These elemental correlations are characteristic of cobalt found in Egyptian alums which were used as the source of the pigment in New Kingdom Egypt and in Mycenaean glass (Kaczmarczyk 1985). Thus style and composition show that these products may be the only true Egyptian imports found at Ugarit.

Late Bronze Age: Western Asiatic styles

Virtually all Western Asiatic styles, as defined by Peltenburg (1972), are represented at Ugarit. However, the items made in the 'International Western-Asiatic style' greatly outnumber those made in 'Northern Levantine styles'.

Northern Levantine style

Less than twenty items belonging to this group were recovered from Ugarit. This style, as defined by Peltenburg (1972, 133-136), shows strongly Aegean features: shapes such as stirrup jars, the design derived from the Minoan octopus (Caubet 1983-1984, no.195) or face-goblets in the form of a female head with heavy make-up, belong to the Aegean vocabulary. We analysed one such goblet (AO 15732: Minet el Beida, tomb VI, 1932; Schaeffer 1932, pl.XII, 3-4; Mazzoni 1979-1980, 245, note 1, no. 2) and found the glazes to be very similar to those discussed below in connection with the 'Polychrome International style'. We propose to merge these two groups into one 'Polychrome Western-Asiatic style', for it may be too early to label it 'Polychrome Levantine'.

Polychrome Western Asiatic style

Most faience vessels from Late Bronze Age Ugarit belong to this style (Peltenburg 1974: 'International Western Asiatic Style'); its characteristics are the appearance of yellow or orange glazes and the use of thick, large bands of black colour, contrasting with white or pale blue or green zones. Common shapes are blossom bowls or goblets with petals of different colours in relief (83AO 50: Ras Shamra 1935, unpublished) and pyxis or cosmetic boxes with pierced lugs, successors of the Middle Bronze Age example seen above (AO 15729: Minet el Beida, tomb VI, unpublished; for

this type see Peltenburg 1983, 214). Here are also some rare closed shapes, such as a spout of a vase with yellow, white and black bands (83AO 145: Minet el Beida, tomb VI, unpublished). The chariot group (AO 18522: Lower city, North of Baal Temple: Schaeffer 1936, 114, fig. 7 and pl.XVIII,1) is a unique example in this style and technique. Most common are cups and cylindrical goblets or buckets of simpler manufacture displaying only two different colours of glaze, pale blue or grey and yellow or black, with occasional contrasting drips on the rim; for example, a hemispherical bowl, inner glaze yellow with black band, outer glaze blue-grey (83AO 70: Ras Shamra, Acropolis, unpublished) and a hemispherical bowl, inner glaze yellow, outer glaze pale blue (83AO 71: Ras Shamra, no provenance, unpublished).

At least four colours (white, yellow, green or blue and black) were represented on the six specimens analysed: no opacifier was used in the production of white faience; instead, a transparent glaze was deposited over a white body made from fairly pure sand or powdered quartz. Yellow was achieved by means of lead antimonate, a pigment used all over the Near East from the middle of the second millennium BC until modern times. It is noteworthy however, that the antimony: lead ratios in Ras Shamra materials are about three times higher than those encountered in contemporary Egyptian New Kingdom faience (Kaczmarczyk and Hedges 1983). Greater availability of antimony, which both Syria and Egypt had to import, is indicated for Ras Shamra. The black was obtained by the use of manganese and iron oxides containing a higher proportion of iron than that observed in many other Ras Shamra blacks. The recipe used was one very easily distinguished from Egyptian pigments. The presence of cobalt (0.1 - 0.3%) in the black glaze of one of the objects (AO 18522) is rather surprising and difficult to explain at the moment, except that another unique source of manganese and iron might have been used. The blue and green glazes owe their colour to copper derived from bronze, as in several cases cited above.

Plain blue-green faience and glazed clay vessels

Glazed vessels of this simpler type occur at Ras Shamra with either a siliceous or a clay body (see below). In the latter case, specific shapes such as footed bottles and ovoid flasks characterize the type (Caubet 1985, Peltenburg 1985). Glazed clay (over 12% Al_2O_3) bottles and flasks were found in Cyprus, on the Syrian coast and on the Middle Euphrates valley; some examples may come from Mesopotamia (Ur); they belong to the latest period of the Late Bronze Age (end of thirteenth to twelfth, or even the eleventh century BC). On the two specimens we subjected to analysis - a flask (83AO 31) and a bottle (AO 15749) - both from Minet el Beida, tomb VI, (Caubet 1985), the glazes were characterised by rather elevated levels of iron and barium. The former was always and the latter was occasionally in excess of the normal colourant, copper. High levels of iron are easy to explain as being due either to deliberate addition of ferruginous minerals or to the use of sand of high iron content. The presence of so much barium (0.3 - 0.9% BaO), in the absence of manganese, is most unusual and suggests the use of copper minerals unlike those being used in Egypt, for instance. Possibly copper from the same source as the barium-rich ore processed at Norsun Tepe in the fourth millennium BC was used (Zwicker 1980).

Egyptian blue

Five specimens of 'Egyptian blue', as identified by x-ray diffraction, were subjected to chemical analysis by x-ray fluorescence and atomic absorption. Of these one consisted of a finished object in the form of a scaraboid with an engraved design of a 'smiting god' (AO 14726: Minet el Beida, point 213,

Schaeffer 1932, pl. V, 4). The four others were in the form of large lumps, some pillow-shaped (83AO 149: Ras Shamra 1959, 'Tranchée Sud'; 83AO 150: Ras Shamra 1954, store room in royal palace, point 1425; 83AO 151: Ras Shamra, no provenance; 83AO 152: Ras Shamra 1933, Trench 24 III, all unpublished). All but one (83AO 149) were dark blue and contained low levels of tin and/or arsenic, suggesting the use of alloyed copper scrap. In the dark blue specimens the CuO and CaO concentration had ranges of 8-15% and 10-12% respectively. These ranges fall within the limits observed in second and first millennium BC Egyptian and Mesopotamian blue frits (Kaczmarcyk and Hedges 1983, Tite et al. 1984). To ensure that the low alkali contents were not representative of a leached outer layer, powder intended for atomic absorption analysis was removed from well below the surface. While the low alkali contents suggest greater affinity with Mesopotamian materials, the copper content is significantly lower than normally observed in Assyrian specimens from Nimurd and Nineveh (Tite et al. 1984). However, while the analysis seem to favour local manufacture for the Ras Shamra Egyptian blue, the final verdict must at least await a significant number of analyses of Mesopotamian frits of the second millennium BC. The Assyrian frits alluded to above are all of the ninth to seventh centuries BC.

The one pale blue example from Ugarit (83AO 149) shows a rather unusual composition: very low copper and calcium contents (5% CuO, 6% CaO) and some lead and antimony (1% PbO, 2% Sb_2O_5), as if the specimen represented an unsuccessful attempt at making a green frit. Tite et al. (1984) report no comparable specimen in their compilation, while in Egypt such frits appear only in the first millennium BC (Kaczmarczyk and Hedges 1983) and tend to be green.

Preliminary comments on the elemental composition

Manganese

Manganese is seldom seen except in black where it was obviously used in conjunction with iron to make a pigment known in the Near East since the sixth millennium BC. The principal exception is with the grey objects of presumably Egyptian origin where the element is correlated with cobalt. The paucity of manganese in other colours indicates that it is not a major impurity in the sand utilised for the manufacture of Ras Shamra faience. Faience made in Egypt frequently contains low levels of manganese (0.1 - 0.5% MnO) because the element is a much more common impurity in Egyptian sands. That psilomelane was the mineral source of manganese in the present case is attested by the fact that the manganese is invariably accompanied by barium. This too contrasts with Egypt where pyrolusite, probably mined in the western Sinai, was the preferred source of manganese during the New Kingdom.

Iron

Iron was present in each and every glaze examined at levels in excess of 0.1% Fe_2O_3. There can be no doubt in most instances that the element was introduced with the sand. In black glazes it came either with the manganese from a ferruginous manganese ore or was introduced deliberately in those specimens where the iron:manganese ratio was relatively high and the iron oxide concentration was much higher than in the surrounding non-black ground. For example, the model chariot (AO 15822), in which the black and yellow areas contained less than 0.4% Fe_2O_3, in contrast with the black design containing c. 1% Fe_2O_3 and c. 0.4% MnO. Another colour in

which minerals containing iron must have been introduced is yellow, for it was in yellow sections of polychrome vessels that the highest levels have been recorded (over 10% in AO 15729). In these there appears to be a correlation with either lead or antimony. Of course, in the blue-grey model grapes of Egyptian origin, iron is also elevated and correlated with cobalt.

Cobalt

Cobalt in excess of 1% was found in the blue-grey objects of Egyptian provenance (AO 14803 and 83AO 148), but was also detected in one case of black (AO 18522, model chariot) and in one of the blue glazes (83AO 53, rectangular box).

Nickel

Nickel was most prominent in the examples of Egyptian origin cited above where it was correlated with cobalt. However, at levels below 0.06%, it was sporadically encountered in different glazes with a frequency higher than that in Egyptian faience, in which the element is most uncommon (Kaczmarczyk and Hedges 1983). It is obviously introduced as an impurity with some other ingredient, most pobably copper or iron. A more precise correlation is difficult to establish due to the high measurement errors associated with percentages below 0.1% NiO.

Copper

Copper was the principal component in all blue and green glazes and the concentrations range from 0.5 to 5%, the normal span for ancient faience of Egypt for example. In some instances copper was also used to reinforce the black on polychrome objects. For example, while the green portion of pyxis AO 15729 contained less than 0.5% CuO the black section had over 2% CuO, accompanied by an equal amount of MnO. As might have been expected, the highest copper concentrations were encountered in the blue frits (5 - 20% CuO).

Zinc

Zinc was not a significant impurity except in the objects of Egyptian origin, in which it was correlated with cobalt, as were several other elements.

Arsenic

Arsenic was detected in two of the blue frits (c. 0.1% As_2O_3 in AO 14726 and in 83AO 151) and was undoubtedly introduced with the copper when arsenical-copper objects were scrapped for use as a source of copper. Traces of the element also showed up in several yellow glazes into which it probably entered with lead.

Strontium

Strontium oxide in the 0.1 - 0.4% range is much more common in the Ugarit examples than in the Egyptian faience, for example, undoubtedly because of a different source of lime, the principal source of this particular impurity.

Tin

Tin oxide was never detected above 1% and in almost all instances appeared to be correlated with copper. It would appear that in Ugarit, as in Egypt and Mesopotamia, bronze served as a source of copper, introducing into the glaze elements such as tin and arsenic, noted above.

Antimony

Antimony was only detected in the company of lead in colours such as yellow, dull orange or green. It was apparently used to make lead antimonate, a pigment whose use in Egyptian faience is attested as early as the beginning of the fifteenth century BC. The date of its introduction into Mesopotamia is not known. As noted in the preceding chapter, the proportions of the two elements employed at Ugarit suggest that the antimony was easier to come by in Northern Syria than in Egypt, so that the idea of Iran or Anatolia as a likely source is strengthened.

Barium

Barium is detected in almost all the dark glazes coloured by manganese and its presence was explained when the latter element was discussed. However it occasionally showed up in the absence of manganese, suggesting that BaO was a significant impurity in some principal ingredient of Ugarit faience. Lime, sand or copper ores are all possible sources of this additional barium.

Lead

Lead appears very often in glazes containing copper, indicating that the same copper sources were used as those that served for the production of metal objects. Copper artefacts from Ras Shamra invariably contain 0.5% to 2% lead (Schaeffer 1945). Only in the yellow glazes (even in the absence of copper) does the concentration of PbO exceed 1% in all specimens examined and as much as 11% PbO has been detected in pyxis AO 15729.

Preliminary remarks on the cores

Few analyses of the cores are yet available. The following types may be distinguished:

1. White siliceous cores, made with pure sand, are the most frequent. Some display a yellowish colour due to impurities in the sand.

2. Hard, coarse-grained siliceous cores coloured red or green by iron, which presumably comes with the original sand. For example, the body material of one specimen (83AO 66) contained 2.7% Fe_2O_3. Other examples were a Middle Bronze Age (?) goblet (83AO 48), a blue glazed box (83AO 53) and a blue glazed footed bowl (83AO 141).

3. Lucas Variant D, in which a hard blue-grey core covered with a like-coloured glaze, appear to be Egyptian imports. This type of core is not found in vessels but only in small amulets or beads.

4. Clay cores appear at Ugarit at the end of the Late Bronze Age; they show traces of wheel turning, and a fine net of cracks due to different

rates of cooling between body and glaze. A white layer of pure sand or powdered quartz is sometimes applied between body and glaze. Analysis shows levels of at least 12% Al_2O_3 corresponding to approximately 30% of clay, the material that gave plasticity to the body, allowing it to be thrown on a wheel.

5. Pigments or 'Egyptian blue', see p. 51

Acknowledgements

The authors are most grateful to M.Jack Ligot and M.Christian Lahanier for giving them the opportunity to work at the Laboratoire de Recherche des Musées de France. They express their gratitude to M.Alain Duval and M.Alain Leclaire for assistance with the analyses performed in the LRMF and they wish to thank Miss Helen Hatcher at the Research Laboratory for Archaeology, University of Oxford, for the atomic absorption analyses of several specimens.

References

Caubet A (1983-1984). In Au Pays de Baal et d'Astarté. Paris, Musée du Petit Palais

Caubet A (1985). Poterie tournée à glacure au Bronze Récent: Chypre et Syrie. In Mélanges Jean Deshayes. Paris

Caubet A and Yon M (1985). Kition Bamboula III. Paris

Kaczmarczyk A and Hedges R E M (1983). Ancient Egyptian faience. Warminster

Kaczmarczyk A (1985). The sources of cobalt in ancient Egyptian pigments. Proceedings of the 1984 Symposium on Archaeometry. Washington, Smithsonian Institution Press

Lucas A and Harris J R (1962) Ancient Egyptian materials and industries. London

Mazzoni S (1979-1980). Essai d'interpretation des vases plastiques dans la Syrie du Bronze Moyen Récent. Annales Archaeologiques Arabes Syriennes 29-30, 237-252. Damas

Peltenburg E J (1972). On the classification of faience vases from Late Bronze Age Cyprus. Acts of the First International Congress of Cypriot Studies A'. Nicosia

Peltenburg E J (1974). The glazed vases. In Excavations at Kition, I V Karageorghis et al., 106-144. Nicosia

Peltenburg E J (1983). Glazed vessels from Hala Sultan Tekke 1972-1979. In Hala Sultan Tekke 8 Studies in Mediterranean Archaeology LXV: 8, P Åström et al., 214-217. Göteborg

Peltenburg E J (1985). Glazed vessels from Bronze and Iron Age Kition. In Kition V, V Karageorghis et al. Nicosia

Sagona C (1980). Middle Bronze Age vessels from Palestine. Zeitschrift der Deutschen Palästeins Verein 96, 101-120

Salles J F (1980) La Nécropole K de Byblos. Paris

Schaeffer C F A (1932). Les fouilles de Minet el Beida et de Ras Shamra: Troisième campagne. Syria XIII, 1-27

Shaeffer C F A (1938). Les fouilles de Ras Shamra - Ugarit: Neuvième campagne. Syria XIX, 193-255

Schaeffer C F A (1939). Ugaritica I. Paris

Schaeffer C F A (1945). La contribution de la Syrie ancienne à l'invention du Bronze. Journal of Egyptian Archaeology 31, 92-95

Strauss E C (1974). Die Nunschale. Eine Gefässgruppe des Neuen Reiches (Munchner Ägyptologische Studien 30)

Tite M S, Bimson M and Cowell M R (1984). Technological examination of Egyptian Blue. In Archaeological Chemistry III Advances in Chemistry Series 205. 215-242. Washington

Woolley L (1955). Alalakh. Oxford

Zwicker U (1980). Investigations on the extractive metallurgy of Cu/Sb/As ore and the excavated smelting products from Norsun Tepe (Keban) on the Upper Euphrates (3500-2800 BC). In Aspects of Early Metallurgy, W A Oddy ed., British Museum Occasional Paper 17, 13-24. London

COMPOSITION OF COLOURS IN MINOAN FAIENCE

Karen Polinger Foster

Department of Classics
Wesleyan University
Middletown, CT 06457

Abstract

X-ray fluorescence analysis of fifty pieces of Minoan faience in the Ashmolean Museum has contributed to a more complete understanding of the Minoan faience industry, especially its polychrome innovations and refinements. Almost from the start a wide range of colours was used, many of which were carefully mixed to create naturalistic, pictorial effects. This paper presents a synopsis of the analytical results followed by a discussion of how faience colours from Crete and elsewhere fit into the context of related polychrome work, particularly wall painting and pottery decoration. The paper continues with a consideration of whether specific colour compositions in faience and other media were primarily aesthetic or technical in inspiration. Finally, it concludes with an appraisal of the historical development and special characteristics of Minoan faience colours.

Keywords: FAIENCE, POLYCHROME, X-RAY FLUORESCENCE, MINOAN, COLOURS, WALL PAINTING, POTTERY

Introduction

Among many other topics, the Elder Pliny treats the development of colours in his Natural History. He notes especially the transition from monochrome to polychrome, the application of light and shade, the existence of 'austere' and 'florid' colours, as well as what he terms the 'splendor', 'tonos' and 'harmoge' of colours (Nat.Hist.LIB.XXXV,xi Pollitt 1965). For Pliny, the famous fourth century paintings that 'would sell for the value of whole towns' (Nat.Hist.LIB.XXXV,xxxii) may have seemed as removed in time and concept as medieval alchemical theories do to the modern colourist (Fleming 1984). Yet Pliny's compilation of the important features of colours and painting affords us not only a guide, however imperfect, but also a point midway between the making of Minoan faience and the rediscovery of its composition.

Faience colours

X-ray fluorescence analysis of some fifty pieces of Minoan faience in the

Ashmolean Museum has yielded insights into the nature of faience colouring in mid-second millennium Crete (Foster and Kaczmarczyk 1982). For the most part, expected mineral and earth colours predominate: red from iron; white from quartz or limestone; green from copper; and purple from red and blue, which itself seems to be coloured by Egyptian blue (Chase 1971, Tite, Bimson and Cowell, this volume). In the Ashmolean pieces, purple was a fortuitous layering, though this may not be true of a set of necklace elements from Mallia, originally red-violet (Detournay et al. 1980). The most interesting series of results involves black and grey, with formula changes from reduced iron to barium-rich manganese derived from psilomelane, and then to barium-poor manganese from pyrolusite.

As with much materials analysis, the conclusions are outnumbered by the new questions raised. In this paper a few provisional answers will be suggested, which may collectively contribute to a fuller understanding of how Minoan faience colours fit into the context of other Bronze Age polychrome work.

Thanks to extensive, recent research (Kaczmarczyk and Hedges 1983) a great deal is now known about Egyptian faience colours. From the Archaic Period until the Eighteenth Dynasty one finds white (quartz), green (copper), blue (copper, Egyptian blue), and black/brown (manganese, iron). New Kingdom innovations, particularly the introduction of cobalt (Taylor 1977, Kaczmarczyk forthcoming) and lead antimonate, signalled a wider palette.

Less complete series of analyses are presently available for other Bronze Age faience. Mesopotamian faience from Tell al-Rimah, to take one example, is coloured by ferruginous manganese black, green from copper, and yellow with high concentrations of lead and antimony (Pollard and Moorey 1982, cf Hedges and Moorey 1975, Hedges 1976). Cypriote faience, mainly that from Kition, has been subject to analysis (Peltenburg and McKerrell 1974). The preliminary results point to predictable formulae for red and yellow, but unusual ones for green, black, and blue-grey. The few published analyses of faience from Central Europe indicate relatively high levels of cobalt and opacifying antimony, while studies recently done on British beads suggest that tin-bronze or its by-products were the copper source (Aspinall et al. 1972)

Wall painting colours

With these colour compositions in mind, we turn now to a brief consideration of polychrome formulae used in other media, especially Aegean and Egyptian painting and pottery. The most recent analytical work done on frescoes from Knossos has produced a wealth of information (Cameron et al. 1977, Profi et al. 1976). The primary colours were red and yellow ochres and blue from either Egyptian blue, glaucophane, or riebeckite. Mixing produced the secondary colours, while white and black consisted respectively of lime or kaolinite and carbon, soot, or perhaps carbonaceous shale. Restoration and subsequent analytical work on the Haghia Triada sarcophagus have revealed that it was painted using much the same colours (Levi 1956). Very similar results obtain from Mycenaean frescoes available for recent analysis (Profi et al. 1974), as well as from work carried out on wall paintings from Akrotiri (Asimenos 1978, Filippakis 1978, Noll et al. 1975a).

As for colours in Egyptian painting, one has not only the artifacts and lumps of pigment but also lexicographical clues to the pigments and painting substances used (Iversen 1955). The colours were made from a wide variety of materials, with several sources often tapped (Lucas and Harris

1962). Green, for instance, might be malachite, artificial frit, or blue and yellow combined. Occasionally some rather unusual pigments were employed (Riederer 1974), including huntite for white (Barbieri et al. 1974), cobalt aluminate for blue, and atacamite for green.

Ceramic colours

Though the range of colours is not nearly so wide as in faience, it is essential to look at ceramic colours because of the analogous pyrotechnology involved in firing pigmented areas. Minoan pottery, extensively studied from a stylistic standpoint, has been scientifically examined as well. From about the beginning of the second millennium the capability existed for polychrome work. This leaves aside the variegated Vasilike ware colours of the third millennium, since these seem to have been produced by knowledgeable manipulation of happenstance (Betancourt et al. 1979, Myer and Betancourt 1981). The brilliance of Kamares ware was in no small measure due to the intensity of its colours. Black, the usual background colour, had a high iron content; white consisted of talc; and the iron oxide red accents appear to have been applied with an organic binding medium after firing (Noll et al. 1971, 1974). Analyses of Minoan pottery ranging from Early Minoan II ware from Palaikastro to Late Minoan III B Knossos pieces have confirmed the iron pigment formulae for red and black (Stos-Fertner et al. 1979). The few white samples, however, were found to contain huntite and metakaolinite.

The discoveries on Santorini have given rise to a multitude of technical studies, among them a series of analyses on Theran pottery (Noll 1978, Maniatis and Tite 1978). The earlier pottery, though stylistically different from Minoan ware, has very similar colouring agents for black, white and red. Between Middle Minoan III and Late Minoan I, a significant change occurred, namely the use of manganese black. This, in conjunction with application of all three colours to an unfired pot surface, sheds new light on the independence of Theran potters from their Minoan counterparts (Magalousis and Gritton 1981).

As an aside, it should be noted that the choice of iron versus manganese for black has a very interesting geographical and chronological distribution (Noll et al. 1975, Farnsworth and Simmons 1963). Black made by iron reduction seems to have been more widespread and of greater antiquity. As we have seen, it was the preferred black for Minoan pottery. Manganese black, on the other hand, was used for colouring pottery from other parts of the Aegean. These include southeast Anatolia during the sixth to fifth millennia; Thrace, Thessaly and Attica during the fourth to third millennia; and Aegina, Thera and Cyprus at various points during the Bronze Age. Both manganese and soot were called upon to make black decoration on Egyptian pottery, the important consideration here being the concurrent traditions of ceramic painting and post-firing painting (Noll 1981). Some materials, such as manganese and iron oxides, could be used in both methods, while others, soot and huntite for instance, could only be applied to the already-fired surface.

The choice of colours

This brings us to another issue in colour composition, namely the interrelationships among the following: availability of colourants, technological advances, and workshop innovation or conservatism. For the most part, naturally occurring, locally exploitable sources were used for colour formulae, with notable exceptions like lapis lazuli and Egyptian

blue. The latter was ingeniously combined with riebeckite in Minoan wall painting, apparently to make the supply of Egyptian blue last longer (Cameron et al. 1977). The nature and extent of the international trade in pigments is difficult to elucidate. Accidents of preservation occasionally supply evidence, as for example a wooden box, filled with huntite, from a third century AD Roman shipwreck (Barbieri et al. 1974). The picture is further complicated by the fact that during times of prosperity it seems to have been more economically advantageous, at least in Egypt, to import nearly all raw materials (Kaczmarczyk and Hedges 1983).

Often, major chemical and technological changes had little effect on colour appearance. Such is the case, for instance, with the Minoan switch from iron to manganese black. Sometimes, however, one finds that improvement or variation in technique does produce a discernible difference. The fine gloss and texture of much Late Minoan pottery, for example, is a result of finer pigment grinding, lower firing temperature and a concomitant lack of bubbles in the black (Noll, Holm and Born 1975, Stos-Fertner, Hedges and Evely 1979).

Within workshops concerned with similar problems of colouration and pyrotechnology, there must have been a certain measure of co-operation, - and competition for that matter. We may glimpse some of this thanks to recent analytical and archaeological work. Faience and fresco copper pigments, to take one area, seem to have been derived from metallurgical processes - bronze filings, slag, bronze corrosion products, and so forth (Profi et al. 1974, Kaczmarczyk and Hedges 1983). As we have already suggested, Minoan faience-makers were influenced by their Egyptian counterparts to abandon tradition and to adopt both the technique and ore source of manganese black (Foster and Kaczmarczyk 1982). This is so startling a change that one wonders about a possible spatial separation of luxury craftsmen within the palace confines, or a radical reorganisation of workshop infrastructure (Foster forthcoming).

As for the composition of specific faience and other colours, the problem here is to try to determine if the colour was intentional or unintentional, all the while keeping in mind the distorting effects of time and weathering, not to mention early conservation substances such as 'Japanese varnish' (Levi 1956). A few accidental colours are relatively easy to spot: purple in Minoan faience (Foster and Kaczmarczyk 1982); purple-brown and perhaps early greens in some Egyptian faience (Kaczmarczyk and Hedges 1983); and red corrected to blue-green in Attic vase painting (Noll et al. 1975).

Many colours, however, seem to the twentieth century eye to be successful results of premeditation. Minoan faience is particularly noteworthy for its subtle shades of greys and browns. X-ray fluorescence analysis has shown that these were achieved by manipulation of formulae involving copper, iron, and manganese. There is a similarly wide range of greens: olive colours made from copper and manganese mixtures and grey-greens from copper and iron combinations (Foster and Kaczmarczyk 1982).

Over the years, scientific studies of Minoan wall painting colours have afforded insights into the careful work of the pigment-maker. The intensity of blue colours, for example, was found to be directly related to the concentration of quartz, with more quartz for lighter blues (Profi et al. 1976). Greyish tones in blue are products of complex mixtures of glaucophane, quartz, iron oxide, calcite, mica, chlorite, and a very small quantity of black (Profi et al. 1976). Unlike faience greens, Minoan fresco greens reflect a variety of blue and yellow combinations, not only with respect to individual ingredients, but also in terms of the ordering

of layers of blue and yellow (Cameron *et al.* 1977).

Beyond Crete there is likewise much evidence for deliberate manufacturing choices. One may cite several of the more innovative examples to give an idea of the colourists' abilities: in Mycenaean frescoes, brown from Egyptian blue overlaid by iron oxide, or from opaque black, limonite, and hematite (Profi *et al.* 1974); in Egyptian faience, indigo-violet from manganese, cobalt and nickel, with an intentional selection of plant ashes instead of natron (Kaczmarczyk and Hedges 1983); and in Egyptian painting, black and ochre mixed to produce a deep, rich red (Mekhitarian 1978).

As for the mechanical aspects of polychrome work, prepared colours were applied in several ways: inlaying, overlaying, or juxtaposing (Vandiver 1983). Within these broad categories, subvarieties may be defined; for example, one in which colours were inlaid in white with clear demarcations, or one in which linear designs were drawn over coloured surfaces (Kaczmarczyk and Hedges 1983). It should be noted that distinctions among subvarieties are sometimes blurred, as in Kamares ware, with paint strokes side by side or laid down in sequence, usually, but not always, black - white - red (Noll *et al.* 1975).

Over-riding stylistic considerations seem to have determined what specific polychrome techniques were to be used. The requisites of Amarna art, to take one instance, included an emphasis on subtle colouration and naturalistic contours. Amarna faience tiles, with their melding of colour and line on a glossy surface, contributed substantially to the unified appearance of the new ceremonial halls (Smith 1965).

Polychrome faience

Let us focus on two last points about Minoan polychrome faience: first, its historical development and second, its special characteristics, both technical and aesthetic. Pride of place has traditionally gone to Knossos as the innovator of polychrome faience. The earliest extant work is the Town Mosaic, probably best dated Middle Minoan III A, about 1600 BC or a bit earlier. The multicoloured impulse, however, was certainly present some thousand years before in the Egyptian Archaic and Old Kingdom tricolour faience done in brown/black, green and white (Kaczmarczyk and Hedges 1983). Why, then, should Egypt not be credited as the originator of polychrome faience?

The reason lies, I think, not so much in the larger or smaller number of colours used, but in the way in which the colours were integrated into a unified pictorial principle. Minoan colours, whether in faience or wall painting, serve as vehicles for a visual expression that is uniquely Cretan. Naturalistic yet formal (Cadogan 1976), spontaneous yet intellectualized - these are the contradictory bases of Minoan art. In the Town Mosaic one sees the hallmark greys and browns, subtle greens and blues, vibrant highlights of red, and confident use of white. These create the spatial illusions fundamental to the realization of the Minoan aesthetic.

It is with the masterpieces of the Temple Repositories that Minoan polychrome faience realizes its potential (Foster 1979). There, individual colours and a multitude of gradations were combined with relief forms of consummate artistry. The achievement of the opalescent argonaut shell from Zakros follows closely upon these successes.

Conclusions

We have come full circle back to Pliny's pronouncements about the ideal function of colours and the essence of polychrome. Scientific studies in the last decade have started to quantify this essence, but not such that its aura is diminished. On the contrary, once technical matters are defined, then the aesthetic assumes a new and enhanced dimension. In the case of Minoan faience colours, we may now begin to speak of their composition, not only formulaic but also conceptual.

Acknowledgements

I would like to thank Mavis Bimson and Ian Freestone for having invited me to participate in the Symposium and the American Council of Learned Societies Travel Grant Program for having made it possible for me to go to London. Alexander Kaczmarczyk and Benjamin R Foster read drafts of the manuscript; I am grateful for their comments, corrections, and support.

References

Asimenos K (1978). Technological Observations on the Thera wall-paintings. In Thera and the Aegean World I, C Doumas ed., 571-578. London

Aspinall A, Warren S E, Crummett J G and Newton R G (1972). Neutron activation analysis of faience beads. Archaeometry 14, 27-40

Barbieri M, Calderoni G, Cortesi C and Fornaseri M (1974). Huntite, a mineral used in antiquity. Archaeometry 16, 211-20

Betancourt P P et al. (1979). Vasilike Ware: An Early Bronze Age Pottery style in Crete (Studies in Mediterranean Archaeology 56). Göteborg, Paul Åströms Forlag

Cadogan G (1976). Palaces of Minoan Crete. London, Barrie & Jenkins

Cameron M A S, Jones R E and Philippakis S E (1977). Scientific analyses of Minoan fresco samples from Knossos. Annual of the British School at Athens 72, 121-84

Chase W T (1971). Egyptian Blue as a pigment and ceramic material. In Science and Archaeology, R H Brill ed., 80-90. Cambridge, Mass., MIT Press

Detournay B, Poursat J-C and Vandenabeele F (1980). Fouilles Exécutées à Mallia: Le Quartier Mu II. Études Crétoises XXVI. Paris, Geuthner

Farnsworth M and Simmons I (1963). Colouring agents for Greek glazes. American Journal of Archaeology 67, 389-96

Filippakis S E (1978). Analysis of pigments from Thera. In Thera and the Aegean World I, C Doumas ed., 599-604. London

Fleming S (1984). Pigments in history: The growth of the traditional palette. Archaeology 37, 68-69

Foster K P (1979). Aegean faience of the Bronze Age. New Haven, Yale University Press

Foster K P (forthcoming). Reconstructing Minoan palatial faience workshops. In The Function of the Minoan palaces, R Hägg and N Marinatos eds. Stockholm, The Swedish Institute in Athens

Foster K P and Kaczmarczyk A (1982). X-ray fluorescence analysis of some Minoan faience. Archaeometry 24, 143-57

Hedges R E M (1976). Pre-Islamic glazes in Mesopotamia - Nippur. Archaeometry 18, 209-13

Hedges R E M and Moorey P R S (1975). Pre-Islamic ceramic glazes at Kish and Nineveh in Iraq. Archaeometry 17, 25-43

Iversen E (1955). Some Ancient Egyptian paints and pigments: A lexicographical study. Copenhagen, Ejnar Munksgaard

Kaczmarczyk A (forthcoming). The Source of cobalt in Ancient Egyptian pigments. In Archaeometry Symposium Proceedings 1984 Washington, Smithsonian Institution

Kaczmarczyk A and Hedges R E M (1983). Ancient Egyptian faience: An analytical survey of Egyptian faience from Predynastic to Roman times. Warminster, Aris and Phillips

Levi D (1956). The Sarcophagus of Haghia Triada restored. Archaeology 9, 192-99

Lucas A and Harris J R (1962). Ancient Egyptian materials and industries. London, Edward Arnold

Magalousis N M and Gritton V (1981). Aegean ceramics: Atomic absorption analysis of local and import ware from Thera, Greece. In Scientific studies in ancient ceramics, M J Hughes, ed., British Museum Occasional Paper 19, 103-116. London, British Museum

Maniatis Y and Tite M S (1978). Ceramic technology in the Aegean world during the Bronze Age. In Thera and the Aegean World I, C Doumas ed., 483-492. London

Mekhitarian, Arpag (1978). Egyptian Painting. Skira-Rizzoli Books

Myer G H and Betancourt P P (1981). The Composition of Vasilike Ware and the production of mottled colours of the slip. In Scientific studies in ancient ceramics, M J Hughes, ed., British Museum Occasional Paper 19, 51-56. London, British Museum

Noll W (1978). Material and techniques of the Minoan ceramics of Thera and Crete. In Thera and the Aegean World I, C Doumas ed., 493-505. London

Noll W (1981). Mineralogy and technology of the painted ceramics of Ancient Egypt. In Scientific studies in ancient ceramics, M J Hughes, ed., British Museum Occasional Paper 19, 143-154. London, British Museum

Noll W, Holm R and Born L (1971.) Chemie und Technik altkretischer Vasenmalerei vom Kamares-Typ. Naturwissenschaften 58, 615-18

Noll W, Holm R and Born L (1974). Chemie und Technik altkretischer Vasenmalerei vom Kamares-Typ II. Naturwissenschaften 61, 361-62

Noll W, Holm R and Born L (1975). Painting of ancient ceramics. Angewandte Chemie International Edition 14, 602-13

Noll W, Holm R and Born L (1975a). Keramiken und Wandmalereien der Ausgrabungen von Thera. Naturwissenschaften 62, 87-94

Peltenburg E J and McKerrell H (1974) The Glazed vases (including a polychrome rhyton). In Excavations at Kition I: The Tombs, V Karageorghis ed., 105-144. Nicosia, the Department of Antiquities

Pollard A M and Moorey P R S (1982). Some analyses of Middle Assyrian faience and related materials from Tell al-Rimah in Iraq. Archaeometry 24, 45-50

Pollitt J J (1965). The Art of Greece 1400 - 31 B.C. : Sources and documents. Englewood Cliffs, N J, Prentice-Hall

Profi S, Weier L and Filippakis S E (1974). X-ray analysis of Greek Bronze Age pigments from Mycenae. Studies in Conservation 19, 105-12

Profi S, Weier L and Filippakis S E (1976). X-ray analysis of Greek Bronze Age pigments from Knossos. Studies in Conservation 21, 34-39

Riederer J (1974). Recently identified Egyptian pigments. Archaeometry 16, 102-9

Smith W S (1965). The Art and architecture of Ancient Egypt. Penguin Books.

Stos-Fertner Z, Hedges R E M and Evely R D G (1979). The Application of the XRF-XRD method to the analysis of the pigments of Minoan painted pottery. Archaeometry 21, 187-94

Taylor J R (1977). The Origin and use of cobalt compounds as blue pigments. Science and Archaeology 19, 3-15

Vandiver P (1983). Egyptian faience technology. In Ancient Egyptian faience, A Kaczmarczyk and R E M Hedges, A 1-137. Warminster, Aris and Phillips

FAIENCE IN EBLA DURING MIDDLE BRONZE AGE II

Stefania Mazzoni

Dipartimento di scienze storiche del Mondo antico
University of Pisa, Via Galvani 1, 56110 Pisa

Abstract

The evidence of faience at Ebla is still quite limited; however, a small group of objects has some relevance. These objects come from different contexts of the Middle Bronze Age city and have local Syrian characteristics, which become more widespread during the following Late Bronze Age period. The most important piece is a rhyton in the shape of a human head, with a hathoric hairdress. It foreshadows the production of the plastic vases and of the so-called female masks, which were found during the Late Bronze Age from Enkomi to Tchoga Zanbil. A miniature amulet represents two sitting figures, which are made in the same style as the contemporary monumental Syrian statues, and which foreshadows a similar specimen from Assur. A reclining bull shows the changes that Egyptian animal models underwent in Syria and starts a type which continues in the later specimens from Nuzi, Assur and Tchoga Zanbil. A local imitation of Egyptian alabastra is attested by a phial, which belongs to a local production spread from Syria to Palestine. This is evidence of the beginning of faience production in Syria. In the Middle Bronze Age phase it is still limited and occasional and asserts itself only during the Late Bronze Age. Though it still depends on and copies the richer contemporary Egyptian repertory, it already has peculiar typological and stylistic characteristics.

Keywords: FAIENCE, SYRIA, EBLA, BRONZE AGE.

Introduction

Evidence for faience in Ebla is still quite partial and is limited in amount. For the most part, it includes some individual objects found in the Middle Bronze II levels, that is, the city's best known and most flourishing period. The faience of the Late Bronze Age is even less documented, as this period is, in fact, the least known phase in the site's general stratigraphy. The specimens which date from Iron I-III are also very rare, although this period is attested both on the Acropolis and in the Lower City. Thus the small group of faience from Middle Bronze II, because of its age and typology, makes an original contribution to our knowledge of Syrian faience (Peltenburg 1971, 6-12). Several intact

objects were found in different contexts in the level of destruction of the Middle Bronze II city, which are discussed in detail in the following paragraphs.

Faience objects found at Ebla

A rhyton in the shape of a female head with a hathoric hairdress

A vase with a female head wearing a hathoric hairdress, TM.70.B.930 (Fig.1)[1], comes from L1556 in the private houses of area B (Matthiae 1975, 487, Fig. 423a; 1977, Pl. 101; 1984b, Fig. 96; Kohlmeyer 1982, 117, No 99; Caubet 1984, 127, No 160; Mazzoni 1985, 236, No 115). It was found on the floor in the level of the destruction usually ascribed to the conquest of Ebla by the Hittite kings around the end of the seventeenth century BC (Matthiae 1977, 116). Consequently, the stratigraphic location of the object allows us to date it not later than the end of this century.

We have dealt elsewhere with the iconography of the vase, namely, the female face, which should be identified with a kind of 'Ishtar's rhyton', known from the Hittite texts (Mazzoni 1979-80, 237-252). As is well known, this is a production which developed particularly during the Late Bronze Age when it paralleled the production of 'boîtes à fard' with hathoric heads, which possibly recall the image of Qudshu/'Anat. Here we will limit ourselves to pointing out the technical characteristics of the objects. The vase is handmade from pinkish-beige sand covered with a rather thick whitish glaze with iridescent green and blue reflections; the decoration is painted in black. The inner surface shows some apparent traces of burning.

The same technical characteristics are found in all the other Eblaic faience from the Middle Bronze II, indicating a local production which had its own technology. It is quite likely that this was the basis of the production of Syrian faience of the Late Bronze Age. This phenomenon is quite clear with regard to the typologies of the objects, the iconographies and the stylistic characteristics. In fact, as we will see in other faience from Ebla, these are the prototypes of some objects which were diffused, even outside the region, during the Late Bronze Age.

A miniature amulet representing two sitting figures

A small idol (TM.74.E.331) represents a sitting couple (Fig. 2)[2] and comes from the destruction of the city Acropolis. Here, too, the object is made of the same sandy clay covered by a thick glaze of a homogeneous light green colour with silvery flecks, giving it an iridescent aspect. The traces of a band painted in black are still visible between the two figures. A deep abrasion on the object's back leads us to believe that it was originally attached to a support.

The two figures sit with their hands on their knees and the hands on the inner side hold a cup. This iconography belongs to the repertories of the Old Syrian monumental statues (Mazzoni 1980, 79-98, Figs. 17-19), and their dress to the 'Wulstmantel' type (Mazzoni 1979, 111-35). These comparisons are in accord with the stratigraphic dating of the object which, just as for the first piece, must be limited to the date of the city's destruction, that is, the end of the seventeenth century BC. It is therefore the prototype of the miniature sitting figure from Assur, which belongs to the same genre as the group of faience from the age of Tukulti-Ninurta I (the

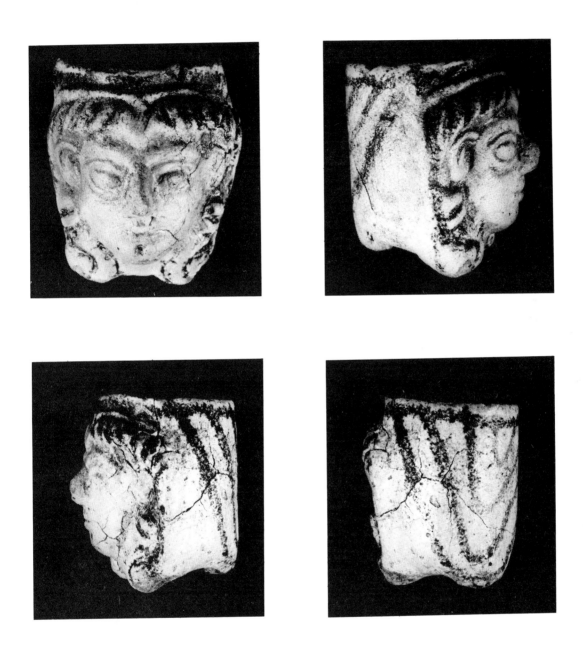

Fig. 1 Rhyton with hathoric hairdress TM.70.B.930. Height 7cm

Fig. 2 Miniature amulet representing two sitting figures TM.74.E.331. Height 2.8cm

Fig. 3 Model of bull TM.78.Q.150. Height 3.4cm

Fig. 4 Alabastron-shaped phial TM.75.G.257. Height 8cm

thirteenth century) (Andrae 1935, 85-86, No Ass.1434, Fig. 68), but which could be older. The faience images of miniature standing figures spread during this period from Assur (Andrae 1935, 82-84, Pl. 34), to Nuzi (Starr 1939, 419-20, Pl. 101 H) to Ras Shamra (Bossert 1951, 43, Figs.633-34; Frankfort 1954, 162, Pl. 153A). They are all characterized by the long, fringed dress and by the schematic rendering of the facial features and bodies. It is quite likely that this production descends from the Old Syrian tradition, both with regard to the type of the objects and their iconographic characteristics.

The model of a bull

This Old Syrian tradition is better known and documented for animal figurines, one example of which is TM.78.Q.150 (Fig. 3),[3] the image of a sitting bull, which was found on the second step of the staircase in L2975 of the northeast wing of the so-called Western Palace in area Q. The destruction of this building also dates from the end of the seventeenth century BC (Matthiae 1980, 99-118; 1982, 1-14; 1983, 530-42; 1984a, 19-31). It shares the same technical characteristics of the other faience, the pinkish sandy clay is covered by a thick light blue/white glaze and the eyes, nose, forehead and body are painted in black. It is handmade and not moulded, as is usual for faience of this period. The typology could be an imitation of the Egyptian production of faience in the shape of animals during the Middle Kingdom, which was certainly well known in the region during this period, as is proved by the presence of several figurines in one of the 'dêpots d'offrandes' of Byblos, which was found in the antecella of the obelisk temple (Dunand 1954, 1958, Pls. XCIX-CVIII). In this case we have a true Egyptian production, made both by hand and with the mould (Riefstahl 1948, 93, No 6; Cooney 1953, 5, Nos 9-10, Pl. VIII A-B). The Eblaic figurine is clearly inspired by this Egyptian production, but its stylistic characteristics belong to a local manufacture, as is the case of the Late Bronze Age faience figures of animals from Nuzi (Starr 1939, 430-34, Pls. 110A; 111A-B), Assur (Andrae 1935, 93-94, Fig. 75, Pl. 37a, n, Nos Ass 5125, 14984a-e, 12323 h1-2, i) and Tchoga Zanbil (Ghirshman 1968, 22, Nos GTZ 955-58, Pls. XIX, LXXVII).

A phial in the shape of an alabastron

The faience miniature vase TM.75.G.257 (Fig. 4)[4] has basically a similar story. It was found in L2762, in one of the private houses built over the ruins of Palace G. Its technical characteristics are the same as those observed in the other specimens, a greenish-white glaze with a slight silvery iridescence is spread over the pinkish sand clay; some traces of a high band of grey-black paint remain on the rim. This specimen is also apparently handmade and not moulded. It is a local production, as is proved by a miniature vase from Qadesh (Pézard 1931, 74, note 2, Pl. XXXVIII,2) of the same shape and general proportions, which was found in a tomb containing two bodies and pottery from Middle Bronze I-II and which has already been compared with a similar specimen from Tomb 3 of Gezer of the Twelfth Dynasty.

The alabastron-shaped vase can be compared with a series of faience bottles from the Jericho tombs and generally from Palestine. In Jericho the bottles are found beginning with Group IV, which dates from the end of the Middle Bronze Age (Kenyon 1964, 175, 200), that is, certainly from the Middle Bronze II of our terminology; in Palestine they can be dated in other sites to the end of the Middle Bronze II (Sagona 1980, 101-107, Figs. 1-4, Types I-II). These faience groups copy the shapes of the Egyptian

Fig. 5 Female figure TM.66.E.197. Height 4.5cm

Fig. 6 Miniature bowl TM.74.G.151. External diameter at mouth 7cm

stone alabastra, which are generally found with them in the same funerary furnitures (Kenyon 1964, Figs. 100, 154, 171, 179, 238; Dajani 1962, 67-75, Pl. XVI). A miniature faience vase from Cyprus (Caubet 1972, 114, Fig.1, Pl. XIX,1; 1981, 56, No CKY 93, Pl. 24) apparently belongs to the same Syrian production, and also dates from the Middle Bronze II. In fact, it was compared with the Egyptian faience vases of the Middle Kingdom and with the Palestinian production from the Middle Bronze II, although it has also been tentatively, albeit doubtfully, dated from the Late Bronze Age. In any case, its origin from the Egyptian stone alabastra is very clear in this case.

In contrast, a glass pendant with a naked female figure (TM.66.E.197; Fig. 5)[5] in a frontal standing position, probably belongs to the same chronological period, although there is no stratigraphic evidence for this. In fact, it was found in a Late Bronze Age level immediately over the destruction level of Palace E, which probably dates from the end of the seventeenth century BC (Fronzaroli 1967, 98, Pl. LXVI, 3; Matthiae 1984b, 118-19). However, this specimen has already been attributed (Peltenburg 1971, 8; 1977, 187-88) to a unitarian typology, which dates from the period between the middle of the second millennium (Barag 1970, 188), seventeenth-sixteenth centuries (Kühne 1969, 307-309). This production is apparently a local one, although it is different from the contemporary Syrian production of clay figurines, which have schematic and geometric features. It is therefore quite likely that it descends not from local but perhaps from Mesopotamian models; in fact the contemporary Mesopotamian production of glass pendants corresponds perfectly with the local Mesopotamian production of clay figurines, of which it is only a luxury type.

A miniature bowl

Lastly, we will mention a miniature bowl (TM.74.G.151), which was found in an Iron Age level (Fig. 6).[6] This may be a late example of the bowls with duckbill handles which spread over Syria around the Middle Bronze II. A faience specimen from Ugarit (Schaeffer 1938, 241, Pl. XXII, 2; Kohlmeyer 1982, 142 No 133; Caubet 1984, 172, No 194; Mazzoni 1985, 261 No 151), with a long arm-shaped handle which ends with a duck head and a hand which holds the cup, dates from the end of the seventeenth and the beginning of the sixteenth centuries. Rightly enough, because of its technique, it was compared with the Eblaic hathoric vase, which is basically contemporary with it, whereas the typology descends from the duck-shaped Egyptian bowls. We wish to recall here that during Middle Bronze II the clay bowls with bird/duckbill handles are quite common at Byblos (Montet 1928, 244, No 912, Pl. CXLVI; Dunand 1954, 1958, 565, No 12978, Fig. 652 for example) whereas the wooden bowls with duck wings appear in the Jericho tombs (Kenyon 1960; Figs. 127, 202; 1964, Figs. 110, 172, 10; 187, 208, 242) which are a simplified version of blue marble Egyptian bowls of the 'ducks with spread wings' type (Terrace 1966, 61-62, Pl. XXV, 29-31, Type II). The majority of these bowls were found in funerary contexts, as at Jericho, as was the faience specimen from Ugarit. This could lead us to believe that during this period in Syria and Palestine they adopted not only the typology but also the symbology of regeneration, which in Egypt was associated with this fowl, because of its migratory habits (Herrman 1932, 86-105; Hornung 1976, 137).

Conclusion

In conclusion, these objects are evidence for a Middle Bronze II production of Syrian faience. They are characterized by the same workmanship: they are handmade, the glaze is quite heavy, iridescent, greenish-white, or light blue in colour, paint is quite rare and used only for some simple decorations in a blackish-grey colour. The technique of molding is not documented. Glass is evidently used in those cases when the imitation of the Mesopotamian models is quite strong.

The objects belong to several genres, including animal figures, rhyta, amulets, and miniature vases. The Egyptian tradition is apparently responsible for the formation of this varied repertory, which was not mass produced, nor were too many specimens produced, at least if we judge that the sporadic nature of the evidence during this period is real and not casual. Apparently the Egyptian experience, which concurred in the formation of the genres and probably of the techniques, did not have great influence. In fact a local style is always adopted, both in the animal and in the human figures; even in the vases with the hathoric head the Egyptian influence is not direct but indirect. As we have already pointed out, in Egypt there were some vases with applied hathoric masks, or with painted faces, and not true hathoric plastic vases, which are found in Syria.

Lastly, we propose three more reflections about the genres of these few objects. In the first place, faience production certainly did not spread over Syria during this period, as it did in the Late Bronze Age; mass production was never achieved and so it is possible to note - as a probable consequence of this circumstance - that there are some differences in the realization even of similar categories. In the second place, although this producton is quite limited, it certainly marks the starting point for the better known productions of the Late Bronze Age, which have quite a few similarities to, and often the same repertories as, the contemporary Mesopotamian and Iranian productions. It has already been pointed out that the glass pendants of the Middle Bronze Age and the female masks of the thirteenth century BC (Peltenburg 1977, 185-86, 188) have a Babylonian genesis, or a Mesopotamian origin, and yet the Syrian production is quite unique and independent within this picture. In the light of our Middle Bronze II evidence, we might ask ourselves if this originality does not derive from a possible Syrian origin; in this case, Syria would have furnished the inspiration for many categories of faience which later spread to and were produced 'in loco' in Mesopotamia and in Iran. The only exception would concern the glass pendants, whose stylistic characteristics depend more on the Mesopotamian models. Finally, it is now difficult to believe that the contemporary presence of the female plastic vases, the bull figurines and the human shaped amulets from Syria to Assur to Tchoga Zanbil is a casual one. These objects, moreover, are found in all these sites along with the lotus-shaped bowls and with the masks, which are no longer enigmatic (Parrot 1969, 409-18; Peltenburg 1977, 177-92; Kühne 1974, 101-10) in often similar contexts in the period between the Middle and Late Bronze Age.

We would like to conclude with an observation about the continuity in technical progress between the two phases of the Middle Bronze II and the Late Bronze Age. Between these two periods, passage was made from the occasional to standard production with a large regional diffusion and entry into international trade. It is difficult to say whether or not this passage was due to technical improvement of faience production, and whether or not this improvement was influenced by the intensification of direct relations with Egypt. This might have been the case, particularly with

regard to faience productions of coastal Syria through the presence of Egyptian imports, which were certainly more numerous on the coast than inland. On the other hand, the internationalism of that period certainly contributed to the spread of products throughout the region, which has already been observed in the plastic vases and in the masks (Peltenburg 1977, 185, 187). This could be, however, a more complicated phenomenon, which might be more usefully studied in the light of the diffusion of rites related to a female deity, Ishtar, or Qudshu/'Anat, or Pinikir. Whichever interpretation we wish to give this phenomenon, it has not yet taken place in the Middle Bronze II in Syria. In fact, during this period in this region faience was a luxury, an exotic product, and it was apparently not yet linked to a repertory specialized according to genre and function.

Appendix

CHEMICAL ANALYSIS OF FAIENCE GLAZES FROM EBLA: MIDDLE BRONZE AGE II

Marco Verità and Lorenzo Lazzarini

Stazione Sperimentale del Vetro,
Murano, Venezia

Laboratorio Scientifico
della Soprintendenza ai Beni
Artistici e Storici di Venezia

Small samples (1-2mm^2) of glazes were removed from faience objects TM 74 E 331; TM 74 E 1036; TM 74 G 151; TM 78 Q 150 and TM 70 B 930 discussed by Mazzoni in the preceding paper. The glaze samples were embedded in polyester resin, cut, polished and examined with a stereo and polarizing microscope as well as with a wavelength dispersive x-ray spectrometer coupled to a scanning electron microscope, with the hope that information about their structure and chemical composition would yield clues to the location and method of their manufacture.

It was apparent from preliminary examination that most glazes exhibited a gray-greenish homogeneous appearance typical of devitrified glass. Sample TM 70 B 930, however, contained a few fragments of what appeared to be unaltered glass, blue-green in colour, and about 20-30μm^2 in thickness. The ceramic body of the samples had the glassy appearance of a sintered product, and only quartz and small quantities of iron oxides could be identified with reflected light. For examination with a wavelength dispersive x-ray spectrometer, samples of the faience were coated with a 15 nm coating of carbon. Measurements were taken using various standard glasses for quantitative comparison. The results of these quantitative analyses are presented in Table 1. Values on the right are those obtained from the fragments of blue-green glass in sample TM 70 B 930. On the left are mean values obtained for the other samples, all of which yielded similar analyses. From these data it may be deduced that the glaze now covering most of the objects is what is left after a nearly complete deterioration of the original glass. It is likely that this chemical alteration is largely due to the action of water, which leached alkaline components from the glazes and caused the formation of a stratified and weathered glass with an amorphous, opaque, and porous structure.

The composition of the glass fragments in sample TM 70 B 930, which were apparently protected from water by an internal position in the glaze near the ceramic body, is not that of a completely unaltered glass, however. It

is probable that the original composition of the glass has been modified by a reaction at the interface with the clay of the ceramic, taking up some silica and alumina. This is likely, considering that the rather high values for silica and alumina of the glazes would have made the melting of such a glass a practical impossibility for the technology available at that period.

It is possible, nonetheless, to deduce some interesting facts about the original composition of the glass from the data obtained. The glass was manufactured by melting a mixture of three materials, a vitrifying substance, probably a quartz-rich sand containing a certain amount of potassium feldspar; a flux, most likely a sodic ash obtained from the ignition of plant matter; and a pigment, a mixture of copper and iron oxides. Neither the sand nor the flux contained a sufficient percentage of calcium or magnesium oxides (which have a stabilizing effect on glass) to prevent its deterioration, and it is likely that the glaze started to opacify and corrode soon after the manufacture of the faience. Evidently only the portion of the glaze in contact with the ceramic body of the faience was sufficiently enriched in SiO_2 and Al_2O_3 to be preserved unaltered until now.

It is impossible, in any case, to establish the exact composition of the original glass used to glaze the faience. With respect to the altered composition we have found it should have contained a higher proportion of alkalies Na_2O, K_2O and a smaller percentage of SiO_2 and Al_2O_3. Due to these variations in composition, we cannot make direct comparisons with other analyzed glasses. There is a certain similarity, however, between the glaze of sample TM 70 B 930 and some Egyptian glasses, analyses of which can be found in Besborodov 1975, p.254.

Table 1. Microanalysis of Glazes on Faience from Ebla

	Altered glasses Average composition	Unaltered glass Sample TM 70 B 930
SiO_2	90.0	69.0
Al_2O_3	4.40	4.50
Na_2O	0.20	9.50
K_2O	1.70	5.60
CaO	0.60	3.80
MgO	0.35	0.95
MnO	0.00	0.02
TiO_2	0.16	0.35
P_2O_5	0.02	0.13
SO_3	0.30	0.22
PbO	0.00	0.00
B_2O_3	0.00	0.00
Cl	0.05	0.55
BaO	0.00	0.00
Fe_2O_3	1.80	2.60
CuO	0.50	2.80

Notes

1. TM.70.B.930, Square DhIV8ii, Sector B, Lev.4, L.1556. H. 7cm; mouth 5 x 5.5cm; H.face 6.4cm; Width face 7cm.
2. TM.74.E.331, Square EgVI3iii, Sector E, Lev.7, L.748, near South wall. H.2.8cm; Width 2.6cm; thickness 1.9cm (base).
3. TM.78.Q.150, Square DeV9i, Sector Q, Lev.5, L.2975, on the 2nd step of the staircase. H.3.4cm; length 6cm; depth 2cm.
4. TM.75.G.257, Squares Di4i + DlV4iv, Sector G, Lev. 5, L.2762. H. 8cm; mouth 2.7/1.1cm.
5. TM.66.E.197, Square EhVI5, Sector E, under Locus g, over L.152 and M.147. H.4.5cm; width 2cm; depth 1.5cm.
6. TM.74.G.151, Square EbV7iii, Sector G, Lev.4, from the removal of M.2584 and M.2583. H.3.5cm; diam. mouth 7cm; diam. body 7.5cm; handle 1.5cm.

References

Andrae W (1935). Die jüngeren Ischtar-Tempel in Assur. Leipzig

Barag D (1970). Mesopotamian core-formed glass vessels (1500-500 B.C.). In Glass and Glassmaking in Ancient Mesopotamia, L A Oppenheim ed. Corning

Besborodov Ph (1975). Chemie und technologie der antiken und mittelalterliche Gläser, Von Zabern Verlag, Mainz 1975

Bossert H Th (1951). Altsyrien. Tübingen

Caubet A and Lagarce E (1972). Vases en faiences de Chypre. Report of the Department of Antiquities, Cyprus, 113-28

Caubet A, Karageorghis V and Yon M (1981). Les antiquités de Chypre. Age du Bronze. Paris

Caubet A (1984). In Au pays de Baal et d'Astarté, 1000 ans d'art en Syrie. Paris

Cooney J D (1953). Egyptian art in the collection of Albert Gallatin. Journal of Near Eastern Studies, 12, 1-19

Dajani A K (1962). Some of the industries of the Middle Bronze Period. Annual of the Department of Antiquities of Jordan 6-7, 55-75

Dunand M (1954,1958). Fouilles de Byblos II, 1933-1938. Paris

Frankfort H (1954). The art and the architecture of the ancient Orient. Harmondsworth

Fronzaroli P (1967). Il Settore E. In Missione archeologica in Siria. Rapporto preliminare sulla campagna 1966 (Tell Mardikh), P Matthiae ed., 79-110

Ghirshman R (1968). Tchoga Zanbil (Dur Untash), II. Temenos, Temples, Palais, Tombes. Paris

Herrman A (1932). Das Motiv der Ente mit zurückgewendeten Kopf im ägyptischen Kunstgewerbe. Zeitschrift für ägyptische Sprache und Altertumskunde 68, 86-105

Hornung E and Staehelin E (1976). Skaräbaen und andere Siegelamulete aus Basiler Sammlungen. Mainz

Kenyon K M (1960). Excavations at Jericho, I. The tombs excavated in 1952-54. London

Kenyon K M (1964). Excavations at Jericho, II. The tombs excavated in 1955-58. London

Kohlmeyer K (1982). In Land des Baal. Syrien-Forum der Völker und Kulturen, K Kohlmeyer and E Strommenger eds. Berlin

Kühne H (1969). Bemerkungen zu einigen Glasreliefs des 2. Jahrtausends v.Chr. aus Syrien und Palästina. Zeitschrift für Assyriologie und vorderasiatische Archäologie 59/NF 25, 299-318

Kühne H (1974). 'Rätselhafte Masken' - Zur Frage ihrer Herkunft und Deutung. Baghdader Mitteilungen 7, 101-10

Matthiae P (1975). Syrische Kunst. In Der Alte Orient, Propylaen Kunstgeschichte XIV, W Orthmann ed. Berlin

Matthiae P (1977). Ebla. Un impero ritrovato. Torino

Matthiae P (1980). Campagne de fouilles à Ebla en 1979, les tombes princières et le palais de la ville basse à l'époque amorrhéenne. Académie des Inscriptions et Belles Lettres, Comptes Rendus, 94-118

Matthiae P (1982). Die Fürstengräber des Palastes Q in Ebla. Antike Welt 13, 1-17

Matthiae P (1983). Fouilles de Tell Mardikh-Ebla en 1982, nouvelles recherches sur l'architecture palatine d'Ebla. Akadémie des Inscriptions et Belles Lettres, Comptes Rendus, 530-54

Matthiae P (1984a). New Discoveries at Ebla. The Excavation of the Western Palace and the Royal Necropolis of the Amorite Period. Biblical Archaeologist, 19-31

Matthiae P (1984b). I tesori di Ebla Roma

Mazzoni S (1979). Nota sull'evoluzione del costume paleosiriano. Egitto e Vicino Oriente II, 111-35

Mazzoni S (1979-80). Essai d'interprétation des vases plastiques dans la Syrie du Bronze Moyen et Récent. Annales Archéologiques Arabes Syriennes XXIX/XXX, 237-52

Mazzoni S (1980). Una statua reale paleosiriana del Cleveland Museum. Studi Eblaiti III, 79-98

Mazzoni S (1985). In Da Ebla a Damasco. 10.000 anni di storia e d'arte della Siria. Roma

Montet P (1928). Byblos et l'Egypte. Quatre campagnes de fouilles à Gebeil, 1921-24. Paris

Parrot A (1969). De la Méditerranée à l'Iran. Masques énigmatiques. In Ugaritica VI, Cl F A Schaeffer ed., 409-18. Paris

Peltenburg E (1971). Some early developments of vitreous materials. World Archaeology 3, 6-12

Peltenburg E (1977). A faience from Hala Sultan Tekke and second millennium B.C. Western Asiatic pendants depicting females. In Hala Sultan Tekke 3, 177-92. Göteborg

Pézard M (1931). Qadesh. Mission archéologique à Tell Nebi Mend 1921-22. Paris

Riefstahl E (1948). Glass and glazes from ancient Egypt. Brooklyn

Sagona C (1980). Middle Bronze faience vessels from Palestine. Zeitschrift des deutschen Palästina Vereins 96, 101-20

Schaeffer Cl F A (1938). Les fouilles de Ras Shamra-Ugarit. Neuvième campagne (Printemps 1937) Syria XIX, 195-255

Starr R F S (1939). Nuzi. Report on the Excavations at Yorgan Tepe, near Kirkuk, Iraq. Cambridge, Mass.

Terrace E B (1966). 'Blue Marble' plastic vessels and other figures Journal of the American Research Center in Egypt V, 57-63

MANUFACTURE OF AN EIGHTEENTH DYNASTY EGYPTIAN FAIENCE CHALICE

Pamela B Vandiver and W David Kingery
Ceramics and Glass Laboratory
Massachusetts Institute of Technology
Cambridge, Mass. 02139

Abstract

A description of the method of making a blue lotus chalice of Egyptian faience during the middle of the Eighteenth Dynasty is given. The complex sequence of manufacture required to produce this vessel is then interpreted within a framework of the development of faience technology in Egypt.

Keywords: FAIENCE, EGYPT, TECHNOLOGY, COMPOSITION, GLAZE, XERORADIOGRAPHY, MICROPROBE, SEM.

Introduction

During four thousand years to late Roman times, Egyptian faience was widely produced in the Near East and eastern Mediterranean region, and is still being made by bead and stone paste vessel-makers in Iran. Egyptian faience is important in the history of ceramics as the first 'contrived' non-clay body, developed as a white ground for the production of blue-green colours, probably in imitation of lapis lazuli and turquoise. In the arid environment of the Near East, blue and green are special colours which have long been considered as omens of good luck. The blue lotus chalice shown in Fig. 1 (Boston Museum of Fine Arts, No.1901.7396, gift of the Egyptian Exploration Fund) and another similar vessel were excavated from Tomb D115 at Abydos by D McIver and A Mace at the turn of the century (MacIver and Mace 1902). Both chalices have been dated by tomb pottery to the middle part of the Eighteenth Dynasty, between the reigns of Thutmosis III and Amenophis III (c.1504-1349 BC).

Analytical means are now available to determine internal structure, microstructure and composition, which result from specific manufacturing processes. When combined with a thorough investigation of the external characteristics of an object and of other stylistically and technologically similar objects, and when evaluated within the framework of replication studies, we can reconstruct the technology, the constraints and choices of raw materials, the essentials of manufacturing processes, as well as understand the technical solutions or principles underlying the visual impact of a particular object. In other words, we can understand what artisans were accomplishing on a microscopic scale and why certain aspects of the technology were necessary to produce a particular visual or tactile effect. We are attempting to use intensive analysis of a single object as a cultural marker to define faience technology in a particular spatio-temporal context as a guidepost to the content and level of technology representative of the best objects then being produced. Diverse studies of technological change and innovation localise the occurrence of variation as

events within at most one lifetime (Jolly 1972, Stapleton 1975). Thus analyses of single objects act as spatio-temporal guideposts from which one can infer a change has taken place. Such a reconstruction is limited in precision by the uncertain dating and context of some objects and by poor preservation which precludes analysis.

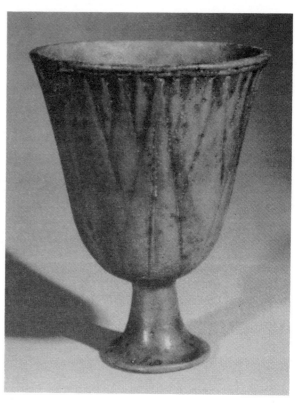

Fig. 1 Blue lotus chalice made of Egyptian faience during the Eighteenth Dynasty (1504-1149 B.C.). The 13 cm tall chalice is displayed at the Boston Museum of Fine Arts (No. 1901.7396, Gift of the Egyptian Exploration Fund).

Early history of Egyptian faience manufacture

The blue lotus chalice represents the culmination of a process of development for Egyptian faience which began in Egypt and Mesopotamia between about 4800 - 4000 BC. The earliest examples are beads and amulets which occur along with more numerous carved and glazed steatite or soapstone objects. Modelling of these early objects was followed by surface grinding in a manner similar to stone working methods. The manufacturing technique, as well as the similarity of form and colour, support the idea that these materials were first developed as substitutes for turquoise, lapis lazuli and malachite, stones rare in Egypt which were mostly imported. In the earliest examples there are variations in glaze thickness and preparation of body constituents. The process was widely used throughout the Near East, but most of the best preserved samples have been found in Egypt.

Often the objects in which Egyptian faience was a part required complex sequences of manufacture, but the production of faience in the Protodynastic and Old Kingdom periods was straightforward (Vandiver 1982, 1983). By the end of the Second Intermediate Period (1532 BC), faience manufacturing methods had been fully developed. During the New Kingdom, when this chalice was made, three basic methods were employed in diverse and elaborate sequences of manufacture to produce master works, often considered unusual in Egyptian art for their naturalistic style.

Egyptian faience was made by modelling or moulding a quartz-paste body of finely ground quartz or sand that is mixed together with minor amounts of lime and alkali, plus copper salts which give the blue-green colour. The alkali, natron, is a mixture of sodium carbonate, bicarbonate, chloride and

sulphate. The mixture of these raw materials with water is thixotropic - stiff at first, and then soft and flowing when it begins to be deformed. If deformed too rapidly, it cracks. Because of these flow properties faience bodies are difficult to shape by throwing on a wheel. Moulding, modelling and construction of complex forms from preformed elements are the chief methods of manufacture. During drying the soluble salts migrate to the surface. As the water evaporates, a layer of effloresced salts is deposited, as shown in Fig. 2. During firing these salts react with the quartz body to form the glaze layer. In areas where drying is more rapid, more salts are deposited so the glaze is thicker. Under the base and at the interior of cups where drying is slower, the glaze is thinner. This method of self-glazing by firing effloresced salts was the prime method of manufacture during the third millennium.

By the end of the Second Intermediate Period (1532 BC), Egyptian faience manufacture developed to become a more sophisticated craft. In addition to the efflorescence technique, glazes were formed by a cementation or slow roasting process. The quartz paste body was modelled, then upon drying, embedded in a special glazing powder (Fig. 2). The powder contained a high lime (CaO) content so that it remained solid at the firing temperature. Alkali and copper compounds in the powder migrate to the faience body and react with the surface to form a glaze. After cooling, the faience object is easily removed from the friable, porous glazing powder. The glaze thickness is fairly uniform over the entire body and the glaze shrinks away from the surrounding powder during firing. However, internal surfaces, concave areas and holes have little glaze. This same process was used to manufacture some of the semi-spherical beads from Abydos, Tomb E3, and according to Kieffer and Allibert (1971) the hippopotamus from Meir, dated to about 1971-1892 BC. No examples of this process from the Old Kingdom have been found. This same process is still used in manufacturing the bright blue donkey beads made at Qom, Iran (Wulff et al., 1968).

A third method of forming a glaze surface was to frit or melt the glaze constituents to form a glass, milling this glass to prepare a fine powder dispersed as a slurry in water which could be added to the paste to make a wide variety of bright colours or applied to the surface by dipping or painting (Fig. 2). When this method was used one sometimes sees drips or runs or a thick rim at the base of the glaze. Examples of this method of glazing have been found in many Kerma tiles, dating to the Second Intermediate Period (1640-1532 BC).

Thus by the beginning of the New Kingdom there were three quite different ways to form a glaze, each of which we have replicated in the laboratory and analysed many times. One of these methods involved forming the glaze as a prefritted glass, although from the archaeological record no glass industry was evident in Egypt before the mid-Eighteenth Dynasty, and the earliest datable glass vessel is inscribed with the cartouche of Thutmosis III.

Manufacture of the chalice

Egyptian faience chalices emerge at the beginning of the Eighteenth Dynasty with little or no apparent development. E Brovarski has suggested a probable sequence of stylistic development from thick-walled, short-stemmed, wide-mouthed vessels to slender, trumpet-shaped forms with elaborate relief decoration (Brovarski and Jones 1982). The relief appears first in the form of a lotus with possible associations with the goddess Hathor and the symbolism of rebirth. Later the relief decoration consists of bands at the rim with narrative scenes and the chalices, perhaps, were used as drinking vessels. The Museum of Fine Arts chalice shown in Fig. 1 is midway in this development. The lotus petals and leaves are cut back in

low relief and subtly modelled. The cup is more elaborately conceived and finely worked than earlier examples.

Fig. 2

Three different methods were used to form a glaze on Egyptian faience. (a) The first method was to incorporate soluble salts in the mixing water or body composition. As the water moved to the surface and evaporated, these salts deposited as an effloresced layer. (b) Some ware used a pre-fritted glass which was ground for use as a glaze. This finely ground glass was added to water to form a slurry and applied by painting or dipping. (c) A third method was to embed and fire the quartz body in a special glazing powder. Glaze constituents migrated to and reacted with the quartz surface.

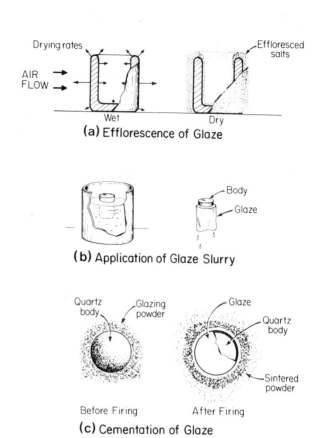

The blue lotus chalice was shaped in two sections. The upper cup was shaped in a concave mould probably made of porous, fired earthenware. The base may have been made in a similar mould or more likely formed around a rod as a cylinder and then flaired open at one end. After moulding, the two parts of the chalice were removed from the moulds before shrinkage occurred and joined together with a small amount of quartz-alkali paste. In order to strengthen the joint, a plug of the body material was inserted inside the foot as shown in the xero-radiograph in Fig. 3, and a coil was placed outside the base where the cylinder joins the cup. The join lines of this coil can be seen with a low-power microscope. The cup and base had to be joined together when they were still damp or cracks from unequal shrinkage of the two parts would have developed at the join. However, when damp, the ware does not have much strength, and the cup was joined to the base slightly off-centre so that when the chalice was set aside to dry, the cup tilted towards the side with least support, and is not perfectly symmetrical (Fig. 4). Once the cup was dry enough to be handled without changing shape, the relief decoration was incised on the surface and the space between the petals and upper border cut back or scraped away to form the beautifully symmetrical lotus design shown in Fig. 4. There are five sepals, or leaves, and thirty five petals incised and carved in low relief on the chalice. The blue lotus actually has four green sepals and twelve to sixteen petals, so a certain amount of artistic license was exercised.

Carving and incising this pattern eliminated the effloresced layer from the surface, so a special technique was employed to add an effloresced salt layer sufficient to form a glaze during firing. When almost dry, the chalice was dipped in a slurry prepared from a finely ground mixture of milled white quartz and alkali to build up a layer of about 0.5 mm thick on the surface. The slurry contained soluble alkali, lime and copper in solution which migrated to the surface and formed an efflorescent layer

during drying. The interior of the body is a greyish brown tint resulting from iron impurities and is coated with a fine white quartz layer and glaze. The internal surface of the cup and the inside of the base had a much slower rate of drying than the external surfaces. As a result, the glaze layer is thinner on these surfaces, particularly inside the base.

However, inside, about two-thirds of the way from the bottom of the cup and inside the base, the glaze ends in a slightly thickened rim which would be unexpected with the efflorescent process. The white alkali-rich efflorescing layer was applied by dipping the chalice into a slurry; first one end and then the other. The slurry did not reach all the way to the bottom of the bowl or foot during dipping. (The greyish body colour seems to go all the way to the surface where no white layer was added; however, there is some iron-staining of the surface and discolouration from the accumulation of clay and dirt in the porous areas of exposed body).

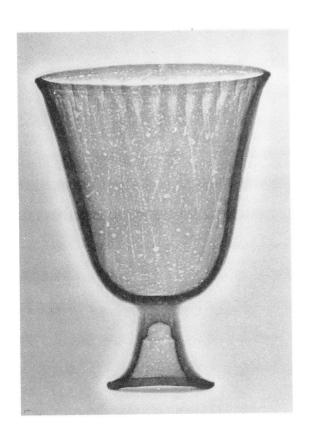

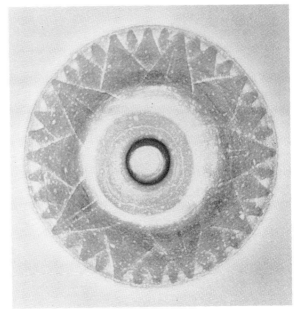

Fig. 3 Xero-radiograph of the chalice seen from the side. Material added inside the base to strengthen the join can be seen along with the porosity resulting from low moulding pressures.

Fig. 4 Xero-radiograph of the chalice from above gives a special view of the beautifully symmetrical lotus pattern formed by incising and scraping the dry ware. The inner dark circle is the join, surrounded by the base and the outer circle is the cup. The cup is tilted to the upper right.

There is a thicker ridge of slurry and some slurry drips at the level where the dipped layer ended on the interior of both bowl and foot. There are horizontal facets near the interior of the lip and the foot where excess slurry was removed and the surface layer smoothed. Once the slurry stiffened and began to dry the leaves, petals and sepal spines were outlined with shallow grooves, and the bands at the top and bottom of the cup reworked.

A relatively thick slurry was necessary to form the white quartz-alkali layer. When the chalice was dipped into the slurry, bubbles formed between the slurry and body along some of the incised decoration. During reworking and drying a thin surface layer of salts effloresced, and during firing the alkali-lime-silicate glass which formed did not spread out to wet the underlying body, as lead glazes do or alkaline glazes fired at a higher temperature. As a result, the glaze has crawled at the sepal spines, edges of the petals, and in many areas of flat surface, leaving residual holes. This glaze defect is fairly common in faience objects, and is an external indication of the time and temperature firing envelope.

The manufacture of the blue lotus chalice involved a more lengthy and complex process requiring a greater number of steps and a greater degree of precision than found in the manufacture of objects from earlier periods. The body was moulded, joined and carved; the glaze is formed by a combination of efflorescence and application methods. This sequence required relatively tight control of the moisture content of the vessel. For instance, if the two moulded parts had been too dry the join would have cracked. If the join or vessel had been too wet when the slurry layer was applied, warping and flow cracks would have resulted. If the vessel had been too dry, the slurry would have delaminated on drying. If the body had been too dry during incising, the fine detail would have been lost because the body tends to powder and break down. Thus, there was not only a complex manufacturing sequence, but the necessity of carrying out certain operations at various stages of drying which demanded mastery of the process as well as the artisan's conceptual sophistication in the complexity of design and degree of risk in execution he was willing to undertake.

Internal structure

The internal structure of the chalice reinforces the sequence of manufacture reconstructed from external characteristics. The microstructure in Fig.5, taken at 300x as a backscattered SEM composite shows jagged, angular quartz particles measuring about 10-200 μm (0.01-0.2mm). These angular particles were probably ground, but perhaps they were taken from a recently weathered sediment. The interior body colour is actually a greyish white from the iron impurity in the sand. A white surface layer of a slightly finer particle size appears between the inner body and glaze. The glaze extends about half way into the intermediate layer. Tite, Bimson and Freestone (1983) have established that the efflorescence technique leads to a relatively sharp demarcation of the glaze just below the body and some residual glass at the contact points of the quartz particles in the body, whereas in the cementation technique the body has less glass and is more friable and the glaze tends to sink into the body leaving a large interaction zone. The chalice body has a small amount of, but sufficient glass in the body for coherence (Fig. 6) but a thicker interaction zone than reported for the efflorescence technique. The thicker interaction zone is probably caused by a higher concentration of alkali in the applied white surface layer and by a slower drying rate in our sample which was taken from the base of the cup.

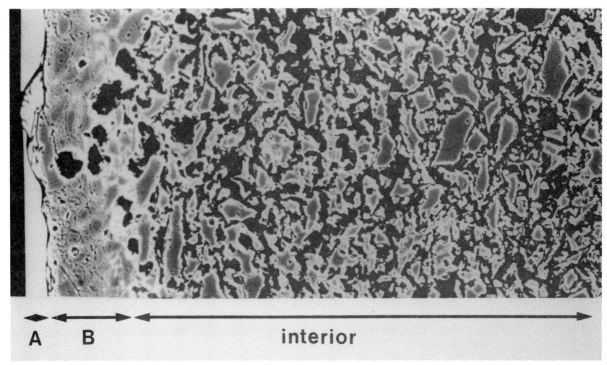

Fig. 5 The microstructure of the body interior, fine white powdered quartz layer (B) and glaze (A) illustrates how a small fraction of liquid silicate formed at the firing temperature bonds the quartz particles together. Salts deposited on the surface form the glaze.

Fig. 6 Microstructure of white quartz layer showing the glass envelope which coheres the angular quartz particles together and acts as a high viscosity bonding material. Scale bar = 10 μm.

From the coarse particle size of the quartz in the body, a limited range of workability is apparent as a given constraint of the raw material. The gritty paste is difficult to work, and can range in texture and formability from modern toothpaste to wet beach sand. The microstructure in Fig. 5 shows a network of cracks, especially noticeable at the bottom, which isolate volumes of about 0.3-0.5mm in size. These cracks are the result of pressing the paste into the mould. This sample was taken at the edge of a chip in the base of the cup of a second similar chalice from the same tomb. The upper glazed surface is the exterior of the cup. A diamond core drill stopped just short of the white quartz layer on the internal surface, so that an almost complete cross section is shown. The body material on the interior is more tightly packed. This tighter packing is the result of force applied from the interior of the paste during moulding.

Looking at the cross section in Fig. 5, the bright blue glaze is transparent although some cracks from weathering are apparent near the centre. However, looking directly at right angles to the surface of the chalice, the visual impact is that of a glaze which appears soft and translucent in texture and mottled with small white inclusions. A 10x magnifying glass reveals that there are quartz particles dispersed in a transition region at the interface with the underlying white ground although the surface of the glaze is smooth and the glaze is transparent. These coarse quartz particles act as a rough white background to scatter the incoming light, giving a soft diffuse reflectance to the glaze, a characteristic usually not achieved in modern reproductions of Egyptian faience.

Using the small two millimetre-sized sample taken from a chip in a second chalice found in the same tomb at Abydos (B.M.F.A. 1901.7397), we report the compositions given in Table 1. For the glaze and interparticle glass, electron beam microprobe analysis in a wavelength dispersive mode was employed, and concentrations were corrected for differential matrix effects using the technique of Bence and Albee (1968). The beam was rastered over a 16μm square to try to avoid problems with alkali loss. The sodium concentration decreased exponentially after the first 20% of counting time, unless the stage was slowly traversed beneath the beam at a rate sufficient to maximise the number of counts. The overall body and white quartz layer compositions were obtained using the same Cameca MBX in energy dispersive mode and curve fitting using the chi-square technique and the same geological standards. The slightly higher than expected silica content is caused by weathering of the glaze, the prime factor causing alkali loss and which prevented firing temperature determination by reheating of the sample. The composition was sampled by analysing from the exterior to the interior of the sample by zigzagging in contiguous jumps of 10 to 25 μm normal to the surface of the cross section. No concentration gradients or diffusion profiles were encountered in this analysis.

The glaze composition consists of a reaction between alkali, lime and copper at the firing temperature of about 900°C. We estimate this to be the firing temperature because the glaze is relatively viscous, as shown in Fig. 6 by the coalescence of fine quartz particles in the interparticle glass and by the presence of crawling shown in Fig. 7. The glaze would be much more fluid and run at 1000°C. The glaze is, however, more homogeneous than would be expected of the same composition fired to 800°C. The body analysis shows that almost pure quartz is present with about a half percent of iron oxide, but without a clay addition. The iron content in the glaze and glassy phase in the white quartz layer is variable, but does not vary with SiO_2 or CuO and thus may have been introduced with other raw materials, or may be the result of iron staining of the sample during burial, especially in the porous white quartz layer. The MgO+CaO total is much less than often reported whereas the CuO total is higher.

Table 1. Chemical compositions of the blue glaze layer, glassy phase in the white quartz layer, overall of the white quartz layer and of the interior of the body in weight percent.

	Glaze	Glassy Phase	White Quartz Layer	Interior of Body
	Mean and Range of 7	Mean and Range of 4	Mean and Range of 5	Mean and Range of 5
SiO_2	77.60 (73.80-079.70)	80.36 (77.00-082.32)	94.04 (92.50-095.39)	94.90 (97.50-099.50)
Al_2O_3	0.48 (00.26-000.91)	0.64 (00.30-001.16)	0.44 (00.21-000.60)	0.04 (00.02-000.06
TiO_2	0.03 (00.00-000.06)	0.04 (00.00-000.11)	0.04 (00.03-000.05)	BDL
CaO	1.36 (00.99-001.85)	1.68 (00.98-002.54)	0.47 (00.32-000.65)	0.40 (00.33-000.54)
MgO	0.13 (00.05-000.27)	0.29 (00.08-000.42)	0.07 (00.06-000.08)	BDL
Na_2O	9.71 (00.05-009.71)*	10.79 (00.37-010.79)	0.25 (00.23-000.28)	BDL
K_2O	0.27 (00.16-000.83)	0.51 (00.16-001.45)	0.11 (00.08-000.16)	BDL
CuO	7.68 (06.18-010.98)	4.78 (04.37-005.24)	2.09 (01.08-002.71)	BDL
FeO	0.44 (00.12-001.17)	1.03 (00.40-001.87)	0.40 (00.29-000.51)	0.50 (00.31-001.02)
P_2O_5	0.19 (00.07-000.39)	0.12 (00.06-000.18)	0.07 (00.04-000.10)	BDL
Cl	1.40 (00.07-000.39)	1.07 (00.54-001.93)	0.21 (00.09-000.37)	BDL
SO_3	0.43 (00.38-000.56)	0.22 (00.06-000.47)	0.15 (00.08-000.22)	BDL
PbO	0.08 (00.06-000.09)	0.05 (00.00-000.08)	BDL	BDL
SnO_2	0.16 (00.05-000.31)	BDL**	0.11 (00.07-000.17)	BDL
BaO	0.05 (00.00-000.06)	BDL	BDL	BDL
Total	100.01 (90.18-100.01)	101.58 (90.32-100.02)	98.45 (97.13-100.11)	99.44 (98.01-100.01)

Notes *Maximum Value Reported
**BDL = Below Detection Limit of a few parts per hundred; Cr_2O_3 and CoO were found to be below the detection limit in all cases

There is very little tin oxide, and thus the copper was not introduced as bronze firescale; malachite is a more probable source. The sodium and potassium values are suspect because of the alkali volatilisation problem in ancient glasses. Sodium is reported as the maximum value measured; whereas, for potassium, because it is present in a trace concentration, the average value is reported. Because of the high chloride and sulphate concentrations relative to sodium, the source of the major flux was probably natron, the well-known mixture of sodium carbonate, bicarbonate, chloride, and sulphate used in embalming. The silica content in the glassy phase of the white quartz layer is higher than expected. We suspect that fine quartz particles were present in the sampling volume beneath the surface. This sampling volume may range from 3-5 μm in depth. Chromium and cobalt were also analysed and found to be below detection limits of a few hundredths of a percent. The overall glaze composition is about 77% SiO_2, 11% alkali ($Na_2O + K_2O$), 2% alkaline earth (CaO + MgO), 8% CuO + Cu_2O, 1% Cl and about 1% other constituents. The bonding material that forms lenses between quartz particles and holds the body together has about the same composition as the glaze. The body consists primarily of ground quartz without a sand or feldspar addition.

The phase equilibrium diagram for the soda-lime-silica system shows the expected composition of liquid glass in equilibrium with quartz at the estimated firing temperature (Fig. 8), modified but probably not drastically changed by the CuO and Cu_2O present. The silica content of the liquid is about 75 weight % at 900°C and if cooled fairly rapidly in the common Near Eastern updraft kilns with separate firebox and firing chamber, would form a glass. Slower cooling would result in precipitation of the crystalline phase devitrite which is not found in faience. A higher temperature combined with slower cooling might result in the presence of cristobalite or tridymite, phases rarely found in faience. The amount of silica in the interparticle glass provides a limit on the firing temperature which might have been reached. If the glass contained no lime or copper, it would be soluble in hot water - similar to sodium-silicate water glass. As a result, the lime and copper content are critical for satisfactory corrosion resistance. The reactions predicted in the phase diagram act as a corroboration of the chemical analyses.

Fig. 7 During the relatively low temperature firing the viscous alkaline glaze saturated with silica does not spread out to wet the underlying body. As a result, "crawling" of the glaze is a fairly common faience defect. Separated quartz particles at the interface of the glaze and underlying white layer can be distinguished. They give the glaze a translucent appearance.

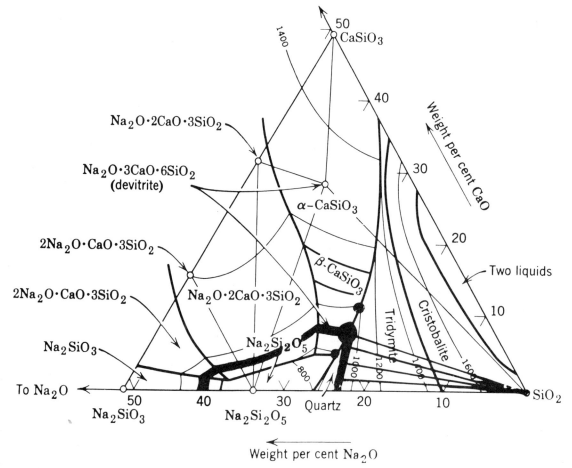

Fig. 8 The phase equilibria diagram for the Na_2O-CaO-SiO_2 system shows the liquid phase in equilibrium with quartz at the firing temperature of 900°C. The SiO_2 content of the liquid which cools to form a glass is about 75 weight %.

Discussion and conclusions

The brown, iron-containing sedimentary clays of Egypt, often referred to as Nile mud, are easy to shape, form and fire into a satisfactory earthenware. On such a body a transparent alkaline copper glaze has a muddy colour; even more important, the alkaline glaze has a high contraction on cooling which could cause it to delaminate or spall from the underlying earthenware after firing at low temperature. The quartz paste Egyptian faience body, which is white in colour and has a high contraction on cooling, was a quite remarkable technical solution to the problem of achieving a brilliant blue-green equivalent of turquoise, lapis lazuli and malachite. The ability to model and mould a variety of sizes, shapes and colours was obviously attractive since the technology spread throughout the Near Eastern and Mediterranean world. The uses of faience multiplied early in the development of the Egyptian state. However, the limited workability meant that modelling and moulding rather than throwing were the prime methods of manufacture. The quartz body was the forerunner of Islamic quartz-frit-clay porcelain, Medici porcelain and French soft-paste porcelain.

Other studies (Vandiver 1982, 1983) have shown that after an initial and technologically complex period of experimentation during predynastic times (c.4800-3050 BC) in which stone working methods were used to form Egyptian faience beads and amulets, the efflorescence method of glazing was adopted and became a conservative technological tradition during the third millennium. There are no objects from these periods with all-over glazes or variations in glaze thickness which cannot be related to the drying of an effloresced coating. During the Middle Kingdom, at least as early as the reign of Senwosret I (1971-1928 BC), the cementation method of glazing was used. Some pieces of Egyptian faience are glazed all over without variation in thickness. The objects tend to be simple shapes, made quite directly without the complex sequence of manufacturing steps found in the chalice described above. In the New Kingdom, a greater diversity of shapes is made, the fritting of glazes and their application as slurries is practised, and the body material is mixed with powdered coloured glasses in order to produce a wide variety of colours. Many of these second millennium objects represent tour de force craftsmanship, and they rise above the common level of craftsmanship as artistic and technical masterworks. The goblet, shown in Fig. 1, was made at an expansive time in Egyptian history when power and wealth were at a high point. We would like to suggest, in contrast to the conservatism which characterises the third millennium faience technology, that during much of the second millennium Egyptian faience held high value as an art material and that faience makers held positions of esteem to judge by the richness of grave goods found in the burial of a chief of faience workers at Lisht (personal communication, J Bourriau), that the possibilities for a variety of visual effects were investigated and exploited, that there was a high level of artistic achievement, and that a new spirit of technological ferment was present as new technological solutions to making and firing large quantities of multi-coloured jewellery, tiles, inlays and vessels were perfected. The object described in this paper serves as a guidepost to this technological and artistic ferment.

Acknowledgements

We would like to thank the staff of the Department of Egyptian and Ancient Near Eastern Art at the Boston Museum of Fine Arts for helping us with the examination of the chalice, and for allowing us to sample a chipped area in the similar chalice from the same tomb at Abydos. We would like to express our gratitude to Prof. William Kelly Simpson, Curator; Dr Edward Brovarski, Assistant Curator, and especially to Peter Lacovara, Departmental Assistant.

References

Bence A E and Albee A L (1968). Empirical correction factors for the electron microanalysis of silicates and oxides. Journal of Geology 76, 382-403

Brovarski E and Millward Jones A (1982). Faience vessels. In Egypt's Golden Age: The art of living in the New Kingdom, 1558-1085 BC, 140-151. Boston, Museum of Fine Arts

Jolly A (1972). The evolution of primate behaviour. MacMillan

Keifer C and Allibert A (1971). Pharoanic Blue ceramics: The process of self-glazing. Archaeology 24, 107-117

Kingery W D and Vandiver P (1986). Ceramic masterpieces: art, structure, technology. New York, Macmillan Free Press

MacIver D and Mace A (1902). El Amrah and Abydos, 1899-1901. London

Stapleton D H (1975). The transfer of technology to the United States in the nineteenth century, Ph.D. Thesis, University of Delaware

Tite M S, Freestone I C and Bimson M (1983) Egyptian faience: An investigation of the methods of production. Archaeometry 25, 17-27

Vandiver P (1982). Technological change in Egyptian faience. In Archaeological ceramics, J S Olin and A D Franklin, eds., 167-179. Smithsonian Institution Press

Vandiver P (1983). Egyptian faience manufacture. In Ancient Egyptian Faience, A Kaczmarczyk and R E M Hedges. Warminster, Aris and Phillips

Vandiver P (1987). Egyptian faience: the first high-tec ceramic. In Ceramics and civilization, Vol.III, W D Kingery, ed., Columbus, Ohio, American Ceramics Society

Wulff H E, Wulff H S and Koch L (1986). Egyptian faience: A possible survival in Iran. Archaeology 21, 98-107

SILICATE INDUSTRIES OF LATE BRONZE-EARLY IRON PALESTINE: TECHNOLOGICAL INTERACTION BETWEEN EGYPT AND THE LEVANT

P E McGovern

Museum Applied Science Center for Archaeology
University Museum
University of Pennsylvania
Philadelphia, PA 19104

Abstract

The study is based on the largest silicate collections of the Late Bronze Age from well-dated excavations east and west of the Jordan River - the Baq'ah Valley on the Transjordanian plateau, and Beth Shan at the juncture of the Jezreel and Jordan Valleys. Samples were studied under low and high powder (SEM) magnification to characterize the materials and their state of preservation. Extensive multivariate evaluation by correlation, factor, and cluster analysis of compositonal data for the glazes and glasses, obtained by proton-induced x-ray emission (PIXE) spectroscopy, revealed very little overlap between the two groups. Elevated levels of transition metal colourants and opacifiers were used primarily for highly vitrified frits, in addition to glass, in the Baq'ah. At Beth Shan, lesser amounts of these metals were employed in different combinations and sometimes with different trace and minor element profiles, which implied a separate Syro-Palestinian glass/frit tradition. At the latter site, Syro-Palestinian colourants were also applied as overglazes' on effloresced, low-fired faience bodies. Thus, two different technological traditions, the one at Beth Shan representing an accommodation to Egyptian practice, were attested within a distance of fifty kilometers.

Keywords: BAQ'AH VALLEY, BETH SHAN, COLOURANTS, EGYPT, FAIENCE, FRIT, GLASS, GLAZE, OPACIFIERS, PALESTINE, PIXE, SEM, SILICATE TECHNOLOGY, SYRIA, TRANSITION METALS

Introduction

Palestine, comprising modern-day Israel and Jordan, lies on the southern periphery of the greater Syro-Palestine region. Previous studies of silicate collections from sites to the north, in particular Nuzi (Vandiver 1982), have demonstrated that experimentation in glass and frit began at least by 1600 BC, near the end of the Middle Bronze Age (cf.Oppenheim *et al.* 1970). Particularly noteworthy about this experimentation was the variety of metal colourants and opacifiers used.

Archaeological investigation in Palestine has revealed that the country participated fully in the Middle Bronze-Late Bronze Age urban civilization (Gerstenblith 1983, Drower 1973; for Jordan, see McGovern 1986a). In addition, the availability of some of the metal ores for colourants there, such as iron (Coughenour 1976), copper (Conrad and Rothenberg 1980), and manganese (Bender 1974), some of which were being exploited contemporaneously, strongly suggests that this area would have contributed directly to the innovations in metallurgical and silicate technology. Deposits of other necessary raw materials for silicate production - silica sand and sandstone, alkali salts, and lime - are widely distributed throughout the country.

Besides serving as a monitor for developments in the glass/frit industry, the Palestinian evidence is also potentially of great value as a touchstone for changes in the traditional Egyptian faience industry as the latter came in contact with and was affected by Syro-Palestinian innovations. The Egyptian industry, which initially developed in the Chalcolithic period, remained highly conservative over the next two millennia (Kaczmarczyk and Hedges 1983). Egypt began to interact again significantly with the Levant around 1750 BC with the rise of the Semitic 'Hyksos' dynasties in the Nile Delta, whose material culture was virtually indistinguishable from that of Palestine. Under these circumstances, Palestine would be a natural trading partner with Egypt for raw materials and finished products. Following the return of native Egyptians to power ca. 1550 BC (the beginning of the Late Bronze Age), Palestine played a more subservient role to Egypt as a forward defensive position and erstwhile client state (Weinstein 1981), but this relationship might well have intensified Egyptian contacts. Correspondingly, the New Kingdom faience industry in Egypt proper now evidenced improvisation, particularly in the use of colourants and opacifiers.

Palestinian reference collections

The silicate collections of two Palestinian sites - Beth Shan and the Baq'ah Valey of Jordan (Fig.1) - were studied, in order to elucidate the technological innovation and interaction between different industries in the Late Bronze and Early Iron Ages (ca. 1550-1050 BC).

Beth Shan, which was excavated by the University Museum between 1921 and 1934 (Rowe 1930 and 1940), is one of the most important sites of the period. The massive tell is strategically situated at the juncture of the Jezreel and Jordan valleys at the eastern terminus of the *Via Maris*, the main overland route between Egypt and the Near East. After crossing the shallow fords of the Jordan River here, roads branched off to Damascus and Amman. In recognition of its crucial location, the Egyptians chose Beth Shan as their northernmost frontier post. By 1300 BC, the site had been laid out along Egyptian architectural lines with a temple, 'commandant's house', and fortress (James and McGovern 1986).

The temple and its deposits illustrate how Egyptian and Syro-Palestinian artistic and technological traditions might be blended together at such a border site. The architectural layout of the building - a columned, open forecourt with stairs leading up to a sanctuary (Rowe 1940, pl.4, fig.3) - was very similar to the River Valley shrines at el-Amarna, Akhenaten's capital along the Middle Nile. The temple was very likely jointly dedicated to a female Syro-Palestinian deity (Ashtarte) and Hathor, the Egyptian goddess of turquoise and foreign countries, both of whom are depicted on artifacts from the building.

For the purposes of this study, the most important discovery from the temple was the more than 10,000 beads and 400 pendants in glass, faience, and frit (Fig.2), in addition to vessels of glass, glazed pottery, and faience (McGovern 1986b). Altogether, they represent the largest silicate collection in Late Bronze Age Palestine.

The Beth Shan group, however, lacked well-dated materials for the Late Bronze I period (ca. 1550-1400 BC). This gap was filled by the Baq'ah Valley collection, which also provided Late Bronze II (ca. 1400-1200 BC) and Iron IA (ca. 1200-1050 BC) material. The Baq'ah Valley, a well-watered, fertile depression twenty kilometers northwest of Amman, was one of the more intensively settled areas of Jordan (McGovern 1985a). The main north-south route of antiquity, the King's Highway, probably ran through the center of the valley, with side roads descending through the Wadi Umm ad-Danānīr to the Jordan Valley.

The Baq'ah collection was recovered from burial caves on the northwestern sides of the valley (McGovern 1986a). The corpus is smaller than that of Beth Shan - approximately three hundred beads and pendants for the Late Bronze Age and ten examples for the period after 1200 BC, when the silicate industry apparently fell into decline. Still, it is the largest group thus far excavated in Jordan, and from an area that was influenced minimally by Egypt and thus is an excellent complement of the Beth Shan collection.

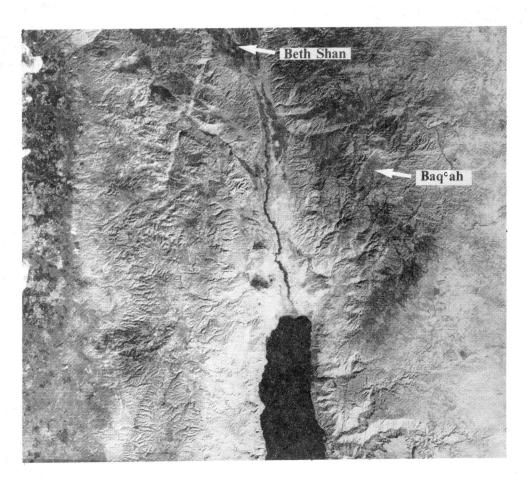

Fig. 1 LANDSAT Satellite photograph from an altitude of 900km. The Dead Sea appears at the bottom, and the Mediterranean is just visible to the left. The Baq'ah stands out as a flat elliptical area, a unique geomorphological feature on the central Transjordanian plateau at the intersection of three flexures in the earth's crust.

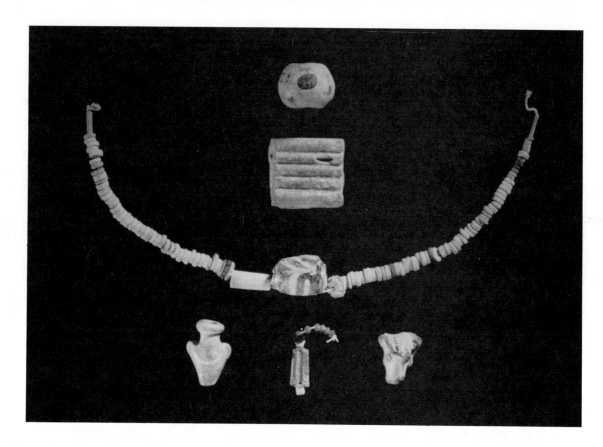

Fig. 2 Representative examples of beads and pendants from the Beth Shan collection. At the bottom, from left to right, are shown an ib ('heart') pendant (YELLOW1 and WHITE1), a pendant possibly depicting reeds (BLUE3), and a ram's head pendant (WHITE3, WHITE4, BROWN2, and SILVER1). In the middle of the string of beads is a large barrel-shaped bead with a feather or ogee pattern in antimonate white (WHITE10), and whose base glass is coloured with a silver colloid (SILVER3 and SILVER4). Above a bead spacer, an eye bead is shown at the top; the brown (BRO-1X7) and white (WHI-1X13) eyes are impressed into a blue-green (B/GR-1X6) surface (black, BLA-1X3, on the interior).

Sampling and analytical techniques

Macroscopic and low-power microscopic examination allowed materials (glass, frit, faience, glassy faience) to be characterized preliminarily, fabrication techniques defined, larger inclusions noted, and the extent of weathering determined. Fifty-four Beth Shan (Table 1) and twenty-eight Baq'ah (Table 2) small artifacts (beads and pendants) were selected as being sufficiently intact and representative of the range of variation for further analysis. A definitive characterization of the materials, including their vitrification structures and inclusions, was then carried out using a scanning electron microscope (SEM) with an attached energy dispersive system (EDS) for semi-quantitative chemical determination. Both original surfaces and prepared cross-sections were examined.

More precise chemical determinations of glasses and glazes covering faience and frit was done by proton-induced x-ray emission spectroscopy (PIXE). Surfaces were ground down as much as a tenth of a millimeter with an alumina burr, to minimize surface weathering effects.

The PIXE system is well-suited to such an investigation: the beam can be reduced to 0.5mm, which is quite adequate for a material whose homogeneity has been checked independently; there is relatively little *Brehmstrahllung* background, especially as compared with electron or x-ray spectroscopy; since the beam penetrates only about 10-15 microns, the method is essentially non-destructive; finally, it is very time and cost efficient, since many elements can be measured simultaneously. Corning glass standard B (Brill 1972) was used for calibration. A 1.3 MeV proton beam in a helium atmosphere was used to measure the low atomic number elements. A 2.0 MeV beam in an air or nitrogen atmosphere, in conjunction with potassium chloride, vanadium, and aluminium filters, enabled the elements of higher atomic number to be measured with greater sensitivity (Swann 1982).

Twenty-five elements were typically measured, and the weight percentages were then normalized to a hundred percent. A beryllium window between the sample and the lithium-drifted silicon detector effectively blocked out the lower energy x-rays from elements with an atomic weight less than sodium. Since the latter is at the lower detection limit, several samples were retested by emission spectroscopy as a check; in these instances, the sodium contents were within the one-sigma experimental error of each method.

Experimental results

Sodium appears to have been the primary flux in all the samples (Tables 3 and 4). Nine to ten percent of the oxide was probably typical. Many of the samples, however, have lower sodium values, which is most likely the result of leaching out; otherwise, extremely high temperatures, beyond the pyrotechnological expertise of the period, would have been required to vitrify the silica.

Low potassium values presumably also reflect leaching effects. Thus, the Beth Shan specimens overall averaged 2.75% potassium oxide. Several Beth Shan examples (PURPLE1, BLA-1X2, GRAY3), however, retain as much as 7.26% suggesting the use of a plant ash as a flux. The potassium oxide content of the Baq'ah group is uniformly low, never more than 2.74% and averaging 0.44%. Alkaline earth and aluminium contents for both collections are comparable - approximately 4% aluminium and calcium, and 1% magnesium - in accord with other published results (Brill 1970, Sayre 1965).

The colourants and opacifiers have the most distinctive chemistry of the two collections, and serve to distinguish between them. Computer clustering of log-normalized oxide data (unweighted pair-group method after Rholf *et al.* 1982) for titanium and elements of higher atomic weight shows remarkably little overlap for visually similar colours of each group (Fig.3).

Most notably, the largest Baq'ah subgroup was comprised of dark colours - two grays, two browns, two purples, one black, and one blue-green, clustering together and marked as Baq'ah on Figure 3 - which were the result of elevated levels of copper (average of 1.23%), manganese (average of 1.64%), and cobalt (average of 0.34%), as the oxides. By contrast, only two Beth Shan examples (PURPLE1 and GRAY1) have elevated copper, manganese, and cobalt levels, and these are in noticeably lower

amounts than in the Baq'ah group; two additional examples (BROWN1 and GRAY3) were high in manganese and copper. The precise colouration of the objects depends on the relative amount of each element in a specific oxidation state (Bamford 1977), uniformly high amounts of the three elements yielding a gray or black.

Complementary copper-manganese and cobalt-manganese scattergrams (Figs.4 and 5) highlight the prevalence of dark colours in the Baq'ah collection. The Baq'ah specimens, which cluster together, appear in the upper right corner of each graph, reflecting their higher absolute content of the transition metals. Included here are also examples that were high in only one or two of the elements. Thus, only Beth Shan has examples (BLUE1, BLUE2, BLUE-1X8, and BLUE-IX10) of cobalt aluminate blue, which all have trace levels of manganese, placing them in the middle of the copper-manganese scattergram (Fig.4). Zinc and nickel, while not present in large enough quantitites to affect the colouration, show a relatively high correlation (R^2) with cobalt at both sites (for Beth Shan 0.6236; for Baq'ah 0.6057; Fig.6).

The manganese in the manganese browns from Beth Shan correlates with the trace elements nickel and zinc (R^2=0.8286), and two examples (BROWN3 and BROWN4) have only trace levels of copper (cf the minor amounts in BROWN1 and BROWN2). In contrast, the Baq'ah manganese browns show no correlation between manganese and nickel or zinc, and all the specimens (BRO-A2-1, BRO-B3-2, BRO-B3-3, and BRO-B3-5), except one (BRO-B3-4), contain copper as a minor element. All the specimens have iron as an additional trace or minor element; in the presence of manganese, iron would be oxidized to the ferric state, which also produces a brown in tetrahedral co-ordination.

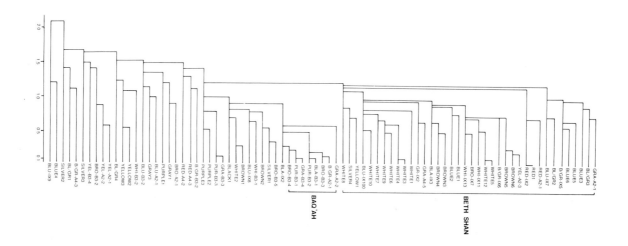

Fig. 3 Dendrogram of Beth Shan and Baq'ah specimens with major subgroups indicated. The oxide data were expressed in logarithms, since many chemical elements appear to be lognormally distributed in nature and the relative rather than absolute changes in the elements are thus measured. The significance level of the clustering (shown at the bottom of the figure) was calculated by plotting the cophenetic correlation matrix against the cluster analysis. Here, specimens that merge at values greater than 0.55 are less significant, accounting for some of the colour mixing on the lower half of the figure. Similar chemical compositions were also observed for different colours on the same example (e.g., BROIX7 and WHI-IX13; WHITE2 and BROWN1; SILVER1 and BROWN2) because of ion migration and possible overlapping of the beam scan.

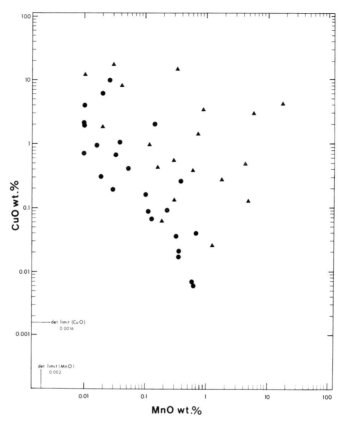

Fig. 4 Copper-manganese scattergram of Beth Shan and Baq'ah specimens, indicated by filled circles and triangles respectively, with more than a trace amount of one or both elements.

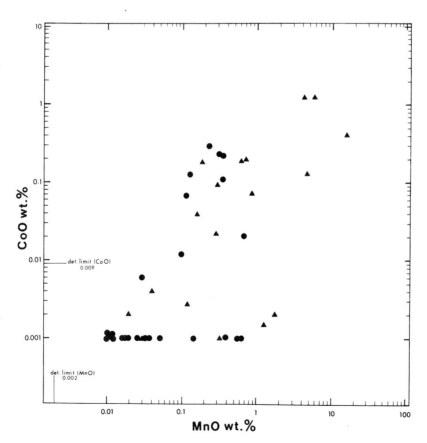

Fig. 5 Cobalt-manganese scattergram of Beth Shan and Baq'ah specimens, indicated by filled circles and triangles respectively, with more than a trace amount of one or both elements.

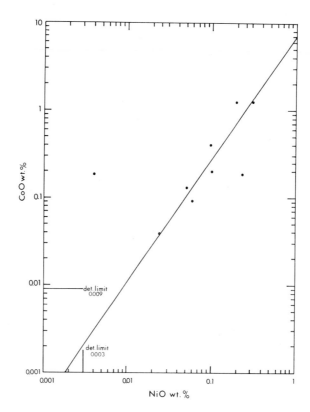

Fig. 6 Regression line for cobalt versus nickel content of Baq'ah samples with a cobalt content greater than a trace amount. Residual mean square of 1.4085.

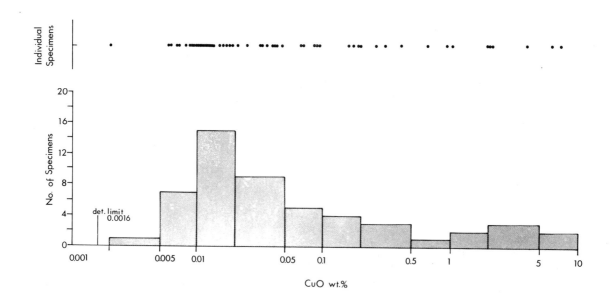

Fig. 7 Histogram of copper contents for the Beth Shan collection on a logarithmic scale. Individual determinations for the fifty-four specimens are shown by dots above the histogram.

Cupric blue-green/blue and Egyptian Blue examples from both sites, which have relatively low cobalt and manganese levels, are closer to the main axes of the scattergrams. All but one of the Baq'ah specimens (B/GR-A2-1) cluster together with the Beth Shan examples, dependent upon the relative amounts of copper, tin as a minor element (up to 1.20%), arsenic and iron as trace elements, and antimony as an opacifier (up to 8.25%). Egyptian Blue frit (copper calcium silicate) clusters out separately if the lower atomic weight elements are included in the statistical analysis. Calcium generally exceeds the stoichiometric equivalency with copper, indicating that additional lime was added to the frit batch mixture.

A histogram of the copper oxide content of all the Beth Shan examples (Fig.7) on a logarithmic scale exhibits a bimodal normal distribution, which is typical of elements that are present at both trace/minor and major levels (also observed for iron, manganese, cobalt, silver, and lead). One copper peak is centered at about 0.02%, and the other around 3%. The lower value represents the trace amount deriving from the various raw materials, whereas the upper amount results from the use of copper as a separate additive for colouration, apparently according to a standard formula. The corresponding Baq'ah values are approximately 0.03% and 3%. The relative tin oxide content (tin oxide divided by copper plus tin oxides) of the Baq'ah examples, which contain tin and/or copper in amounts exceeding trace levels, was higher than that for the Beth Shan group (Fig.8). In general, both sites have values that group together around 3% and 15%. However, more of the Baq'ah specimens fall in the midrange, and four Baq'ah specimens range between 53% and 97%. The latter (YEL-A2-2, GRA-B3-4, BROWN-B3-4, and RED-A4-3) have fairly high levels of tin (0.102%, 0.147%, 0.078%, and 0.925%, respectively), which are more likely explained by deliberate addition (Kaczmarczyk and Hedges 1983; cf Sayre 1963) than differential leaching or oxidation enrichment (Hedges and Moorey 1975).

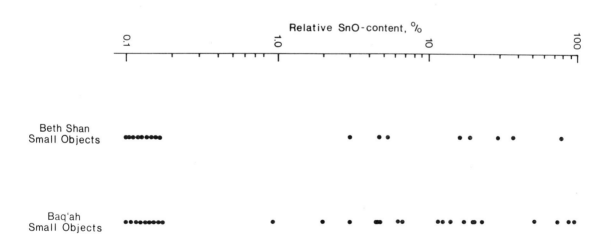

Fig. 8 The relative tin oxide content, i.e. the amount of tin oxide divided by the sum of the tin oxide and copper oxide, for Beth Shan and Baq'ah specimens with a copper and/or tin oxide content above the trace level.

Since tin is known to have been transported in ingot form during the Late Bronze Age (Maddin et al. 1977) and added separately to copper, there is no reason to exclude this possibility for silicate materials. The relative tin content (tin divided by copper plus tin) of Baq'ah bronzes for the period from 1550 to 1050 BC averages 9.25%, which is more than twice the Late Bronze II Beth Shan average (4.10%). Thus, most of the tin in the glasses and glazes might well have entered unintentionally as bronze refuse used as a copper colourant, but occasionally tin appears to have been added in a richer form, perhaps to achieve a glossier appearance (Kaczmarczyk and Hedges 1983). At Beth Shan, there was a higher correlation of copper with arsenic as a trace element and iron as a minor element ($R^2=0.5267$) than in the Baq'ah ($R^2=0.0458$).

At both sites, white colouration was achieved exclusively by calcium antimonate. The Baq'ah whites (only two examples) have higher antimony levels (average of 16.37%) than the Beth Shan examples (average of 5.60%), and consequently cluster separately. Differences in the amounts of antimony, iron, and titanium account for the two Beth Shan subgroups. Antimony was also used as an opacifier (Sayre 1963) at both sites for cupric blue-green, manganese brown, copper-manganese-cobalt grey (only Baq'ah), cobalt blue (only Beth Shan), and ferric red (only Baq'ah). The values for the Beth Shan corpus ranged very high, up to 8.25% (BLU-IX-7) and averaging 2.02%. Four Baq'ah examples fell within a more typical range of 0.1-0.3% (cf. Sayre 1963, Kaczmarczyk and Hedges 1983). A very slight correlation (R^2 ca. 0.259 between antimony and the trace elements titanium and iron was noted at both sites.

The basic composition of lead antimonate yellow or brown (with elevated iron) was the same at each site. On average, antimony is 3% and lead 4.5%, which converts to an approximately 1:1 stoichiometric relationship. However, sometimes lead is considerably in excess of antimony (e.g. YELLOW2) and vice versa (e.g. YEL-A2-3). A Baq'ah subgroup is segregated out on the dendrogram (Fig.3) because of minor amounts of tin (up to 0.183%). Lead correlated with the trace element zinc at Beth Shan ($R^2=0.6045$), but not in the Baq'ah.

Red colourants were rare. Two Late Bronze Age examples from Beth Shan averaged 3.90% ferric oxide; a Late Bronze Age Baq'ah example contained 7.03% of the latter. After ca. 1200 BC, a unique variety with as much as 47.96% ferric oxide and 0.73% cobalt (RED-A4-2 and RED-A4-3) appeared in the Baq'ah. The iron is dispersed as spherical particles up to two microns in diameter (cf. Hess and Perlman 1974). No example of cuprous red has yet been documented from either site (cf. Vandiver 1982, Kaczmarczyk and Hedges 1983).

Another unique colourant was a silver oxide at Beth Shan, which gave a silvery colour (SILVER2, SILVER3, and SILVER4) or a purple in the presence of a small amount of cobalt (PURPLE2 AND PURPLE3). The silver content was as high as 0.77%, and dispersed as colloidal particles up to one micron in diameter. The silver correlated most closely with titanium and manganese as trace elements ($R^2=0.4199$).

Three Beth Shan black specimens (BLACK1, BL-IX2, and BL-IX3) could not have been coloured by one or more of the heavy metals, since they were not present at high enough levels. Possibly, the colouration was achieved by elemental carbon (suggested by elevated levels of potassium and strontium, most likely from an organic source), which is not detected by PIXE. Iron sulphide (Sayre and Smith 1974) is ruled out by iron and sulphur being present in only trace amounts. If reduced carbon is responsible for the

black, it is difficult to explain the presence of antimony in the pentavalent oxidation state on one of the examples (WHI-IX11), unless a two-step reduction-oxidation process were employed.

Materials characterization

The majority of the Baq'ah samples are well-fused frits (see Note) with up to 75% glassy phase (Fig.9). Agglomerations of particles or crystals, with a glassy composition and elevated heavy metal levels according to EDS determinations, can be seen embedded in the matrix, particularly in the dark coloured copper-manganese-cobalt and lead antimonate yellow/brown specimens (Fig.10). The particle sizes for the variously coloured frits (up to 50 microns in diameter) and the relative fractions of glass are comparable to similarly coloured frits at Nuzi (Vandiver 1982) and New Kingdom Egyptian Blue examples (Tite et al.1984).

The faience at both sites appears to have been made by the efflorescence technique (Tite et al. 983) in which salts migrate to the surface during the drying process and are then fired to a glaze (Vandiver 1983). As compared with the rather diffuse glaze boundaries and very little sintering of interior silica particles of the Beth Shan examples (Fig.11), the Baq'ah glazes on both faiences and frits (10-50 microns thick) are much better defined, suggesting that the drying process was more intensive and/or that higher firing temperatures were employed. In turn, the Baq'ah faience is more appropriately described as glassy faience because of its extensive vitrification structure, as compared with the much more limited sintering of silica particles in the Beth Shan faience.

Only cupric blue-green and ferric red faience were effloresced. Other colours (yellow, white, grey, etc), which were first developed within the Syro-Palestinian glass/frit industry, were overlaid as glazes (up to 300 microns thick) onto the effloresced surfaces (Fig.12), probably as liquid slurries, and fired. The latter technique was only observed at Beth Shan, not in the Baq'ah.

Discussion

The rarity of small frit artifacts at Beth Shan and the overlaying of Syro-Palestinian glazes onto low-fired, effloresced faience surfaces there may well represent accommodations to traditional Egyptian practice. In Egypt itself, a conservative tendency in the use of Syro-Palestinian colourants has been noted in the New Kingdom industry (Vandiver 1983, Peltenburg 1974), although glass vessels and elaborate, polychrome jewellery and tiles were also improvised there.

The coalescence of Syro-Palestinian and Egyptian technological traditions at Beth Shan, where a New Kingdom garrison had been set up, is culturally very significant. Perhaps artisans were brought in from Egypt or native craftsmen were trained in Egyptian faience manufacture. Pieces of refuse glass and faience, a large piece of an Egyptian blue cake, and a mould for a fluted bead or inlay from the same contexts as the beads and pendants (James and McGovern 1986) provide evidence for local production of small objects, in addition to the idiosyncratic character of Beth Shan's silicate materials.

Fig. 9 SEM micrograph at 800x of extensive sintering of silica particles on the interior of Baq'ah field no. A2-56 (RED-A2-1), a disc bead.

Fig. 10 SEM micrograph at 1000x of Egyptian Blue frit crystal (the lath - like particle embedded in the glassy matrix, at lower centre) in Baq'ah field no. A2-87 (comparable to field no. A2-102, BLU-A2-1).

Fig. 11 SEM micrograph at 100x of ill-defined faience glaze on Beth Shan field no. 27.11.159a (BL/GR4), a petal or leaf pendant.

Fig. 12 SEM micrograph at 500x of lead antimonate yellow overglaze (YELLOW3) on copper effloresced glass (GRAY1) of Beth Shan field no. 26.9.171, a petal or leaf pendant. Note poorly vitrified silica particles beneath the glazes.

The probable adoption of foreign colourants and opacifiers has been documented in other Eastern Mediterranean silicate industries (e.g. for Crete see Foster and Kaczmarczyk 1982 and for Egypt see Kaczmarczyk and Hedges 1983). Assuming that the expertise were available, it would be anticipated that native ore deposits would eventually be sought out for producing the same colourants locally. Thus, Palestine has rich copper ore bodies northwest of the Gulf of Aqaba/Eilat (Timna), which were exploited by the Egyptians in the Late Bronze Age. The correlation of copper with arsenic and iron in blue-green/blue glasses and glazes at Beth Shan, which was in close contact with Egypt, suggests that the copper colourants might derive from the Timna deposits (Craddock 1980); in Jordan, where Egyptian connections were minimal, copper did not correlate with these trace elements. However, the complexity of glass and frit batch mixtures, as well as the problem of the partitioning of elements in the smelting process (Tylecote et al. 1977), should caution against any precise provenancing of the original ore. Especially in the case of copper ores, which are distributed throughout the Near East and yet have been chemically analyzed only to a limited extent, similar chemical profiles may well exist elsewhere.

The availability of copper and manganese ores in Transjordan may explain their high levels in Baq'ah copper-manganese-cobalt dark colourants. Unless a native source is still to be found, the cobalt must have been imported from Egypt. An alum high in cobalt, with zinc, nickel, and manganese as trace elements, has recently been confirmed for the Dakhla oasis of the Western Desert (Kaczmarczyk, personal communication). Cobalt was accompanied by the same elements in the Baq'ah and at Beth Shan, which implies that Palestine was obtaining its cobalt from Egypt rather than from Iran, where arsenical, manganese-free ores occur (Garner 1956a and 1956b).

The absence of copper-manganese-cobalt dark colourants at Beth Shan and their attestation in Egypt (Kaczmarczyk and Hedges 1983) is more difficult to explain. Again, this may reflect greater Egyptian accessibility to metal ores. Manganese deposits with minor amounts of iron exist in the Eastern Desert (el-Shazly and Saleeb 1959), and the copper from Timna operations might have gone primarily to Egyptian markets.

The antimony and lead trace element profiles of the Palestinian colourants and opacifiers cannot be unequivocably tied to specific ore bodies in the mid-world fold belt in Turkey and Iran (Zwicker 1980, Ryan 1957). Lead-zinc deposits are also found in Egypt (Stos-Gale and Gale 1981).

The several examples of a silver colloid colourant at Beth Shan probably did not derive from Egyptian silver ores where gold generally accompanies the silver (Mishara and Meyers 1974, Prag 1978). Until more chemical analyses of Near Eastern silver deposits are carried out, its provenance must remain unresolved.

As a working hypothesis for the provenance of the iron used in the post-1200 BC red glass, it may be proposed that the glass was reworked iron ore slag, which was a by-product of the contemporaneous iron/steel industry (Pigott et al. 1982). A slag sample from the nearby smelting site of Dhahrat Abu Thawab, which yielded early Iron Age sherds in a surface survey, had an elevated cobalt content (as much as 0.33%) that was comparable to the red glass. However, the slag lacked tin, whereas the red glass had a very high amount (0.93%) of the element. Only five beads of the glass were found (McGovern 1986a), suggesting that the glass was not the main goal of production. One example was a horned stratified eye bead in which the white inlays for the eyes were composed of silica particles

rather than calcium antimonate, the standard Late Bronze Age material. Silica parting layers were observed along the interior perforations of the beads.

Conclusions

A central Transjordanian silicate industry in small artifacts is strongly implied by the difference in materials, colourants, and opacifiers of the Baq'ah objects when compared with those from Beth Shan, a Jordan Valley site about 50km away. An industrial installation has not yet been located on the Transjordanian plateau, but will be a major goal of future campaigns in the area. On current knowledge, this region pursued its own variant of the Syro-Palestinian glass/frit tradition throughout the Late Bronze Age. As a result of major dislocations in the economy and consequent social pressures (McGovern 1986a), the industry fell into decline around 1200 BC, although a contemporaneous innovative trend was attested by the appearance of a very high-iron red glass.

At Beth Shan, a different variant of the Syro-Palestinian glass/frit industry apparently developed during the Late Bronze Age. After the site was converted into an Egyptian military garrison, faience of standard New Kingdom type became very common, and Syro-Palestinian colourants were applied as overglazes on effloresced faience surfaces. Industrial debris and moulds at the site indicate that artisans, whether Egyptian or native, manufactured small objects locally, and were probably responsible for the merging together of Syro-Palestinian and Egyptian silicate traditions.

Acknowledgements

The PIXE analyses were carried out in collaboration with C P Swann of the Bartol Research Foundation of the Franklin Institute at the University of Delaware (Newark). M R Notis of Lehigh University made available SEM facilities, and H Moyer assisted with the instrumentation. W G Glanzman prepared the glass/glaze surfaces and sections. E Slikas contributed to the data analysis. S J Fleming kindly advised on graphics presentation. The figures were prepared and inked by M Geshke and C West.

Note

'Frit', according to its modern ceramic definition, is a pre-fused portion of materials, or a glass, which is incorporated into a glaze or glass mixture (Parmelee 1948). Fritting allows highly reactive processes, which might adversely affect glass production, to be carried out beforehand, and enables concentrated, homogeneous materials (such as colourants) to be prepared for easier transport and recipe addition. In the Syro-Palestinian glass/frit industry, frits were often used alone by shaping and refiring the material. The surface particles of the refired frit can fuse to form a glaze, as was observed on many of the Baq'ah fritted examples (cf. the definition of a frit as 'a sintered, polycrystalline body with no glaze coating' in Vandiver 1982).

References

Bamford C R (1977). <u>Colour generation and control in glass</u>, Glass Science and Technology 2. Amsterdam, Elsevier Scientific

Bender F (1974). <u>Geology of Jordan</u>. Berlin, Borntraeger

Brill R H (1970). The chemical interpretation of the texts. In <u>Glass and glassmaking in ancient Mesopotamia</u>, A L Oppenheim, R H Brill, D Barag and A von Saldern, Corning NY, Corning Museum of Glass

Brill R H (1972). A chemical-analytical round-robin on four synthetic ancient glasses. In <u>The 9th International Congress on Glass, Versailles, September 1971, Artistic and Historical Communications</u>, 93-110. Paris, l'Institut du Verre

Conrad H G and Rothenberg B., eds (1980). <u>Antikes Kupfer im Timna-tal</u>. Bochum, Deutsches Bergbau-Museum

Coughenour R A (1976). Preliminary report on the exploration and excavation of Mugharat el Wardeh and Abu Thawab. <u>Annual of the Department of Antiquities of Jordan</u> 21, 71-78

Craddock P T (1980). Composition of copper produced at the ancient smelting camps in the Wadi Timna, Israel. In <u>Scientific studies in early mining and extractive metallurgy</u>, P T Craddock ed., British Museum Occasional Paper 20, 165-174. London, British Museum

Drower M S (1973). Syria, ca.1550-1400 BC. In <u>The Cambridge Ancient History</u> vol 2, part 1, I E S Edwards, C J Gadd, N G L Hammond and E Sollberger eds., 417-525. London, Cambridge University Press

Foster K P and Kaczmarczyk A (1982). X-ray fluorescence analysis of some Minoan faience. <u>Archaeometry</u> 24, 143-57

Garner H (1956a). An early piece of glass from Eridu. <u>Iraq</u> 18, 147-49

Garner H (1956b). The use of imported and native cobalt in Chinese blue and white. <u>Oriental Art</u> 2, 48-50

Gerstenblith P (1983). <u>The Levant at the beginning of the Middle Bronze Age</u>. Dissertation Series 5, W M Weinstein, ed. Philadelphia, American School of Oriental Research.

Hedges R E M and Moorey P R S (1975). Pre-Islamic ceramic glazes at Kish and Nineveh in Iraq. <u>Archaeometry</u> 17, 25-43

Hess J and Perlman I (1974). Mössbauer spectra of iron in ceramics and their relation to pottery colours. <u>Archaeometry</u> 16, 137-52

James F W and McGovern P E (1986). <u>The Late Bronze Age at Beth Shan: A Study of Levels VII and VIII</u>. Philadelphia, University Museum

Kaczmarczyk A and Hedges R E M (1983). <u>Ancient Egyptian faience: An analytical survey of Egyptian faience from Predynastic to Roman Times</u>. Warminster, Aris and Phillips

Maddin R, Wheeler T and Muhly J D (1977). Tin in the ancient Near East: old questions and new finds. <u>Expedition</u> 19, 35-47

McGovern P E (1985a). Environmental constraints for human settlement in the Baq,ah Valley. In Studies in the history and archaeology of Jordan II, 141-42. Amman, Department of Antiquities

McGovern P E (1985b). Late Bronze Age Palestinian pendants: Innovation in a cosompolitan age. The American School of Oriental Research and the Journal for the Study of the Old Testament: Monograph Series

McGovern P E (1986a). The Late Bronze and Early Iron Ages of Central Transjordan: The Baq,ah Valley Project, 1977-1981. Philadelphia, University Museum

McGovern, P E (1986b). The Chemical discrimination by PIXE analysis of imported and domestic silicate artifacts from Beth Shan. In Analytical tools in archaeometry. Newark Del., Bartol Research Foundation of the Franklin Institute

Mishara J and Meyers P (1974). Ancient Egyptian silver: a review. In Recent advances in science and technology of materials vol 3, A Bishay ed., 29-46. New York, Plenum

Oppenheim A L, Brill R H, Barag D and von Saldern A (1970). Glass and glassmaking in ancient Mesopotamia. Corning N.Y., Corning Museum of Glass

Peltenburg E J (1974). The glazed vases (including a polychrome rhyton. In Excavations at Kition, I: The Tombs, V Karageorghis, 105-144. Nicosia, Department of Antiquities

Pigott V, McGovern P E and Notis M (1982). The earliest steel from Transjordan. MASCA Journal 2, 35-39

Prag K (1978). Silver in the Levant in the fourth millennium BC. In Archaeology in the Levant: Essays for Kathleen Kenyon, R Moorey and P J Parr eds., 36-45. Warminster, Aris and Philipps

Rholf F J, Kishpaugh J and Kirk D (1982). NTSYS: Numerical Taxonomy System of Multivariate Statistical Programs. Stony Brook, State University of New York at Stony Brook

Rowe A (1930). Topography and history of Beth-Shan. Philadelphia, University of Pennsylvania for the University Museum

Rowe A (1940). The Four Canaanite temples of Beth-Shan: The temples and cult objects. Philadelphia, University Museum

Ryan C W (1957). A guide to known minerals of Turkey. Ankara, Mineral Research and Exploration Institute of Turkey and the Office of International Economic Cooperation, Ministry of Foreign Affairs

Sayre E V (1963). The intentional use of antimony and manganese in ancient glasses. In Advances in glass technology part 2, F A Matson and G E Rindone eds., 263-282. New York, Plenum

Sayre E V (1965). Summary of the Brookhaven program of analysis of ancient glass. In Application of science in examination of works of art. 145-154. Boston, Museum of Fine Arts

Sayre E V and Smith R W (1974). Analytical studies of ancient Egyptian glass. In Recent advances in science and technology of materials vol 3, A Bishay ed., 47-70. London, Plenum

El-Shazly E M and Saleeb G S (1959). Contribution to the mineralogy of Egyptian manganese deposits. Economic Geology 54, 873-88

Stos-Gale Z A and Gale N H (1981). Sources of galena, lead and silver in predynastic Egypt. Revue d'Archéometrie (suppl) 285-95

Swann C P (1982). The study of archaeological artifacts using proton induced x-rays. Nuclear Instruments and Methods 197, 237-42

Tite M S, Bimson M and Cowell M R (1984). Technological examination of Egyptian Blue. In Archaeological Chemistry III, J B Lambert ed., 215-242. Advances in Chemistry Series 205. Washington, D.C., American Chemical Society

Tite M S, Freestone I C and Bimson M (1983). Egyptian faience: an investigation of the methods of production. Archaeometry 25, 17-27

Tylecote R F, Ghaznavi H A and Boydell P J (1977). Partitioning of trace elements between the ores, fluxes, slags and metal during smelting of copper. Journal of Archaeological Science 4, 305-333

Vandiver P (1982). Mid-second millennium B.C. soda-lime-silicate technology at Nuzi (Iraq). In Early pyrotechnology: The evolution of the first fire-using industries, T A Wertime and S F Wertime eds., 73-92. Washington, D.C., Smithsonian Institution

Vandiver P (1983). Egyptian faience technology. In Ancient Egyptian faience: An analytical survey of Egyptian faience from Predynastic to Roman Times, A Kaczmarczyk and R E M Hedges, A-1 to A-144. Warminster, Aris and Phillips

Weinstein J M (1981). The Egyptian empire in Palestine: a reassessment. Bulletin of the American Schools of Oriental Research 241, 1-28

Zwicker U (1980). Investigations on the extractive metallurgy of Cu/Sb/As ore and excavated smelting products from Norsun-Tepe (Keban) on the upper Euphrates (3500-2800 BC). In Studies in early mining and extractive metallurgy, P T Craddock ed., British Museum Occasional Papers 20, 13-26. London, British Museum

Table 1 BETH SHAN ANALYTICAL CORPUS: SILICATE SMALL ARTIFACTS

Colourant Reference	Field No.	Locus	Description
YELLOW1 WHITE1	25.11.343	1086, Level VII	*ib* ('heart') pendant (McGovern 1985b: no.256). White glass with yellow and white impressed latitudinal bands.
BROWN1 BLUE1 WHITE2	25.11.393	1068, below steps, Level VIII	Ram's head pendant (McGovern 1985b: no.87). White glass with brown overlay; dark brown impressed helices on horns; brown and white impressed circular crumbs for eyes; blue nostrils; red beneath horns not visible.
WHITE3 WHITE4 BROWN2 SILVER1	25.11.394	1086, Level VII	Ram's head pendant (McGovern 1985b: no.89). White glass with horns added as white and brown canes; impressed silvery open circles and brown circular crumbs define eyes; piece of malachite inserted into middle of left eye; silvery impressed crumbs on nostrils.
YELLOW2 PURPLE1	25.11.423	1068, north of steps, Level VII	Small mandrake fruit pendant (McGovern 1985b: no.169). Yellow frit with purple over glaze.
BROWN3 BROWN4	25.11.441	1062, Level VII	Collared spheroid bead. Brown and white swirled glass.
BLUE2	25.11.454	1068, Level VII	Barrel bead. Blue glass.
WHITE5 BROWN5 BL/GR1 SILVER2 BLACK1	25.11.461	1068, Level VII	Barrel bead. Silvery glass with brown, blue-green, and white impressed crumbs; black interior matrix.
WHITE6 WHITE 7	25.11.462i	1068, Level VII	Barrel bead. White glass with purple impressed bands in feather or ogee pattern.
WHITE8 PURPLE2	25.11.462ii	1068, Level VII	Barrel bead. White glass with purple impressed bands.
WHITE9 PURPLE3	25.11.462iii	1068, Level VII	Barrel bead. White glass with purple impressed bands.
BLUE3	25.11.475	1068, near steps Level VII	Reeds(?) pendant (McGovern 1985b: no.216). Blue glazed faience.

BL/GR2 BL/GR3	25.11.486	1068, near steps, Level VII	djed pendant (McGovern 1985b: no.223). Blue-green glazed faience.
SILVER3 SILVER4 WHITE10	26.9.112e	1105, Level VII	Barrel bead. Silvery glass with white impressed bands in feather or ogee pattern.
BLUE4	26.9.154a	1062, Level VII	Spheroid bead. Blue transparent glass.
GRAY1 YELLOW3	26.9.171	1062, below south wall, Level VIII	Petal or leaf pendant (McGovern 1985b: no.210). White faience with yellow and grey overglazes.
BLUE5	27.9.451	1213A, Level VII	Hexagonal ellipsoid bead. Egyptian Blue frit.
BLUE6	27.9.472a	1221, Level VIII	Fluted spheroid bead. Egyptian Blue frit.
RED1	27.9.472c	1221, Level VIII	Disc bead. Red frit.
GR-IX2	27.10.39	1232, Level IX	Spheroid bead. Transparent green glass.
BLU-IX7	27.10.131	1232, Level IX	Cylindrical bead. Blue glass.
BLA-IX2 WHI-IX11	27.10.369	1236, Level IX	Barrel bead. Black glass with white impressed band.
BLU-IX8	27.10.435	1242, Level IX	Cylindrical bead. Blue glass.
BL/GR4	27.11.159a	1284, Level VII	Petal or leaf pendant (McGovern 1985b: no.201). Blue-green glazed faience.
RED-IX2	28.8.50	1334, Level IX	Disc bead. Red glazed faience.
BLU-1X9	28.10.424c	1241, Level IX	Lenticular cylinder bead. Egyptian Blue frit.
B/GR-IX5	28.10.465	1396, Level IX	Cylindrical bead. Blue-green glazed faience.
BLU-IX10	28.11.174b	1398, Level IX	Barrel bead. Blue glass.
WHITE12 GRAY3 BROWN6	28.11.257	1399, Level VIII	Spheroid bead. Gray glass with brown and white impressed crumbs.

BLA-IX3 B/GR-IX6 BRO-IX7 WHI-IX13	28.11.369	1331, Level IX	Cylindrical bead. Gray glass with white, green, and brown impressed crumbs.

Table 2 <u>BAQ'AH VALLEY ANALYTICAL CORPUS: SILICATE SMALL ARTIFACTS</u>

Colourant Reference	Field No.	Locus	Description
GRA-A2-1	A2.33	12, Cave A2	Disc bead. Gray faience or frit.
RED-A2-1	A2.56	17, Cave A2	Disc bead. Red glazed faience.
BRO-A2-1	A2.58	17, Cave A2	Cylindrical bead. Dark brown glazed frit.
YEL-A2-1	A2.61	17, Cave A2	Spheroid bead. White glass with yellow and white impressed eyes.
GRA-A2-2	A2.65	Balk trim, Cave A2	Disc bead. Gray glazed frit.
BLU-A2-1	A2.102	26, Cave A2	Fluted spheroid bead. Egyptian Blue glazed frit.
YEL-A2-2	A2.114	26, Cave A2	Fluted spheroid bead. Yellow glazed frit.
B/GR-A2-1	A2.117 A2.99	26, Cave A2	Fluted spheroid bead. Blue-green glazed faience.
YEL-A2-3	A2.137	27, Cave A2	Spheroid bead. White glass with gray, white, and yellow impressed crumbs.
B/GR-B3-2	B3.58	4, Cave B3	Disc bead. Blue-green glazed faience.
GRA-B3-3 BRO-B3-2	B3.81	8, Cave B3	Barrel bead with four fluted lobes. Dark brown glazed frit.
BLA-B3-1 GRA-B3-4	B3.103	8, Cave B3	Fluted spheroid bead with collars. Gray frit with black glaze.
BLU-B3-2	B3.150	11, Cave B3	Cylindrical bead. Egyptian Blue frit.
PUR-B3-1 BRO-B3-3	B3.182	3, Cave B3	Fluted cylindrical bead. Brown frit with purple glaze.
PUR-B3-2	B3.307	4, Cave B3	Spheroid bead. Purplish brown glazed frit.
BRO-B3-4	B3.311	4, Cave B3	Segmented bead - two spheroids. Brown glazed frit.
BRO-B3-5 WHI-B3-1	B3.358	14, Cave B3	Barrel bead. Brown glass with white impressed band.
PUR-B3-3	B3.359	14, Cave B3	Barrel bead. Purple and white variegated glass.

WHI-B3-2	B3.360	14, Cave B3	Barrel bead. Purple, silvery, yellow, and white variegated glass with silvery and white impressed bands.
YEL-B3-4	B3.363	8, Cave B3	Fluted bicone bead. Yellow frit.
GRA-A4-5	A4.2b	5, Cave A4	Spheroid bead. Gray frit.
RED-A4-2	A4.69	10, Cave A4	Spheroid bead with raised stratified eyes. Dark red glass with inlaid white silica eyes.
B/GR-A4-3	A4.96	9, Cave A4	Fluted spheroid. Egyptian Blue glazed frit.
RED-A4-3	A4.185a	9/13, Cave A4	Spherical bead. Dark red glass.

TABLE 3 PIXE DATA FOR BETH SHAN SPECIMENS (% by weight)

Colourant Reference	Na$_2$O	MgO	Al$_2$O$_3$	SiO$_2$	K$_2$O	CaO	TiO$_2$	MnO	Fe$_2$O$_3$	CoO	NiO	CuO	ZnO	SnO	Sb$_2$O$_5$	PbO
YELLOW1	0.000	0.571	2.946	89.709	1.699	2.044	0.110	0.009	0.759	0.000	0.002	0.033	0.023	0.000	1.007	0.679
WHITE1	0.000	0.000	1.499	92.227	1.094	1.980	0.069	0.004	0.288	0.000	0.000	0.011	0.008	0.000	2.467	0.006
BROWN1	1.360	7.296	2.257	76.080	3.411	4.781	0.075	0.098	0.828	0.012	0.000	0.161	0.060	0.004	1.695	0.014
BLUE1	2.041	2.308	5.828	81.570	4.798	0.000	0.162	0.111	0.885	0.067	0.067	0.089	0.080	0.000	0.271	0.013
WHITE2	1.706	1.406	1.521	90.832	1.098	1.849	0.066	0.003	0.507	0.006	0.000	0.015	0.004	0.007	0.805	0.006
WHITE3	0.000	1.422	3.903	76.766	2.628	0.000	0.200	0.058	0.790	0.000	0.002	0.016	0.012	0.000	13.505	0.022
WHITE4	1.838	1.454	4.636	76.606	3.647	0.000	0.211	0.065	1.086	0.000	0.004	0.042	0.010	0.000	8.694	0.030
BROWN2	0.971	1.162	3.168	84.217	2.917	3.855	0.178	0.029	1.834	0.006	0.000	0.197	0.001	0.011	0.128	0.081
SILVER1	0.995	0.679	3.282	85.561	3.116	2.053	0.213	0.679	1.314	0.021	0.038	0.041	0.010	0.009	1.019	0.063
YELLOW2	0.000	2.683	1.712	81.304	0.555	2.363	0.000	0.025	0.385	0.128	0.000	0.087	0.228	0.253	2.284	8.300
PURPLE1	3.541	1.419	15.477	65.289	7.235	5.178	0.000	0.126	0.427	0.000	0.051	0.068	0.167	0.000	0.000	0.004
BROWN3	0.000	0.000	4.144	88.882	2.716	2.030	0.077	0.638	0.720	0.020	0.009	0.006	0.009	0.000	0.000	0.004
BROWN4	2.238	0.000	3.924	83.782	3.748	3.288	0.085	0.569	0.723	0.000	0.008	0.007	0.011	0.000	3.720	0.005
BLUE2	2.276	3.490	11.010	67.054	2.897	7.194	0.173	0.349	0.737	0.227	0.000	0.017	0.382	0.000	0.000	0.012
WHITE5	0.000	1.615	3.272	88.271	1.564	0.000	0.169	0.010	0.744	0.000	0.001	0.010	0.006	0.000	3.915	3.650
BROWN5	0.000	1.149	3.029	81.770	2.222	3.655	0.143	0.012	1.827	0.000	0.003	0.042	0.007	0.000	2.057	0.017
BL/GR1	0.000	1.028	3.337	86.456	2.734	2.291	0.157	0.000	2.058	0.000	0.028	0.173	0.004	0.071	1.008	0.017
SILVER2	0.000	1.245	2.069	92.353	1.361	1.372	0.063	0.000	0.690	0.000	0.001	0.019	0.010	0.000	0.000	0.009
BLACK1	9.717	4.710	1.028	72.671	3.831	6.787	0.064	0.019	0.505	0.006	0.000	0.025	0.003	0.000	0.000	0.005
WHITE6	0.000	1.017	5.078	79.987	3.433	5.486	0.165	0.006	0.722	0.000	0.001	0.013	0.002	0.000	3.440	0.006
WHITE7	0.000	0.682	6.077	81.089	3.355	3.253	0.151	0.007	0.700	0.010	0.001	0.006	0.003	0.034	4.096	0.004
WHITE8	0.000	0.627	3.636	82.391	2.566	3.253	0.141	0.013	0.546	0.010	0.001	0.009	0.18	0.004	5.662	0.007
PURPLE2	1.217	1.577	1.152	92.285	1.344	0.581	0.076	0.009	0.654	0.005	0.002	0.010	0.023	0.004	0.000	0.007
WHITE9	0.000	1.631	3.850	81.881	2.419	2.864	0.190	0.010	1.120	0.000	0.001	0.018	0.012	0.000	5.513	0.003
PURPLE3	0.608	1.307	1.031	94.788	1.038	0.264	0.058	0.008	0.609	0.009	0.001	0.014	0.002	0.002	0.000	0.008
BLUE3	0.000	0.859	4.654	85.804	3.171	1.356	0.092	0.145	0.489	0.000	0.068	0.060	0.143	0.000	0.000	0.017
BL/GR2	0.000	0.000	1.251	91.889	1.953	0.903	0.044	0.008	0.206	0.000	0.000	2.060	0.024	0.525	0.000	0.015
BL/GR3	1.865	0.626	1.138	88.991	1.163	0.704	0.027	0.005	0.186	0.000	0.006	2.117	0.031	0.000	0.000	0.029
SILVER3	0.000	1.705	4.705	83.330	3.205	4.257	0.107	0.038	0.887	0.000	0.000	4.034	0.006	0.000	0.000	0.002
SILVER4	0.000	0.000	4.234	91.454	1.945	1.166	0.091	0.068	0.485	0.000	0.000	0.008	0.008	0.000	0.000	0.002
WHITE10	0.000	0.994	3.290	86.789	1.659	3.671	0.162	0.017	0.737	0.000	0.001	0.011	0.011	0.000	2.421	0.002
BLUE4	9.641	3.812	1.217	74.446	3.233	5.524	0.041	0.032	0.339	0.000	0.002	0.007	0.000	0.000	0.000	0.001
GRAY1	0.000	0.809	1.752	91.668	1.841	1.650	0.041	0.232	0.286	0.295	0.142	0.094	0.184	0.000	0.000	0.000
YELLOW3	0.000	0.000	1.010	74.790	0.451	1.441	0.000	0.020	0.235	0.000	0.004	0.094	0.323	0.000	12.380	8.015
BLUE5	0.000	1.196	4.478	66.751	1.812	13.724	0.122	0.025	1.131	0.000	0.027	9.735	0.052	0.305	0.000	0.004
BLUE6	0.000	0.999	5.224	81.530	1.675	6.285	0.080	0.010	0.676	0.000	0.005	1.966	0.020	0.000	0.000	0.017
RED1	0.000	0.685	3.960	86.455	1.943	2.154	0.118	0.014	3.765	0.000	0.001	0.048	0.004	0.000	0.000	0.038
GR-IX2	8.403	2.978	1.220	78.794	2.876	4.535	0.025	0.033	0.255	0.000	0.002	0.002	0.003	0.000	0.000	0.001
BLU-IX7	7.352	2.231	0.979	68.834	1.585	8.648	0.073	0.016	0.361	0.000	0.000	0.953	0.007	0.000	8.245	0.002
BLA-IX2	4.344	6.356	2.970	70.666	6.586	7.306	0.093	0.049	0.757	0.007	0.004	0.033	0.012	0.089	0.000	0.010
WHI-IX11	0.000	0.000	7.224	80.712	4.197	3.456	0.170	0.004	0.434	0.000	0.001	0.011	0.006	0.000	3.050	0.002
BLU-IX8	5.710	4.023	7.750	67.401	1.995	9.541	0.089	0.351	0.503	0.110	0.000	0.021	0.189	0.000	1.830	0.003
BL/GR4	0.000	1.361	1.352	84.323	0.789	3.452	0.000	0.019	0.273	0.000	0.016	6.222	0.043	0.211	0.000	0.077
RED-IX2	0.000	0.000	1.509	86.913	3.047	3.414	0.119	0.019	4.043	0.000	0.000	0.069	0.042	0.000	0.000	0.012
BLU-IX9	0.000	2.377	7.438	59.926	2.471	20.299	0.252	0.037	2.966	0.000	0.011	1.045	0.000	0.634	0.000	0.020
B/GR-IX5	0.000	1.191	2.168	89.652	1.298	2.814	0.122	0.052	1.830	0.000	0.001	0.415	0.012	0.080	0.000	0.004
BLU-IX10	10.598	4.143	5.386	65.834	1.374	8.155	0.127	0.319	0.528	0.236	0.201	0.036	0.314	0.000	1.828	0.033
WHITE12	0.000	0.902	2.340	76.764	2.060	0.000	0.335	0.034	1.218	0.000	0.005	0.013	0.007	0.000	15.640	0.000
GRAY3	0.000	0.000	2.856	68.098	7.258	11.624	0.142	0.383	4.252	0.000	0.015	0.266	0.010	0.000	5.001	7.008
BROWN6	0.000	0.474	2.660	71.047	3.168	6.085	0.239	0.303	3.212	0.000	0.011	0.196	0.034	0.000	0.000	0.003
BLA-IX3	0.000	0.000	5.030	87.148	3.991	1.708	0.306	0.019	0.715	0.000	0.010	0.010	0.004	0.000	1.265	0.029
B/GR-IX6	0.000	0.000	2.785	85.665	3.764	2.317	0.140	0.019	2.428	0.000	0.000	0.312	0.004	0.000	1.391	1.275
BRO-IX7	0.000	0.000	6.420	79.061	5.247	4.580	0.200	0.009	1.207	0.000	0.000	0.009	0.003	0.000	3.568	0.049
WHI-IX13	0.000	0.000	5.581	76.423	5.158	5.523	0.353	0.036	0.829	0.000	0.000	0.013	0.006	0.000		
MEAN	1.415	1.448	3.731	81.018	2.747	3.939	0.124	0.096	1.050	0.021	0.014	0.585	0.048	0.043	2.205	0.549

113

TABLE 4 PIXE DATA FOR BAQ'AH SPECIMENS (% by weight)

Colourant Reference	Na$_2$O	MgO	Al$_2$O$_3$	SiO$_2$	K$_2$O	CaO	TiO$_2$	MnO	Fe$_2$O$_3$	CoO	NiO	CuO	ZnO	SnO	Sb$_2$O$_5$	PbO
GRA-A2-1	2.129	0.446	2.420	85.260	2.130	1.196	0.136	0.889	0.357	0.074	0.055	3.460	0.206	0.000	0.000	0.034
RED-A2-1	5.953	0.294	3.348	79.894	1.802	0.913	0.071	0.011	7.031	0.006	0.000	0.041	0.004	0.000	0.000	0.024
BRO-A2-1	0.747	0.280	0.806	94.391	0.184	0.393	0.048	1.734	0.957	0.002	0.007	0.278	0.014	0.071	0.000	0.000
YEL-A2-1	1.480	2.100	4.518	68.030	0.036	4.549	0.271	0.014	4.389	0.019	0.004	0.845	0.023	0.183	3.073	9.216
GRA-A2-2	1.592	2.169	6.185	79.777	0.390	4.189	0.231	0.711	1.292	0.200	0.100	1.829	0.210	0.000	0.000	0.046
BLU-A2-1	0.000	0.683	5.969	62.633	0.389	12.142	0.360	0.332	2.006	0.000	0.000	14.494	0.077	0.000	0.000	0.000
YEL-A2-2	0.697	0.488	0.681	87.557	0.021	0.283	0.050	0.003	0.833	0.016	0.001	0.013	0.003	0.102	2.896	6.182
B/GR-A2-1	2.003	0.727	2.941	87.666	0.528	2.318	0.232	0.019	1.468	0.002	0.001	1.824	0.008	0.037	0.000	0.042
YEL-A2-3	0.000	1.706	7.249	77.378	0.351	5.420	0.417	0.498	1.894	0.000	0.020	0.873	0.025	0.000	2.476	0.626
B/GR-B3-2	0.109	0.990	9.247	66.948	0.354	11.389	0.318	0.041	2.068	0.004	0.009	8.081	0.016	0.000	0.000	0.020
GRA-B3-3	1.039	0.271	2.329	85.990	0.121	1.037	0.131	4.658	1.845	0.136	0.049	1.440	0.107	0.237	0.167	0.022
BRO-B3-2	0.980	0.493	7.909	61.126	0.129	4.436	0.243	15.712	3.505	0.408	0.097	4.296	0.052	0.204	0.000	0.061
BLA-B3-1	0.702	0.660	2.878	84.174	0.106	2.640	0.168	4.361	1.937	1.269	0.314	0.465	0.070	0.062	0.000	0.018
GRA-B3-4	0.740	0.278	1.628	95.403	0.085	0.637	0.025	0.291	0.305	0.093	0.059	0.131	0.038	0.147	0.000	0.006
BLU-B3-2	0.000	0.475	1.265	58.852	0.320	17.822	0.165	0.030	0.954	0.000	0.000	17.660	0.023	1.203	0.020	0.006
PUR-B3-1	1.116	0.331	1.953	94.694	0.099	0.538	0.043	0.160	0.291	0.039	0.024	0.425	0.036	0.060	0.000	0.006
BRO-B3-3	0.774	0.486	6.442	73.042	0.306	5.302	0.280	5.851	2.353	1.226	0.197	2.966	0.064	0.028	0.000	0.067
PUR-B3-2	2.535	0.624	1.674	91.879	0.193	0.678	0.096	0.287	1.267	0.022	0.051	0.547	0.039	0.040	0.000	0.008
BRO-B3-4	0.392	0.175	0.513	96.943	0.079	0.197	0.043	1.231	0.242	0.001	0.004	0.026	0.008	0.078	0.000	0.002
BRO-B3-5	1.635	1.472	11.659	75.475	0.399	5.082	0.304	0.117	1.629	0.028	0.001	0.988	0.008	0.031	0.290	0.057
WHI-B3-1	1.583	0.409	8.857	72.598	0.268	0.000	0.184	0.035	1.230	0.027	0.000	0.654	0.004	0.000	13.633	0.066
PUR-B3-3	0.957	0.793	4.172	88.929	0.107	1.487	0.131	0.617	1.524	0.189	0.004	0.388	0.037	0.102	0.007	0.088
WHI-B3-2	0.557	0.351	3.768	71.565	0.017	0.000	0.000	0.054	2.211	0.077	0.000	1.384	0.029	0.060	19.109	0.050
YEL-B3-4	0.912	0.952	0.698	92.027	0.061	1.319	0.047	0.000	2.835	0.185	0.124	0.281	0.005	0.013	0.153	0.163
GRA-A4-5	2.944	0.517	1.809	92.643	0.277	0.207	0.077	0.186	0.613	0.187	0.232	0.062	0.080	0.000	0.000	0.010
RED-A4-2	6.486	0.208	1.187	50.653	2.737	1.502	0.198	0.073	34.912	0.727	0.009	0.138	0.020	0.042	0.248	0.025
B/GR-A4-3	0.126	0.167	0.480	77.226	0.342	5.613	0.420	0.000	1.260	0.000	0.000	12.432	0.005	0.624	0.102	0.040
RED-A4-3	0.663	0.493	0.566	44.677	0.383	2.861	0.359	0.012	47.960	0.416	0.012	0.026	0.020	0.925	0.000	0.012
MEAN	1.388	0.680	3.684	78.480	0.436	3.363	0.180	1.354	4.613	0.191	0.049	2.716	0.044	0.152	1.506	0.603

TYPOLOGY OF FORM AND MATERIAL IN CLASSIFYING SMALL AEGYPTIACA
IN THE MEDITERRANEAN DURING ARCHAIC TIMES: WITH SPECIAL
REFERENCE TO FAIENCE FOUND ON RHODIAN SITES

Günther Hölbl

Hirschengasse 21/36, A-1060 Vienna 6

Abstract

If an historical evaluation of the thousands of small Aegyptiaca spread over the Mediterranean in prehellenistic cultural contexts of the first millennium BC is to be made, then it is first necessary to classify the objects with regard to areas of manufacture or workshops. For this purpose we require a typological classification according to details of external shape and material. We know of four production groups of Egyptian type faience (late Egyptian, including Naukratis; Rhodian-Greek; East Phoenician; West Phoenician-Punic). For a more detailed classification and in order to assign dubious pieces on the basis of their composition, scientific analysis is essential. The rich and diverse faience from Rhodes seems to offer a promising field for investigation.

Keywords: EGYPT, SCARAB, FAIENCE, RHODES, GREECE, PHOENICIA

The historical aim

As in the Bronze Age, the Aegyptiaca - or in the wider sense, Egyptian cultural elements which diffused in the Mediterranean area during the first millennium BC - fulfilled a twofold cultural function. Primarily they were part of Egyptian culture but they also contributed to the local cultures of the Phoenicians, Greeks, Etruscans etc. This double function applies both to imported Egyptian originals and to locally developed elements based on Egyptian models, whether spiritual, artistic or technical.

The historical significance of this imported Egyptian culture depends mainly on local circumstances. Faience held an important position within the cultural contacts and interactions; in the Late Bronze Age it formed a specific component of contemporary cultural *koiné* which sometimes gives at least an impression of homogeneity. In this context we think for example of the beautiful faience rhyton from Kition (Peltenburg 1972 and others). But even in Late Geometric and Archaic times (eighth to sixth centuries BC) we frequently hear of a cultural and commercial *koiné* (e.g. Leclant 1972, 83), although the two active peoples of the Eastern Mediterranean, the Greeks and the Phoenicians, had such individual styles that this appears in certain ways to have been a bipolar one. The Aegyptiaca make up one of the characteristics of the several *koiné* (Greeks in the East,

Phoenicians at Pithekoussai, etc), although there are fundamental differences between the Egyptian cultural component adopted by the Phoenicians and that adopted by the Greeks.

The principle of examining the Aegyptiaca within a local culture leads us to the question of where these objects were manufactured. For it is obvious that mere imports found in a tomb have less significance than the fact that somebody imitates, purposely and with effort, objects which he cannot acquire by import; we may assume that these imitations were as acceptable to their owners as imported originals. A fundamental problem consists in differentiating between various production groups when considering the question of acceptance of or independence from Egyptian influence. To my mind the typological method in its different aspects seems most promising.

The typological method

The typological method aims at classifying Aegyptiaca in as much detail as possible. The typological criteria adopted in classifying Aegyptica are concerned with: (a) the external shape; in this sense stylistic elements are of particular importance and (b) the material; the relationship between form and material must be considered in each case. The formal typological classification must be differentiated from classification based on subject matter. This latter type of classification arranges figurines according to the divinities they represent (Sekhmet, Nefertem, Pataicos-figures etc.) or scarabs according to the philogical content of their inscriptions. With typological classifications it can happen that types which are separated by their subject are linked together, as for instance a certain group of steatite amulets of the Phoenician mother-country as well as the Punic West, which have in common stylistic features such as a bulky triangular nose, accentuated projecting eyes etc. I have named this in a recent study (Hölbl 1985, chapter III.3.3.) the 'standard style' (Einheitsstil) of Phoenician steatite figurines. This 'standard style' links certain figurines of Ptah, Nefertem, the Pataicoi of Isis and Harpocrates (Fig. 1), whereas other figurines of Nefertem are typologically unrelated.

Similarly, among scarabs, specific pieces of blue paste (Egyptian Blue), which first attracted my attention in Veii (Fig. 2) in contexts of the eighth century, can be traced also in Campania and in the East, e.g. at Megiddo, in northern Syria, at Kition, in Crete or at Corinth. These scarabs, unlike the usual scarabs of Egyptian Blue, often have a very thin glaze. On the bases there are partly Egyptian type representations, which one would not consider a priori impossible for the Nile Valley, but also representations of animals, which are stylistically typical of the Middle East, especially of northern Syria. The group is united among other things by a striking execution of the side view (instead of legs there is generally a horizontal bulge divided in the middle: Fig. 2b) and by a special kind of blue paste material. The cultural assignment of these pieces, which concentrate chronologically in the eighth century, must be determined by the Syrian type representations (Fig.2c-d), but it is due to the typology of form and material that we may know the real extent of the group.

A similar situation is found with the steatite figurines of the so-called 'standard style'. The material is uniform, with a particular splintered appearance and characteristic veining. This characteristic material allows us to include other anthropomorphic and theriomorphic Egyptian-type figurines, which do not exhibit the stylistic details of the 'standard style'. The cultural attribution follows from the fact that the

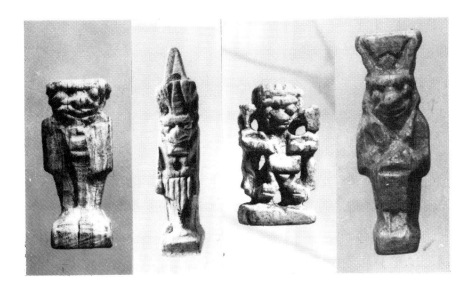

Fig.1 Steatite figurines from Dardinia in Phoenician 'standard style'; 3:1
 a) Ptah; Hölbl 1985, pl 5, 2a
 b) Nefertem: ibid, pl 8, 5b
 c) Pataicos from Tharros; ibid, pl 17, 1a
 d) Isis from Nora; ibid, pl 31, 1b.

Fig.2 Scarab of Egyptian blue from Veii (Etruria), Grotte Cramiccia, tomba 572 (middle of 8th century BC) Hölbl 1979, II, cat 37, pl 68, 4; 3:1.

bases of a few examples carry Phoenician signs, sometimes even a whole inscription (Hölbl 1985, pl.69, 1 c-d), which replace the usual patterns of Egyptian hieroglyphics.

Thus we arrive at the conclusion that typology of form and material can enable us in certain cases to define a production group of Aegyptiaca, even if many of the objects exhibit exclusively Egyptian characteristics; it was these Egyptian characteristics which gave them their magical efficacy. Similarly the primary classification of faience can be carried out by simple observation. For instance, we observe that the figurines of Sekhmet (Fig. 3) and Neferten found on Italian sites form a roughly homogeneous group, and the glaze is always well preserved (Hölbl 1979, I, 196). Connected with a similar typology are pieces from Camirus (Rhodes) (Jacopi 1932, VI-VII, 320-321, fig.63-64). It was remarked by the excavator of Lindos (Blinkenberg 1931, 339), that nearly all Nefertem figurines have lost their glaze. We are therefore confronted with the question: Is it the same material and were the burial conditions in the widespread tombs of Italy so much better than those of the pieces in the votive deposit of Lindos or are the materials and the production methods different, which would suggest that they came from different workshops and therefore have a different origin ? The faience amulets from 'Atlit in northern Palestine, in spite of wide thematic variety, present a very homogeneous aspect in formal typology, i.e. in stylistic features. According to the material employed we can discern two groups (Johns 1933, 48): (a) faience with well-preserved glaze of blue or greenish colour; (b) drab or buff faience which has lost its glaze.

The different appearances of the two types of faience is certainly not due to different burial conditions since examples of both kinds occur in one and the same tomb (Johns 1933, 96); both groups have also been found in Sardinia (Hölbl 1985, chapter II.3.2) (Fig. 4). But it becomes evident that the very same formal type (with rigorous measure of stylistic details) can be recognized in both kinds of material (Hölbl 1985, chapter II, note 441). The examination of Rhodian and Egyptian faience by Tite et al. (this volume), indicates, as perhaps also for 'Atlit, that the glaze was manufactured in one case by application and in the other either by cementation glazing or by the efflorescence self-glazing technique. The limits of the typological method are soon reached in the absence of any analytical information. If a bigger group of objects from far distant sites is linked only by characteristics of the material, then we are confronted with the question: Is the material really so uniform that we may justly postulate a single production group, or do we have an eastern and a western group ? It is also possible, as we have seen at 'Atlit, that pieces of uniform formal typology can be divided by different quality of glaze into two or more groups. Automatically we arrive at the question of a different basic composition indicating a different manufacturing process and after that follows the question of the manufacturing area; for instance, with which of the known production groups (which today we are able to define only in a very general sense) the objects in question can be associated. Here we have to choose between a late Egyptian (with a special branch at Naukratis), a no-smaller Rhodian or, better, East-Greek and an East-Phoenician and a West-Phoenician/Punic one. The two last mentioned are still very obscure, but their existence is indicated by moulds found, for example, at Sidon (G Contenau 1923, 273) and Carthage (Gauckler 1915, pl. CCXXVII) and by, unfortunately only few, typological criteria. To the East-Phoenician production most probably belongs a fine, soft, pale yellowish or buff faience, which is very friable and whose glaze has usually been lost; the West-Phoenician/Punic production is characterized by formal stylization, which is found only in the west (Fig. 5); it is characteristically a hard glassy faience (Hölbl 1985, chapter III.3.4).

Fig.3 Sekhmet of white (?) faience with pale green glaze from Veii, Vaccareccia, tomba 2 (about 700 BC) Hölbl 1979, cat 3, pl 38, 1; 2:1.

Fig.4 Pataicos of pale yellowish to buff, soft, fine faience without preserved glaze from Cagliari (Sardinia), S. Avendrace; Hölbl 1985, pl 14a; 2:1.

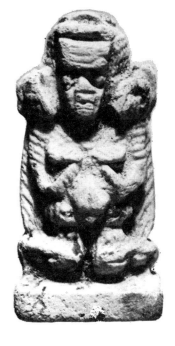

Fig.5 Falcon headed Horus with debased Egyptian crown glassy faience of grassy colour; from Sulcis (Sardinia), S. Avendrace; Hölbl 1985, pl 44, 1a; 1.5:1.

Faience from Rhodes

For a more detailed classification and in order to assign atypical pieces to a group on the basis of composition, scientific analysis will be essential. To solve the questions regarding the treatment and evolution of imported Egyptian cultural elements we have to concentrate on those areas which combine imports from Egypt with Egyptianizing objects and where archaeological evidence suggests that a local production existed. The island of Rhodes, at an intersection of sea routes from different directions, was also a centre of cultural interconnections in the Mediterranean area. It is a Greek island with a certain amount of Phoenician culture, perhaps (according to Coldstream 1982, 269) even a Phoenician *enoikismós*. A clear expression of the cultural influences interacting on Rhodes is, of course, Egyptian and Egyptianizing faience. These comprise:

(1) Egyptian imports - vessels (particularly 'New Year's bottles', e.g. Fig. 9), amulets of every kind: a great many figurines representing divinities, especially Bes, Pataicoi, Isis, Sekhmet and Nefertem from excavations of Salzmann and Biliotti; udjat-eyes, and many Egyptian scarabs, which also come from Naukratis.

(2) Greek faience - a large class of objects, which depends directly on the genuine Egyptian faience industry; I list first those pieces which do not exhibit a special oriental or Phoenician component of any kind. In this class we have:

 a) copies, or objects which show further development of Egyptian cultural elements but remain fully within the Egyptian frame. As for the copies we think for instance of little lentiform flasks (Fig. 6) as imitation of the Egyptian 'New Year's bottles' (Webb 1978, 70) or of non-Egyptian amulets in the shape of Egyptian divinities. Among the objects on which Egyptian elements are freely employed and further developed are the many scarabs from Lindos (Blinkenberg 1931, pl. 61-62) and Ialysos (stipe votiva, unpublished), which form a group with those from Perachora (James 1962; Hölbl 1979, 202-215; 1981, 190).

 b) faience objects with Egyptian decorative elements combined with Greek forms; we may think especially of juglets with painted Sekhmet-Aegis (Fig. 7), of the pyxides (Fig. 10), and alabastra (Webb 1978, 36-60).

 c) many East-Greek faience figurines with Egyptian features in structure and style, the Greek kouros-figurines in Egyptian style (Fig. 8) are noteworthy.

 d) faience in which Egyptian influence is more or less confined to the technique; for example, the globular aryballoi (Webb 1978, 108-113, 120-121).

The objects in (b) to (d) (Webb 1978) are, as Greek products, expressions of the Egyptian cultural element among Greeks.

(3) Faience with eastern stylistic features - faience with eastern stylistic features or Egyptian elements, which are employed in Phoenician or 'Phoenicianising' manner; we have for instance a beautiful tripod bowl in the British Museum (Webb 1978, 76-77, no 268), and vases in the form of a woman with an un-Egyptian mixture of Egyptian elements may also belong to this group (Webb 1978, 11-26; Hölbl 1979, 52-64). The Egyptian elements must form, in these cases also, an Egyptian cultural element among Greeks, even if in certain cases de facto artisans from the Near East were responsible for the products.

Rhodes, of course, is a very suitable area for investigation, because the

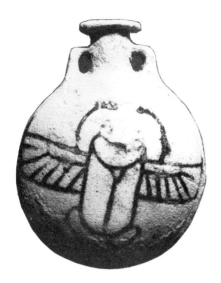

Fig.6 Rhodian 'Pilgrim flask' of whitish faience with traces of turquoise glaze (some yellow spots and design in black) from Camirus (Rhodes) H:78mm; Rhodes Mus inv 13829 Webb 1978, cat 255, 1:1.

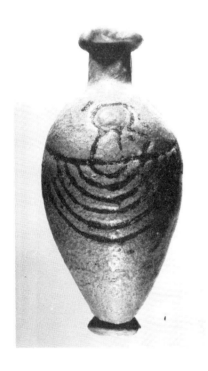

Fig.7 Rhodian juglet of faience with well preserved turquoise glaze; design of Sekhmet aegis (lines in dark brown, solar disk in yellow) from Camirus (Rhodes); H:78mm; Rhodes Mus inv 13698 Webb 1978, cat 284; 1:1.

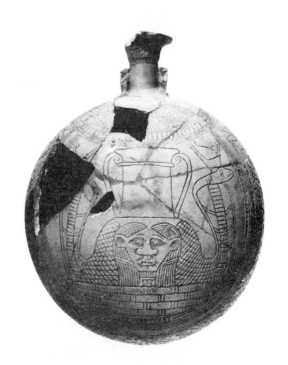

Fig.8 Kouros type figurine of whitish faience with turquoise glaze and brown details from Camirus (Rhodes); H:89.7mm; Rhodes Mus inv 13698; Webb 1978 cat 284; 1:1.

Fig.9 'New Year's bottle' of blue faience from Rhodes; BM Reg. No. GR 1861.4-25.29; 2:1.

Fig.10 Pyxis; BM Reg.No. 1864.10-7.1340; 1:1.

Egyptianizing faience can be linked to the corresponding Egyptian imports; both categories are represented in the votive deposits of Lindos, Ialysos and Camirus, and also in cemeteries, in rather large quantities.

The author is grateful to the Research Laboratory, British Museum, (Tite et al., this volume) for having undertaken the scientific examination of prehellenistic faience found on Rhodes and of two Egyptian shabti-figures of approximately the same date, for comparison. The most serious restriction has resulted from the fact that only rather big and damaged objects could be chosen for the examination. This means that it was not possible to approach the important question of originality and imitation among scarabs and the very small figurines of divinities, which cannot be decided by inspection alone. The purpose of the analysis was the examination of the microstructure of Rhodian, that is, Archaic Greek faience, in order to find out whether it differs from that of the Egyptian originals. Three of the analysed objects (21348, 21353, 21351) form a group, which according to visual criteria is un-Egyptian and belongs to the so-called Rhodian faience industry; they are also characterized by a thick surface layer, which can easily be distinguished from the core and is easily lost. The results of the examination suggested that the presence of a thick surface glaze, and of a thick quartz/glass interaction layer, combined with the absence or almost total absence of interstitial glass in the core, indicate that the glazing mixture was applied to the core prior to firing. The question is whether there are clear differences between the microstructure of the Archaic Greek objects and that of late Egyptian faience. The results of the examination of late Egyptian shabti (Tite et al. 1983, fig 8), do not reveal (in striking contrast to our Rhodian pieces) any clear interaction layer at all. Another faience glazing method, the efflorescence technique, was also used in the East-Greek industry of faience vases, for instance for pyxides, which often carry a really beautiful glaze of good consistency. In these cases (one pyxis, Fig.10, one other Greek vase, Fig.11), as is pointed out in the report, the microstructure does not exhibit any differences from that of the Egyptian 'New Year's bottle' Fig.9) examined for comparison. This means that for the present that our judgement remains limited to the criteria of formal typology including the range of colours.

When an investigator, occupied with Egyptian-type faience from outside Egypt, is trying to divide his material into Egyptian originals and objects made outside the Nile Valley, it is our experience that there are always pieces which remain in doubt. This is because exact stylistic parallels are not available or are inadequately published. Among the pieces analysed at the Research Laboratory, there are two (Figs. 12,13), which I considered as Egyptian, but as a precaution, supplied with a question mark. The microstructure has come out as practically identical with that of the two Egyptian shabtis and, as production method, the cementation glazing technique is suggested. I think, together with the authors of the report, that there is no reason to doubt the Egyptian origin of the two statuettes found on Rhodes.

Most of the few comparative analyses undertaken until now have their limitations. We need only call to mind the comparative examinations of Perachora scarabs and Naukratis scarabs in the British Museum (James 1962, 467). Today it is beyond all doubt that these scarabs represent two distinct production groups with quite different features, above all with regard to the decoration of the bases of the scarabs. The Perachora group from outside Egypt had disappeared by the end of the seventh century, when the Naukratis group was beginning. However, analysis did not reveal any differences. The blue paste material of the scarabs from Veii, of those

Fig.11 Dolphin-shaped vase; BM Reg.No. GR 1861.4-25.27; 1:1.

Fig.12 Figurine; BM Reg.No.
 GR 1864.10-7.133B; 2:1

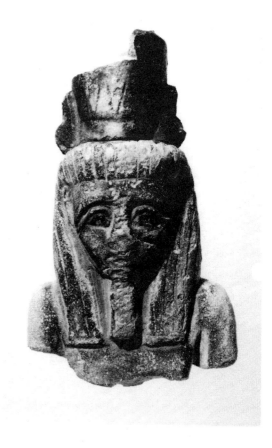

Fig.13 Figurine; BM Reg. No.
 GR 1864.10-7.850; 3:1.

from Perachora and those from Naukratis is distinguishable by the human eye but comparative analyses are lacking.

It is still necessary therefore to have a general integrated typological method. It is also essential that comparative analysis of faience from outside Egypt should be extended beyond the microstructure to include the chemical composition etc., especially since such good results have been published for Egypt herself by Kaczmarczyk and Hedges (1983).

From the point of view of the Egyptologist, we need as detailed a characterization as possible of faience techniques in the East-Greek, East-Phoenician and Punic territory. This must be the basic requirement for defining more closely different production groups according to chronology and region of production. Furthermore we have to discuss the distribution of the various production groups, which means that one has to try to define the distribution areas of certain types of Aegyptiaca: for instance the distribution area of the Perachora group seems approximately recognizable. Proceeding in this manner we should more easily gain some knowledge of the specific routes along which the Egyptian cultural influences travelled at various periods and, moreover, of the intermediaries who were the bearers of these Egyptian elements. There are intermediaries who cannot be considered in purely ethnic terms: (a) those who bring and distribute Egyptian imports, (b) those who work up the Egyptian originals, copying and developing further the Egyptian elements and (c) those who distribute the imitations etc. An assessment of the Aegyptiaca (of which the faience amounts to perhaps two-thirds) within and in association with the local cultures, which is required methodologically, already shows that there existed in the first millennium BC clear differences between the Greek islands (especially Rhodes), the Greek mainland (especially Perachora), Cyprus, Palestine and Phoenicia, Syria with the Greek settlements (e.g. Al Mina), and even more so in the west: Etruria, South-Italy and in particular West-Phoenian and Punic areas.

References

Blinkenberg Chr (1931). Lindos Fouilles de l'Acropole 1902-1914, I: Les petits objets. Berlin

Coldstream J N (1982). Greeks and Phoenicians in the Aegean. In Phonizier im Westen, H G Niemeyer ed., 261-275. Mainz, Ph v Zabern

Contenau G (1923). Deuxième mission archéologique à Sidon (1920). Syria IV, 261-281

Gauckler P (1915). Nécropoles puniques, I-II. Paris

Hölbl G (1979). Beziehungen der ägyptischen Kultur zu Altitalien, I-II. Leiden, Brill

Hölbl G (1981). Die Ausbreitung des ägyptischen Kulturgutes in den ägäischen Raum vom 8, bis zum 6 Jh v Chr Orientalia 50, 186-192

Hölbl G (1985). Ägyptisches Kulturgut im phonikischen und punischen Sarsinien, I-II. Leiden, Brill

Jacopi G (1932). Clara Rhodos, VI-VII. Bergamo

James T G H (1962). The Egyptian-Type objects. In Perachora, The sanctuaries of Hera Akraia and Limenia, II, T J Dunbabin ed., Oxford University Press

Johns C N (1933). Excavations at 'Atlit (1930-31). Quarterly of the Department of Antiquities in Palestine 2 41-104, pl. XIV-XXXVII

Kaczmarczyk A and Hedges R E M (1983). Ancient Egyptian faience. Warminster, Aris & Phillips

Leclant J (1972). Remarques préliminaires sur le matériel égyptien et égyptisant à Chypre. In Acts of the First International Congress of Cypriot Studies A. Nicosia

Peltenburg E J (1972). On the classification of faience vases from Late Bronze Age Cyprus. In Acts of the First International Congress of Cypriot Studies A. 129-136, pl XXIII. Nicosia

Tite M S Freestone I C and Bimson M (1983). Egyptian faience: an investigation of the methods of production. Archaeometry 25, 17-27

Webb V (1978). Archaic Greek faience. Warminster, Aris & Phillips

THE SCIENTIFIC EXAMINATION OF PRE-HELLENISTIC FAIENCE FROM RHODES

M S Tite, I C Freestone and M Bimson
British Museum Research Laboratory, London WC1B 3DG

Abstract

A small group of prehellenistic faience from Rhodes (Hölbl, this volume) has been subdivided into three on the basis of microstructure and inferred method of manufacture. A locally produced group of faience appears to have a glaze formed by the direct application of the glaze mixture. A second group, employing the efflorescence technique, may be of mixed provenance while the microstructure of a third group of material imported from Egypt suggests the use of the cementation method of glazing.

Keywords: FAIENCE, RHODES, EGYPT, MEDITERRANEAN, TECHNOLOGY, PROVENANCE, MICROSTRUCTURE

Introduction

A small group of prehellenistic faience objects (first millennium BC) from Rhodes, selected by Hölbl (this volume), were examined in order to establish whether or not there were any technological or compositional differences between faience imported to Rhodes from Egypt and that produced in Rhodes itself in an Egyptian style. The choice of objects was to a considerable extent influenced by the need to avoid disfiguring the object when cutting the required section through the glaze. With this restriction, objects were selected in order to represent both imported and locally-produced material. In addition, two shabti-figures produced and found in Egypt and of approximately the same date as the Rhodian material were included for comparison.

Experimental procedures

Polished sections through the glazes and into the cores of the faience objects were examined in the scanning electron microscope (SEM) in which the phases present could be distinguished on the basis of their atomic number contrast (i.e. the quartz appears darker than the higher atomic number glass phase). Analyses of various phases within the sections were undertaken using an electron microprobe.

Results and discussion

(a) *Microstructure*

The SEM examination showed that, typically, the faience consists of a quartz core containing varying amounts of interstitial glass (Fig.1: Layer III). The core is encased in an interaction layer which is made up of quartz embedded in a continuous matrix of glass (Layer II). Overlying this interaction layer, there is in some cases a surface layer of quartz-free glaze (Layer I). The microstructure of the faience can therefore be defined in terms of: (1) thickness of the surface glaze layer; (2) the thickness of the glaze-core interaction layer; (3) the nature of the boundary between the surface layers and the core, and (4) the extent of any interstitial glass phase within the quartz core. Data on these parameters, together with details on the objects, are given in Table 1.

On the basis of observed microstructures, it was possible to divide the faience objects into three primary groups. The method of production used for each of these three groups could then be inferred by comparing the associated microstructure with those observed in faience reproduced in the laboratory by the three principal methods used in antiquity: that is, by direct application of the glaze and by the efflorescence and cementation glazing techniques (Tite *et al.* 1983, Vandiver 1983).

The first group consists of three objects thought to have been made in Rhodes (21348, 21353, 21351). The glaze is thick with a tendency to be even thicker in incisions and indentations in the surface and in places it is flaking away from the core. The microstructures are characterised by thick surface glaze and glaze-core interaction layers (200 - 600μm) and by quartz cores which contain either no interstitial glass (21351, 21353) or only sufficient glass to produce bonding between apices of angular quartz grains (21348) (Fig.2). The boundary between the surface layers and quartz core is clearly defined. Because of the thick surface glaze layers, the clearly defined boundaries and the limited amounts of interstitial glass, it seems probable that these objects were made by direct application of the glazing mixture, in the form of prefired and ground frit, to the surface of the quartz body prior to firing.

Fig.1 Diagramatic representation of the microstructure of faience showing surface glaze (Layer I), glaze-core interaction (Layer II) and quartz core (Layer III).

The second group consists of two objects thought to have been produced in Rhodes (21349, 21352) and one thought to have been imported to Rhodes from Egypt (21350). One has a uniformly white glaze (211349) and the other two have uniformly thin bluish glazes with some coloration in the cores (21352, 21350). The microstructures are characterised by no, or only thin and fragmented, surface-glaze layers (20 - 50μm) and thick glaze-core interaction layers (100 - 400μm) which merge into and are not readily distinguished from the quartz cores (Fig.3). The cores themselves contain fairly extensive interstitial glass which is sufficient to bond together adjacent faces of the quartz grains and even to surround the smaller quartz grains. Because of the diffuse boundaries between the surface layers and the cores, and because of the extensive interstitial glass in the cores, it seems probable that these objects were made by the efflorescence glazing technique in which the glaze components were mixed with the quartz body prior to firing.

The third group consists of two objects thought to have been imported to Rhodes from Egypt (21346, 21347), as well as two shabti figures which were both produced and found in Egypt (21566, 21343). The glaze is irregularly distributed, thick in some places and apparently absent in others. The microstructures are all characterised by no or only thin fragmented surface glaze layers (20μm) and thick glaze-core interaction layers (100 - 300μm). For shabti 21343, the boundary between the surface layers and the core is fairly diffuse and the core contains sufficient glass to bond together the adjacent faces of the quartz grains (Fig.4). It therefore seems probable that this object was also made by the efflorescence glazing technique. In contrast, for the other three objects (21346, 21347, 21566), the boundaries

Table 1 MICROSTRUCTURE DATA

BMRL no.	Registration no.	Description	Suggested production region [1]	Surface glaze (Layer I)[2] μm	Glaze-core interaction (Layer II) μm	Boundary[3] (Layer II to Layer III)	Core (Layer III) interstitial glass[4]	Suggested production method
21348	64-10-7-797	Figurine	Rhodes	200	300	Defined	Apex	Applied
21353	60-4-4-65	Cup	Rhodes	600	600	Defined	None	Applied
21351	64-10-7-804	Figurine	Rhodes (?)	200	200	Defined	None	Applied
21346	64-10-7-850/926	Figurine	Egypt (?)	(20)	200	Defined	Apex/face	Cementation/efflor.
21347	64-10-7-1338	Figurine	Egypt (?)	(20)	100	Defined	Apex/face	Cementation/efflor.
21566	-	Shabti	Egypt	(20)	200	Defined	Apex/face	Cementation/efflor.
21343	66664	Shabti	Egypt	-	300	Diffuse	Face	Efflorescence
21349	64-10-7-1340	Pyxis	Rhodes	(50)	400	Diffuse	Face	Efflorescence
21352	61-4-25-27	Vase	Rhodes	-	200	Diffuse	Face	Efflorescence
21350	61-4-25-29	Bottle	Egypt	-	100	Diffuse	Face	Efflorescence

1. Based on typological criteria by G Holbl, (this volume) except for 21343 and 21566 which were produced and found in Egypt.

2. Brackets indicate that the glaze layer is irregular in thickness and fragmented.

3. Defined - boundary between surface layers and core clearly defined.
 Diffuse - boundary diffuse such that surface layers and core merge and are not readily distinguished.

4. Apex - glass produces bond between apices of adjacent quartz grains

5. Face - glass produces bond between faces of adjacent quartz grains.

Fig.2 SEM photomicrograph of section through faience cup from Rhodes (21353) showing severely weathered glaze layer, glaze-core interaction layer and quartz core containing no interstitial glass. The high atomic number areas in the core (white) represent unreacted mineral phases (feldspars etc.) present as impurities in quartz sand.

Fig.3 SEM photomicrograph of section through faience pyxis from Rhodes (21349) showing weathered surface glaze layer and glaze-core interaction layer which merges into the more porous quartz core containing extensive weathered interstitial glass.

Fig.4 SEM photomicrograph of section through faience shabti from Egypt (21343) showing glaze-core interaction layer (grey - light grey/white) and quartz core containing sufficient interstitial glass (white) to bond together adjacent faces of quartz grains (grey).

Fig.5 SEM photomicrograph of section through faience figurine from (?) Egypt (21347) showing fragments of surface glaze (white), glaze-core interaction layer (grey-white) and quartz core containing only sufficient interstitial glass (white) to produce bonding between apices of quartz grains (grey).

are reasonably clearly defined and the cores contain only sufficient glass to produce bonding which is predominantly between apices of the quartz grains rather than between adjacent faces (Fig.5). These observations together with the thin fragmented surface glaze layers suggest that the three objects could have been made by the cementation glazing technique in which the objects were fired whilst buried in a glazing mixture. However, because the amount of interstitial glass is sufficient to produce some bonding between adjacent faces of the quartz grains in the cores, the use of the efflorescence glazing method of production remains a possibility.

(b) *Composition*

The glaze on all the faience objects studied was severely weathered such that there had been almost total depletion of alkalis from the surface glaze layers and, except for one of the shabti figures produced and found in Egypt (21343), the alkali had also been lost from throughout the glaze-core interaction layers. In consequence, the analytical data obtained for both the surface glaze and glaze-core interaction layers are of limited use. Although some alkalis survived in the interstitial glass in the core, the extent of such glass was insufficient for quantitative analysis using the electron microprobe available.

Therefore, as a result of the effect of the weathering, the analytical data could not be used to investigate whether or not there were any significant and consistent differences in glaze composition between the locally produced and imported faience. The analytical data are therefore not included in this paper.

Conclusions

By means of the SEM examination, it has been possible to group together faience objects with similar microstructures and thus provide supplementary criteria for distinguishing between faience produced locally in Rhodes and that imported to Rhodes from Egypt. For example, the microstructures observed support the hypothesis that objects nos.21348, 21353 and 21351 were all produced in Rhodes, whereas objects nos.21346 and 21347 were imported from Egypt. However, the microstructure is merely a reflection of the method used to glaze the faience and it is fairly certain that the three principal methods of glazing (direct application, efflorescence and cementation) were all used in, for example, Egypt during the first millennium BC (Vandiver 1983). Therefore, similarity between the microstructures for a group of faience cannot be taken as definite proof that they were all produced in the same region, but should merely be used to support or otherwise any typological groupings.

Because of the severe weathering experienced by these objects, the major element analytical data for the glaze cannot be used to help distinguish between locally-produced and imported faience.

References

Tite M S, Freestone I C and Bimson M (1983). Egyptian faience: an investigation of the methods of production. Archaeometry 25, 17-27

Vandiver P (1983). Egyptian faience technology. In Ancient Egyptian Faience, Kaczmarczyk A and Hedges R E M, A1-144, Aris and Phillips, Warminster

TECHNOLOGICAL STUDIES OF MEDIEVAL AND LATER PERSIAN FAIENCE: POSSIBLE SUCCESSORS TO THE FAIENCE OF ANTIQUITY

Barbara Kleinmann

Windeckstrasse 6, 68 Mannheim

Abstract

In his treatise the medieval Persian potter Abu'l Qasim gave an exact description of how Persian faience was manufactured. The artificial quartz-frit body is closely related to Egyptian faience of earlier millennia, and both this relationship and the correctness of Abu'l Qasim's instructions and recipes have been confirmed by predominantly textural studies. A similar technique was used for the later Persian faience of the Safavid and the following periods and is currently used by the stone paste potters in Iran. The elaborate Turkish faience from Iznik, dating from the fifteenth to the seventeenth century, was also manufactured according to the method described in Abu'l Qasim's treatise.

Keywords: FAIENCE, ABU'L QASIM, ANALYSIS, MICROSTRUCTURE PERSIA, SEM, FIRING, GLAZE

Introduction

The French term 'faience' orginally referred to ceramics made of a clay body with a white opaque (usually tin) glaze in the Italian city of Faenza. Though it is not etymologically correct, the term will be used here for the high-quartz bodies known as Egyptian and Persian faience. The more scientific-technical term for this artificial product would be 'quartz-frit body' as already proposed by Lucas and Harris (1962).

The technique of making an artificial white faience body was in use from the fifth millennium BC throughout the Near East. It served as a core-material for glazed objects like beads, amulets and small figurines whereas vessels made of glazed faience appeared much later. At the beginning of the first millennium AD this technique fell out of use and there is little evidence of any survival. About a thousand years later, in the twelfth century or perhaps earlier, the process of making a white faience body was revived by Syrian or Persian potters. This provided a suitable material for a white, dense ware in imitation of Chinese stoneware or porcelain. Perhaps the white slip of the Samanid pottery, consisting of finely ground, angular quartz fragments in a clay matrix, can be considered to be a link between the early faience body and Persian faience.

Under Seljuq rule in Persia and Syria a substantial production of faience began in the twelfth century. Older glazing and decorative techniques were continued and brought to perfection. One of the types of faience was painted with underglaze colours developed from the Samanid slip-painted ware and glazed with a transparent, mostly colourless alkaline glaze of a very uniform composition, whereas a second type, called Persian lustre-faience was glazed with an alkali-lead-tin glaze with inglaze or lustre-painting similar to the Samarra faience.

Abu'l Qasim's treatise on ceramics, written in 1301 AD (Allan 1973, Ritter et al. 1935), describes how to make the white quartz-frit body: 10 parts of powdered quartz pebbles, 1 part clay and 1 part of a glaze frit, the latter made by fritting together powdered quartz and plant ash in the ratio of 1:1. The vessels made of this body are then coated with the same glaze frit now serving as a glaze. After the vessels have dried in the sun, they are fired in a closed earthenware pot to avoid contamination by smoke and furnace debris.

The microstructure of medieval Persian faience

The investigations carried out on medieval and later Persian faience as well as on Ottoman Iznik pottery revealed that all three groups had been manufactured by the same technique, which can be traced back to the recipe of Abu'l Qasim. They are discussed together in the following paragraphs.

Macroscopically, the quality of the faience varies due to differences in microstructure. In most cases they are very fine grained and quite hard. Usually the faience bodies are brilliant white but sometimes have a yellow, grey or pink tinge due to impurities. Between sherd and glaze, a very white and more glassy transition zone can be observed in most samples.

Microscopic investigation of thin sections reveals that the body mainly consists of angular quartz fragments with a range of grain sizes predominantly 10-50µm but up to 100µm ('sifted through silk' as advised by Abu'l Qasim) in a glassy matrix; occasionally plagioclase or potash-feldspar can be found, but no calcite. The pores are irregularly shaped and sometimes very large. The more glassy transition zone can best be seen in polarized light: the quartz fragments do not show any change in grain size as one would expect if the transition zone represented an applied slip. Abu'l Qasim does not mention the use of a slip and none could be observed on any of the sixty or so samples of medieval Persian faience analysed.

The polished section of Iznik ware (Fig.1) shows that the porous body is overlain by a broad transition zone in which the quartz fragments are entirely embedded in the glass matrix. The pores have disappeared almost completely except for small round bubbles, which indicate a high degree of degassing during firing. A simultaneous, limited penetration of this uppermost zone of the sherd by the glaze may be inferred because of the behaviour of the under-glaze blue (cobalt) painted on the surface before the glaze was applied. Since cobalt tends to 'run' in a melting glaze, it coloured the transition zone blue, as has been observed in many samples. The polished section of a medieval Persian faience (Fig.2) shows a broad transition zone between the sherd and the purely alkaline glaze. Here too the quartz fragments are entirely embedded in the glassy matrix which contains round bubbles. Large round bubbles which have accumulated exactly at the base of the glaze have been observed in most of the samples analysed. This is very typical of these purely alkaline glazes with a high

Fig.1 Turkish (Iznik) faience, Ottoman period, fifteenth to seventeenth century (reflected light). Note the broad transition zone with a few round bubbles in contrast to the large irregularly shaped pores of the quartz-frit body. Scale bar = 250μm.

Fig.2 Persian faience of the twelfth to fourteenth centuries showing thick transition zone and large bubbles accumulated at the base of the glaze (reflected light). Scale bar = 250μm.

silica content (65 - 70%) and a correspondingly high viscosity. On the other hand, Iznik glazes (Fig.1) are less viscous alkaline-lead glazes with a silica content below 60%.

According to Abu'l Qasim the quartz-frit body contains about 10% of clay, which gives enough plasticity to enable a vessel to be thrown on a potter's wheel. However such a vessel may collapse during drying and in order to avoid this, the modern stone-paste potters in Iran add an organic binder (gum tragacanth) (Wulff 1966) which hardens during drying and preserves the shape of the vessel. Though Abu'l Qasim does not especially mention the use of such a glue it is possible that one was used by the medieval potters. For glazing, the pot was dipped in a suspension in water of the ground glaze-frit. A ceramic body of this composition requires only one firing as described by Abu'l Qasim and as practised by the Iranian stone-paste potters (Wulff 1966). The high percentage of a refractory material such as quartz, and the use of the same frit for both body and glaze reduce the shrinkage to a minimum and avoid problems due to the differing thermal expansion of body and glaze. The bubbles accumulated at the base of the glaze (Figs. 2 and 3) are formed by gases released from the body during firing which are considered to derive in part from the clay in the body and the organic binder.

Parmelee (1973) considers the effect of the bubble population on the physical strength of glazes, on their resistance to corrosion by chemicals and weathering and on their brightness and other properties. He suggests some possible methods for reducing the bubble content of a glaze, including an interfacial coating or wash with alumina between body and glaze. Such a layer causes an increase in the viscosity of the glaze at the interface and reduces the diffusion of gases throught it. This is demonstrated in the sherd shown in Fig.3 where the transition zone is very thin. On the left, a thin layer of underglaze pigment (small white grains) marks the original sherd surface; these pigments must have been applied before the glaze. The medium generally used by potters to fix underglaze pigments is a washed clay, which is itself rich in alumina. That medieval potters also used clay was confirmed by microscopical studies and by the microprobe. New-formed minerals such as diopside are restricted to the layer with the pigments and a much higher alumina content is found at the glaze / sherd interface. Thus the clay medium used to fix the pigment may also have improved the quality of the glaze by reducing the number of gas bubbles.

Table 1 presents the XRF bulk chemical analyses for the three groups of faience investigated, compared to data from the literature (Allan 1973) and to the old analyses of Egyptian faience carried out by Lucas (1962). The mineralogical and chemical composition suggests an almost identical production process throughout several centuries. The same frit was used for body and glaze as indicated by the lead oxide content in the body of the Iznik faience, which has a glaze of the alkali-lead type. Later we will refer to the relatively high alumina content of the medieval Persian faience which differs from the values given by Allan et al. (1973) for this material. Qualitative chemical analyses of the very inhomogeneous interstitial materials were carried out with the scanning electron microscope and revealed a silicate glass similar in composition to the glazes.

The microstructure and quality of Safavid faience

Medieval Persian faience is generally of a good quality because of the amount of clay added, as indicated by the high alumina content of the interstitial glass. However, among the Safavid faience of the sixteenth to

Table 1 XRF analyses of quartz - frit body material from Islamic pottery of various periods

	SiO_2	Al_2O_3	CaO	MgO	K_2O	Na_2O	PbO	Fe_2O_3	P_2O_5	N
Persian, 12-14th cent. Seljuq - Ilkhanid period	84.6 (80.0-90.0)	4.8 (3.0-7.0)	2.0 (1.2-2.2)	0.9 (0.8-1.2)	1.1 (0.9-1.3)	2.6 (2.0-4.0)	(0.5)*	0.7	0.1	29
Persian, 16-18th cent. Safavid and later periods	89.7 (82.0-92.0)	3.1 (1.8-5.4)	1.5 (0.9-1.5)	0.8 (0.5-1.0)	0.9 (0.5-1.2)	2.8 (2.0-5.0)	n.d.	0.4	0.2	16
Turkish, 15-18th cent. Iznik - Ottoman period	92.8 (88.0-94.0)	1.6 (1.4-1.9)	1.7 (1.5-2.2)	0.7 (0.5-1.2)	0.6 (0.5-0.8)	2.0 (1.6-2.5)	2.3 (1.0-3.0)	0.7	0.1	9
Persian, 13-14th cent. (Allan et al. 1973)	90.7	1.6	1.4	0.6	1.1	3.3	0.4			14
Egyptian 'faience', 18th dynasty (Lucas and Harris, 1962)	92.2	2.4	1.9	0.9	– 1.5 –		1.1			10

* = in all samples with lead-tin glazes
n.d. = not detected
N = number of samples analysed

S,Cl analysed in present study but detected only in earlier Persian group (SO_3 = 0.1, Cl = 0.2)

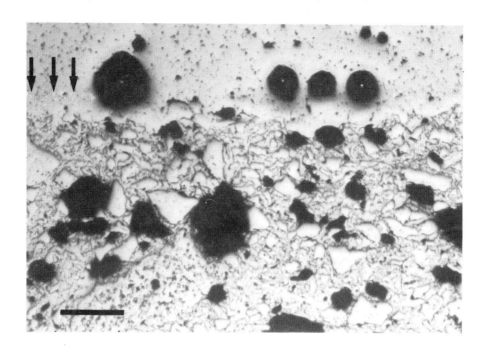

Fig.3 Persian faience of the twelfth to fourteenth century (reflected light). Thin transition zone. Small white grains near base of glaze are pigment and represent the original surface of the body, indicated by arrows. Scale bar = 250μm.

Fig.4 Safavid faience (no 125). A hard, dense almost porcelain-like body with low porosity and fine grain size. SEM photomicrograph. Scale bar = 100μm.

eighteenth centuries extreme differences in sherd quality have been observed. For textural studies with the scanning electron microscope four sherds were selected which represent the range of types from a very dense, almost porcelain-like body to a very friable one. Examples are shown in Figs. 4 and 5 (from polished sections, the sample numbers refer to Table 2). It can be seen that the grain size of the quartz fragments plays a very important role. The hardest sherd (no.126) consists of fine quartz fragments predominantly less than 50μm and occasionally up to 100μm. The interstitial glass contains dispersed minute angular quartz fragments. The transition zone can be distinguished by its low porosity. In figure 4 (no.125) a less hard sherd is shown. The proportion of quartz fragments with grain size above 50μm is greater, but here too the interstitial glass contains enough fine-grained quartz to form a well-sintered and solid sherd. The transition zone is visible as usual. The pore-volume is similar to that of the hardest sherd, in this case it seems to be less important for the strength of the material.

Figure 5 (no.135) shows a sherd which seems to be quite porous and friable to the naked eye: comparing its microstructure with that of the hard body of Fig. 4 it is apparent that the poor quality is due to differences in grain size of the quartz fragments with a high proportion of grains larger than 100μm and the absence of very fine fragments within the interstitial glass. This results in an increased porosity. The transition zone is characterised by a smaller grain size. In this case it may be inferred that a slip from a more carefully prepared quartz-frit mixture has been applied on the already shaped vessel; such a process was observed by Wulff (1966) in the workshops of the modern Iranian stone paste potters. The last example (no.132) is even more friable due to large quartz grains and a tendency of the smaller ones to cluster. There is too little interstitial glass to attach the coarse fragments together, so that a high porosity and friability results.

Fig.5 Safavid faience (no 135). Friable sherd with coarse grain size and high porosity. SEM photomicrograph. Scale bar = 100μm.

Table 2 XRF analyses of quartz-frit body material from Safavid pottery, Iran, 16-18th cent.

		SiO$_2$	Al$_2$O$_3$	CaO	MgO	K$_2$O	Na$_2$O	Fe$_2$O$_3$	TiO$_2$	P$_2$O$_5$
129	body hard and solid, highly sintered, porcelain-like	86.3	4.5	1.6	1.1	1.1	5.0	0.3	<0.1	<0.1
126		86.7	4.4	1.7	1.0	1.0	4.9	0.3	0.1	<0.1
125	body hard and solid, still highly sintered	87.1	4.7	1.2	0.9	1.0	4.6	0.3	<0.1	<0.1
134		92.3	2.6	1.1	0.9	0.8	2.4	0.4	<0.1	<0.1
135	body porous, brittle and friable	92.5	3.4	1.1	0.7	0.8	2.2	0.7	0.2	n.d.
119		91.7	3.5	1.1	0.6	1.3	2.0	0.4	0.1	0.2
132	body porous, very brittle and highly friable	92.0	1.9	1.2	0.7	0.5	2.3	0.8	0.1	n.d.
121		83.4	1.5	5.4	2.9	0.8	2.4	0.3	<0.1	3.1

n.d. = not detected; S,Cl analysed but not detected

Table 2 shows the analyses (XRF) of the bodies of the Safavid samples. The quartz in the stronger bodies (no.126 and no.125, Fig.4) is of a finer grain size and, based on their alkali and alumina content, these sherds have a higher proportion of glass frit and of clay compared to the more friable bodies. The addition of clay is also important for the durability of a glaze and its resistance to weathering. Porosity measurements of these samples confirm what can be seen from the micrographs: the less friable samples low in silica but with a higher proportion of glass have less open pores (about 24 vol.%) and a higher density than the others (about 37 vol.%).

Conclusions

The foregoing demonstrates the relationship between the quality of a faience body and its microstructure. To summarize, the solidity of such bodies depends on their porosity, the grain size and the grain size distribution of the quartz fragments as well as on the amount of the interstitial glass. A friable body is characterized by a higher porosity due to coarser quartz grains and a low glass content. However, the solidity will rise the more the quartz is evenly distributed in the glass and if the distance between the individual fragments is small. This can be optimised by using quartz of a fine grain size limited to a narrow range such as 10-50μm. The glass phase was developed from a glass frit, as advised by Abu'l Qasim, and not from a mixture of alkalies and quartz which would have segregated due to efflorescence effects. The admixed clay (1:1 according to Abu'l Qasim) dissolved in the frit during its remelting and increased the amount and strength of the interstitial glass phase. Its composition is such as to expect the local formation, depending on firing temperature, of secondary minerals (for instance diopside, mullite, feldspars or wollastonite) in the transition zone between clay body and a glaze. From x-ray diffraction data it was established that besides varying amounts of cristobalite only some diopside is present which indicates firing temperatures around 1000°C. Even at high magnifications the quartz fragments showed no signs of melting at their margins as would be the case in stoneware or porcelain. Complete solution of even the finest quartz fragments in the glass phase did not occur. The transition of quartz into cristobalite starts at the surface and is favoured by a small grain size and the presence of alkalies (Salmang and Scholze 1968). The firing temperature cannot be defined exactly but, according to the varing amounts of cristobalite in each sample, a temperature range of 1000 - 1050°C may be assumed. Temperature is a less important factor for the quality of the quartz-frit body because of the addition of a glaze frit in such a proportion to the quartz that an optimal coating of the fragments is guaranteed. Abu'l Qasim's recipe is based on a long experience with this material, and the recipe specifies a body containing 8.3% frit, 8.3% clay and 83.4% quartz (Allan et al. 1973). The calculated components of a typical sherd with a chemical composition of 91.4% SiO_2, 2.4% Al_2O_3, 2.3% CaO, 1.2% MgO, 0.8% K_2O and 2.1% Na_2O will have the proportion frit:clay:quartz being 13.0 : 6.3 : 80.7. This shows encouragingly good agreement with Abu'l Qasim's specification; differences may reflect the variations inherent in the chemical compositions of individual batches of raw material and also the possibility that the ingredients were not weighed carefully or were mixed by dry measure.

In modern ceramic technology a related similar material is manufactured as silica refractories, which are very resistant to corrosion. They have a silica content of more than 94%, a small amount of lime in an amorphous

interstitial phase and a porosity of around twenty per cent, not much less than the hardest sherd of the Safavid sample (24 vol %). Fired at much higher temperatures than the Persian quartz-frit material, they contain cristobalite, tridymite and some residual quartz (Salmang and Scholze 1968). For both materials a slow cooling is required because of the volume changes associated with the phase transitions of silica, which will cause the formation of cracks in the body. Abu'l Qasim left his ware to cool for one week. Abu'l Qasim mentions one single firing, also the modern stone paste potters fire their wares only once (Wulff 1966). His 'pots of two firings' are the ones decorated with lustre-painting applied on the already fired glaze; they require another firing at lower temperatures. The tendancy of the cobalt blue to 'run' into the intermediate zone has already been mentioned. This indicates one single firing. If the vessel had been fired without a glaze, the applied underglaze colours would have reacted with their surrounding material, either the washed clay-suspension with which they were bound to the surface or the pottery surface itself. Spinel-like crystals would have formed, i.e. blue cobalt aluminate. This reaction has been described by Fuchs (1982) for the blue painted Egyptian vessels from Malqata and was confirmed by my own experiments with a quartz-frit material (made according to Abu'l Qasim's recipe) and cobalt oxide. A number of other metal oxides used for underglaze colours behaved in the same way. During the second firing these new formed spinel-like pigments remain undissolved on the surface and their colours will not invade the glaze or the transition zone. If there had been two firings, these pigments would have been formed and could have been identified in the microscope. However none was found in all the samples analysed, including examples of Safavid and Turkish (Iznik) faience. The main argument for one firing is that it is not necessary to fire this material twice.

The need for brevity prevents discussion of all the analytical work that has been done on Egyptian faience. The possible methods of manufacture are summarised by Tite *et al.* (1983). However, their similarity to Persian faience in composition and structure is so striking that the latter may be considered to represent a revival of the earlier technique. We are fortunate to have Abu'l Qasim's treatise which, in the light of the present results, appears to describe accurately how Persian faience was manufactured.

Acknowledgements

This work is part of a large scientific study of Islamic pottery from the ninth to the nineteenth century, carried out at the Staatliche Museum in Berlin and supported by the Stiftung Volkswagenwerk. The author wishes to thank Dr Johanna Zick of the Museum für Islamische Kunst, Berlin, for providing and selecting the samples from the sherd collection of the museum and for many most useful discussions. Many thanks are due to Dr Frank Wlotzka, Max Planck-Institut für Chemie, Mainz, for allowing the use of the microprobe there and also to Dr Gerwulf Schneider, Arbeitsgruppe Archaeometrie an der Freien Universitaet Berlin, for his help with the XRF analyses. The author is very grateful to the Gerda Henkel Stiftung for financial support to attend the British Museum's Symposium.

References

Allan J W (1973). Abu'l Quasim's treatise on ceramics. *Iran* 11, 111-121

Allan J W, Llewellyn L R and Schweizer F (1973). The history of so-called Egyptian faience in Islamic Persia: investigations into Abu'l Qasim's treatise. *Archaeometry* 15, 165-173

Fuchs R (1982). Gedanken zur Herstellung von Farben und der Überlieferung von Farbrezepten in der Antike am Beispiel der in Ägypten verwendeten Blaupigmente. In *Diversarum artium studia: Beiträge zu Kunstwissenschaften, Kunsttechnologie und ihren Randgebieten: Festschrift für Heinz Roosen-Runge zum 70 Geburtstag*, H Engelhart and G Kempter eds., 195-208 Wiesbaden, Reichert

Lucas A and Harris J R (1962). *Ancient Egyptian materials and industries*. London, Edward Arnold

Parmelee C W (1973). *Ceramic glazes*. Boston, Mass

Ritter H, Ruska J, Sarre F and Winderlich R (1935). Orientalische Steinbücher und persische Fayencetechnik. *Istanbuler Mitteilungen* 3, 31-49

Salmang H and Scholze H (1968). *Die physicalischen und chemischen Grundlagen der Keramik*. Berlin, Springer Verlag

Tite M S, Freestone I C and Bimson M (1983). Egyptian faience: an investigation of the methods of production. *Archaeometry* 25, 17-27

Wulff H E (1966). *The traditional crafts of Persia*. Cambridge Mass, The MIT Press

AEGEAN GLASS: CONTINUITY OR DISCONTINUITY?

Virginia E S Webb

19 Abbot's Place, Canterbury, Kent

Abstract

This survey paper sets out to examine the clearest evidence for the status and use of glass in both Bronze and Iron Age Greece. It establishes the first appearance of glass in Mycenean Greece, with strong eastern connections, outlines the development in the use of glass in the Mycenaean period, then shows its use dying out at the end of that period. Cast glass is widespread, trail-decorated and core-wound vessels uncommon, probably imported. With the fall of the palaces, glass manufacture ceases. Its reappearance in Iron Age Greece is a slow process, although distinctive imported glass objects are found during the period of Greek contact with the East, and the developing contacts with the West. Not until the establishment of workshops making distinctive, small core-wound vessels designed to contain unguents, probably on Rhodes, in the mid-sixth century, is it certain that glass is again being made in the Aegean.

Keywords: GLASS, FAIENCE, GREECE, AEGEAN, MYCENAEAN, BRONZE AGE, IRON AGE.

Introduction

The appearance of vitreous materials in the Aegean area provides an interesting case study of the contrasting problems of innovation versus technical dependance. In the case of glass, it would appear that the Aegean was largely dependent on the innovatory centres in the East, and moreover, it seems that the introduction of glass usage takes place twice, in the Late Bronze Age, and then nearly a thousand years later, in the pre-classical Iron Age of Greece.

Glass-making is an arcane skill, not to be handed on by mere report or copying, but by direct apprenticeship. Such craft knowledge as had been built up in the East, and that we have seen evidenced there in both faience and glass, did not exist in the Aegean, though we should accord Minoan Crete a special status with regard to her development of faience (Foster 1979). Because glass was a difficult material to make, with high prestige and perhaps even magical qualities assigned to it, and with its manufacture a jealously guarded monopoly, the history of its use in the Aegean is both informative and suggestive of the areas with which the Aegean was in contact, and of the nature of the diffusion of such technical knowledge.
The date of its invention in the Middle East (Mesopotamia) is still matter for debate (Brill 1970, Peltenburg - this volume) but by looking at the

Aegean, and especially the well-dated Mycenaean contexts, we can trace both the date of its appearance in the Aegean and the subsequent development in its use in a specific cultural area.

The Mycenaean Period

The earliest glass objects in Mycenaean Greece seem to indicate a strong link with the Eastern centres of glass-working. These first pieces of glass to appear in Greece are all apparently of cast glass, including a unique fluted bowl, and we know that this was a technique in use in the East. We owe their recognition to the observations of a number of scholars (Müller 1909, Craig 1970, Fossing 1940). The earliest pieces are elements from necklaces: plain cylindrical beads, pendants and multiple spacers of a distinctive type. From Shaft Grave I, Grave Circle A, Mycenae, comes a multiple spacer (Karo 1930) while from Chamber Tomb 516 (Wace 1932) more complete parts of a similar necklace, including a decorated multiple spacer (with parallels from Nuzi (Starr 1939). All these are made of a solid-textured, cast glass, quite unlike the later, typically Mycenaean plaques which are of spongy texture, and they have their closest parallels with Eastern glass (Barag 1970). Both graves belong to Late Helladic I, and must date to the second half of the sixteenth century.

Further finds in slightly later contexts, but implying even more direct links with the East, have been discussed by Müller (1909) and Craig and Barag (1970). These comprise nude female plaques and star disc pendants - both of undoubted eastern type, and with a large number of parallels from both North Syria and Mesopotamia. These are small in number and now in a very fragmentary condition, but their presence in apparently early Late Helladic contexts is very suggestive, as is the fact that they occur together in significant groups (see Barag and Craig (1970) for detailed discussion). The question of the exact relationship between the eastern finds and their western outliers, is one which awaits detailed technical and stylistic analysis.

These comparatively few objects, then, are all of distinctive material and design. The star disc pendants are apparently of dark blue, but there also occurs a brilliant opaque turquoise blue and this can be paralleled in eastern glass, for instance the plain 'ingots' in the form of undecorated star disc pendants. But such brilliance of colour and fineness of texture can also be found in Minoan Crete (Knossos inlay fragment, Ashmolean, unpublished). Perhaps we should remember that the Kakovatos fluted bowl copies Minoan metal prototypes, and bear in mind that Minoan Crete, with its high level of pyrotechnic skill, may well have had some part to play in the early stages of the introduction of glass technology to the Aegean. This possibility requires further investigation.

The question of the origin of the glass metal used in Mycenaean Greece is one which has plagued workers in the field, and conflicting results in scientific and technical analysis have resulted. Analysis by arc emission spectroscopy and neutron activation of both Mycenaean, Egyptian and Near Eastern glass (Sayre 1964 and 1974) apparently clearly indicates that it is the Near Eastern glass which is alien, and that Mycenaean and Egyptian New Kingdom glasses share common constituents in remarkably similar proportions. This finding is apparently borne out by analyses which show raised aluminium values indicating the use of Egyptian deposits of cobaltiferous alum as the source of cobalt (Kaczmarcyk and Hedges 1984). However, the fact that the very earliest glass in Mycenaean contexts is of distinctive Near Eastern design and technique suggests that the picture is more complex. A programme of combined stylistic and technical analysis is planned using Near Eastern glass from Nuzi (Webb and Vandiver forthcoming).

In Late Helladic II and III the use of glass was adopted on a large scale in both the Mainland and Crete for the manufacture of pendants, inlay pieces and other small items, all of typically Aegean design. The frequent finds of stone moulds for the making of such elements confirm this picture (Haevernick 1960, Vermeule 1967). The texture of much of this glass is spongy and light with clear traces of the movement of the glass in cooling. The colouring is pale blue-violet, opaque or sometimes translucent, with sometimes a very dark blue-black colour (seated lioness inlays from Dendra) or bright turquoise (the curl elements for a headdress from the same tomb: Persson 1931). An unusual piece of moulded glass in the form of the hilt of a Mycenaean sword (Acropolis: Haevernick 1963) is a bright, translucent blue with a smooth fine texture and shows a more careful use than usual of the glass. Like similar faience hilts (Foster 1979) it presumably formed part of a ceremonial or ritual object, and must of necessity be the product of a local workshop (it can be dated to Late Helladic II). The link between faience and glass-working is of great interest; another link is the copying in glass of rectangular plaques first made in faience in Middle Helladic times. This connection requires further investigation.

Later tombs have flat, schematic elements of poor colour and repetitive nature but clearly the glass continues to have the same importance. Whether left clear or coated with gold leaf, the elaborate assemblages of glass elements are the prerogative of the rich / aristocratic families associated with the Mycenaean kings. Such precious work, the product of the palace workshops, is just one indication of the enormous wealth of the Mycenaean kingdoms.

A great variety of beads are also present in large quantities from Late Helladic II onwards. These are of good quality glass, mass-produced as a substitute for cut stone or shells, with trail, eye and applied decoration in contrasting colours. Comparisons for many of these can be found in the Nuzi material (Vandiver 1983). Whether these were made in Greece or not is more difficult to say. They certainly have close contacts with eastern types but the find in a Late Mycenaean grave in Athens of tools which included an apparent mould for spherical beads (Immerwahr 1973), suggests that at least some of these beads were made locally.

The last type of glass to be considered is in fact the one most popular in those areas where glass technology originated. That is to say, the core-wound vessels, decorated with glass trailed in contrasting colour and then marvered into the surface. One might assume that such vessels would be popular in the Aegean and would be imitated. That they apparently were not may indicate the difficulty of the techniques involved, and the fact that glass had already established itself as a cast material for plaques etc. Such finds of core-wound vessels as have been made are few in number. Two come from Crete, and Weinberg (1963) has convincingly argued for a source in Egypt. A number of others were found in Rhodian Late Mycenaean tombs (Harden 1981) and there is an unpublished fragment from Mycenae. Most of these find-places are in areas with contacts with Cyprus and the Levant and an ultimate origin in Egypt seems assured.

Finds of glass from the sub-Mycenaean cemetery at Perati at the end of the Mycenaean period (Iakovidis 1969) show a clear falling off in both the quality and quantity of the glass present although of course we are dealing with a different social class. No longer are there rich burials with the prestige trappings of multiple glass plaques and pendants. Instead we find stray pieces, single beads and amulets, which may have been treasured from earlier more prosperous times or imported from outside Greece.

The Dark Age

During the succeeding centuries of the Protogeometric and Early Geometric periods, glass, like the other luxury crafts of faience, ivory and gold work, disappeared with the fall of the palaces which had supported them. It seems fairly certain that the only finds of glass which are made can be shown to be much older Mycenaean glass, rescued from graves and reused or, later on, to have been imported from outside the Aegean.

A suggestive sequence comes from the newly excavated graves in the North Cemetery, Knossos (Coldstream 1985). From a Sub-Minoan grave comes a single trail-wound bead, perhaps an eastern import, and a small dark blue bead -the pathetic relics of better times, discovered perhaps in the opening of an earlier tomb and reused as offerings together with two Mycenaean faience seed-shaped beads. From a later, very rich Protogeometric tomb comes a single Mycenaean glass rosette. A Late Protogeometric grave on Skyros (Papadimitriou 1936), discussed by Snodgrass (1971) contained both Mycenaean gold discs and a string of dark blue glass beads.

The first signs of renewed contact with the Eastern Mediterranean are faience disc beads, very similar to those found in Cyprus. In Athens and Lefkandi, Euboea, some glass does accompany these faience necklaces, but glass on its own does not reappear until later. When it does appear again, it takes the form of well-made spherical or doughnut-shaped beads, translucent icy green or dark brown in hue, deposited in burials as complete necklaces of graduated beads. Comparisons for such glass must be looked for in the East, and examples can be found as far as Northern Iran, but it must surely be the sophisticated centres of Northern Mesopotamia which are their origin (Harden 1981, Goldstein 1979). Such beads have also been found as far west as eighth-century Italy (Hencken 1968), illustrating the revival of East-West trade in Greek and Phoenician hands. Another type which appears in similar contexts from about the middle of the eighth century are the so-called 'bird beads' (Frey 1982).

Alongside such a quantity of simple glass objects, there are more complex ones, also made of the same icy hue as the spherical beads: seals with Phoenician Egyptianising motifs in relief occur as popular. imports, apparently made in a mould with the perforation drilled through afterwards (Boardman 1968). Other much more impressive imports are the hemispherical bowls of icy green glass which have been found at Fortetsa (Brock 1957) and Praeneste (Curtis 1919). Compare these with the Sargon vase, an alabastron in translucent glass found at Nimrud. These, like many of the beads, were most likely cast and then cold-worked using stone-workers techniques. We must assume that they were intended to mimic rock-crystal, that they required great skill, and that they were only possible, or indeed attempted, in the most wealthy centres of the day. No attempt, understandably, was made to imitate such vessels in the Aegean although it seems possible that some of the spherical beads which are not of translucent glass may have been produced there from recycled material.

The old technique of core-wound glass with trail decoration, also makes its reappearance at this point. Like the hemispherical bowls, brought from the East to participate in the trade with metal-rich Etruria, the juglet from Fortetsa (Brock 1957) has its closest parallels in two finds made in Northern Italy (Weinberg 1962). There is also a comparable piece from Camirus (Barag 1970) and a new unpublished find from Eretria may well belong to this group; a date around 700 BC is most likely.

In addition a small group of unusual objects found in late seventh-century contexts in the Aegean, suggest that experimentation in trail-winding glass was already taking place. These consist of terracotta hawks and staff-

pendants with multi-coloured glass applied as an outer coating (Hogarth 1918, James 1961, Webb - in press, Gordion unpublished Cat.No. G378 Univ.Mus.Philadelphia). Whether this industry was based in the Aegean, or further east, is a question which still waits to be solved.

Other groups of core-wound glass, of extremely high quality, make an appearance in later seventh century Greece, most especially in Rhodes. (Surely not entirely due to the rich graves excavated there but also to Rhodes' key position on the shipping route from Cyprus and the Levant to the wealth of the west). One such group can be identified in Mesopotamia, Rhodes and Carthage (Barag 1970) while another specific type, with a distinctive ring foot, has so far only been found on Rhodes (Harden 1981).

No attempt was made by local workshops to imitate these and it was not until Rhodes had already played host to a derivative faience industry, established using Egyptian technical knowledge (Webb 1978), that any attempt was made to establish a glass industry. What is of interest here is that, like the faience vessels before them, the glass miniature alabastra and amphoriskoi are specifically designed to sell their contents -some unguent or perfumed oil. Finds of a 'waster' used in a child's grave, and the distinctive button knobs at the base, have convinced Weinberg (1966) that the industry was indeed local; and glass manufacture, now once again established in the Aegean, was not to be lost again.

References

Barag D (1970). Mesopotamian core-formed glass vessels 1500 - 500 BC. In Glass and glassmaking in ancient Mesopotamia, Oppenheim et al. 131-199. Corning

Boardman J (1968). Archaic Greek gems. London

Brill R H (1970). The chemical interpretation of the texts. In Glass and glassmaking in Ancient Mesopotamia, Oppenheim et al. 105-128. Corning

Brock J F (1957). Fortetsa: Early Greek tombs at Knossos. Cambridge

Coldstream J N (In press). Knossos: the North Cemetery, Early Greek tombs. British School at Athens Supp.Paper

Craig B (1970). In Glass and glassmaking in ancient Mesopotamia, Oppenheim et al. 187-189. Corning

Curtis C D (1919). The Bernadini Tomb. Memoirs American Academy at Rome 3

Fossing P (1940). Glass before glassblowing. Copenhagen

Foster K P (1979). Aegean faience of the Bronze Age. New Haven

Frey O (1982). Zur geschichtlichen Bedeutung der frühen Seefahrt. Kolloquien zur Allgemeinen und Vergleicher den Archäologie. Munich

Goldstein S M (1979). Pre-Roman and Early Roman glass in the Corning Museum. Corning

Haevernick Th E (1960). Beitrage zur Geschichte des antiken Glases, III, Mykenisches Glas. Jahr.Rom.Germ.Zentr.Museums.Mainz 7, 36-50

Haevernick Th E (1963). Mycenaean glass. Archaeology 16, 90-3

Harden D B (1981). Catalogue of Greek and Roman glass in the British Museum vol 1

Hencken H (1968). Tarquinia, Villanovans and the early Etruscans. Cambridge, Mass.

Iakovidis S E (1969). Perati, to nekrotapheion. Athens

Immerwahr S (1973). Early burials from the Agora cemeteries. Agora 13, 231-32

James T G H (1961.) The Egyptian type objects. Perachora 2, 451-516

Kaczmarcyk A (1984.) Ancient Egyptian faience. Warminster

Karo G (1930). Die Schachtgraber von Mykenai. Munich

Müller K (1909.) Alt-Pylos II. Die Funde den Kuppelgrabern von Kakovatos Mitt.Deutsch.Arch.Inst.Athenische Abteilung 269ff and 297

Mylonas G E (1964). The Grave Circle B of Mycenae. Lund

Persson A W (1931). The Royal Tombs at Dendra near Midea. Lund

Papadimitriou J (1936). Ausgrabungen auf Skyros. Archaeologischer Anzeiger 51, 228-234. Berlin

Sayre E V (1964). Some ancient glass specimens with compositions of particular archaeological significance. BNL 879 T-354 New York

Sayre E V (1974). Analytical studies of ancient Egyptian glass. In Recent advances in science and technology of materials: vol 3, Bishay A 47-70. London, Plenum Press

Snodgrass A M (1971). In The Dark Age of Greece, 242. Edinburgh, The University Press

Starr R F (1939). Nuzi, Report on the excavations at Yorgan Tepe, 1927-31. Cambridge, Mass

Vandiver P (1983). Glass technology at the mid-second millennium BC Hurrian site of Nuzi. Journal of Glass Studies 25, 239-47

Vermeule E T (1967). A Mycenaean jeweller's mold. Bulletin of Museum of Fine Arts 65, 19 Boston

Wace A J B (1932). Chamber tombs at Mycenae. Archaeology 82

Webb V (1978). Archaic Greek faience. Warminster

Webb V (in press). The Faience objects from the Basis. Brit. Mus. Colloquium on the Dating of the Basis Deposit of the Artemision at Ephesus

Weinberg G (1962). Glass vessels in the museums of Greece. Annales du 2e Congrès des Journées Internationales du Verre, 45-53. Liège

Weinberg G (1963). Kretika Chronicha 15-16, 1961-62

Weinberg G (1966). Evidence for glassmaking in ancient Rhodes. In Mélanges Offerts à Kazimir Michalowski, 709-712. Warsaw

THE REPLICATION OF AN OPAQUE RED GLASS FROM NIMRUD

Michael Cable and James W Smedley

University of Sheffield
Department of Ceramics, Glasses and Polymers,
Elmfield, Northumberland Road, Sheffield S10 2TZ

Abstract

As is well known, Mallowan (1954) found cakes of an opaque red glass in a room of the Burnt Palace at Nimrud, associated with charcoal which has a radiocarbon date about 350 BC. This glass is of a type not made today, being rich in oxides of lead and copper and low in silica; a series of melts attempting to replicate this sealing-wax red glass, coloured by precipitated cuprous oxide, has therefore been made. Parameters studied included different batch materials for lead and copper, varying the copper, tin and antimony content, the melting temperature and heat treatment. Serious segregation during melting occurred in the conditions originally used but this was largely suppressed by a better choice of batch material to supply copper. In nearly all cases it was difficult to prevent production of appreciable quantities of a bronze alloy present as a pool in the bottom of the crucible but an appropriate range of colours was produced.

Keywords: GLASS, RED, NIMRUD, MELTING, REPLICATION, OPACIFIER, CUPRITE

Introduction

Ingots of an opaque red glass were found by Mallowan (1954) in a room of the Burnt Palace at Nimrud; charcoal associated with the ingots has since given a radiocarbon date of around 350 BC. Associated finds implied that this was an area where glass was being made (Turner 1954, Mallowan 1954). An analysis of a small piece of the glass by Bimson, using classic gravimetric methods, was reported by Turner and is given in Table 1 together with a more recent electron microprobe analysis of another fragment by Freestone (1986).

Table 1

Analyses of the Nimrud red glass and the composition
used for replication trials (wt%)

Oxide	Nimrud glasses		Base glass for replication
	Bimson	Freestone	
Na_2O	9.71	9.46	10.1
K_2O	1.91	1.43	2.0
CaO	4.4	3.82	4.6
$Al_2O_3 + Fe_2O_3$	4.5	1.11	4.4
PbO	22.8	24.96	22.2
SiO_2	39.5	42.28	39.0
Cu_2O	13.6	8.58	12.5
Sb_2O_3	4.1	4.19	4.5
SnO_2	0.41	NA	1.2

Microscopic examination of a fragment, kindly made available by the Research Laboratory of the British Museum, showed the glass to be less homogeneous than it appears to the naked eye. The colour is due to bright red dendrites but interspersed among these are some opaque yellow patches which, at higher magnification, prove to be particles too small to reveal any structure. The red dendrites are fairly closely packed and appear to show both 60° and 90° branching; the main arms of the dendrites are up to about 350μm long but the side arms are often only about 2μm wide and spaced about 8μm apart. The red colour may thus be attributed to ordinary scattering of the incident light by relatively large particles which are themselves the colour seen in white light; these dendrites are of cuprous oxide (cuprite).

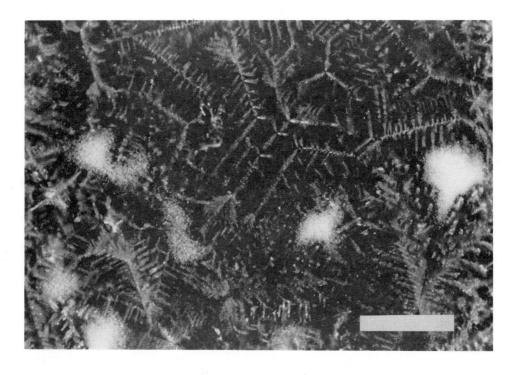

Fig. 1 Polished section of Nimrud glass seen by diffuse reflected light. The large dendrites are red Cu_2O and the very pale patches are fine textured yellow Cu_2O. The bar represents 0.2mm.

The glass also contains significant numbers of small rounded colourless mineral grains, probably quartz, often about 0.15mm in diameter but occasionally up to 0.5mm. There are also a few bubbles, typically about 0.3mm diameter and a few irregularly shaped particles of metal. These observations were made on fragments from near the outer surfaces of one of the original ingots of glass and thus may not be typical of the whole of the original glass. Figure 1 shows a micrograph of a polished section of one of these fragments.

The red cuprite glass found at Nimrud has an unusually low silica content (though still above 50 mole %) and almost as much copper as lead (in molar terms), which is extremely unusual; similar glasses have not been made on a significant scale in recent times. During the last several hundred years copper has often been used to make transparent red (ruby) colours and occasionally opaque brown due to cuprous oxide; the lithyaline glass of Egermann (Bachtik and Pospichal 1964) is of this type.

Relatively oxidized glasses can contain high concentrations of copper dissolved as cupric (Cu^{++}) ions which produce attractive blue to green tints depending on concentration of copper and type of glass. Even these glasses may contain some of the copper as cuprous (Cu^+) ions which produce no visible absorption but may fluoresce. Melting in more reducing conditions (lower oxygen partial pressure or higher temperature) can produce a paler tint by reducing Cu^{++} to Cu^+ and completely colourless glasses can be made. Strongly reduced glasses have a limited solubility for cuprous ions and, on cooling below melting temperature, precipitation of cuprous oxide or metallic copper may occur and produce the red to brown glasses already described.

It was decided that the only practicable approach for a glass technologist investigating the production and properties of the Nimrud glass was to proceed as if it were a modern glass-making problem and to attempt to replicate it. The descriptions of glass-making given in the famous Mesopotamian glass texts (Oppenheim 1970) are by no means clear and unambiguous, but it is quite clear that glass-making at that period was carried out in several stages separated by grinding and mixing and not in a single operation as in the tests described in this paper. Trying to guess and copy the practices of the original Nimrud glass-makers seemed too uncertain so replication was attempted straightforwardly by using the methods normal to current laboratory practice.

The user of any glass may specify one or more properties of the final product and care nothing about the problems of making it; this may be almost as true today as when this glass was made. The glass-maker must consider several important questions which may affect the quality and properties of the product. Many glasses are difficult to make either free from bubbles or homogeneous in composition and hence properties. Choice of raw materials, melting history (time, temperature, atmosphere), working technique and heat treatment can all influence the product but the final result rarely provides direct information about these things. Examining the results of replication trials conducted in known conditions is often the best way to obtain such information.

Experimental methods

Glass composition

The Nimrud glass may be regarded as having alkali, lime, alumina, lead oxide and silica as its basic glass-making constituents; iron oxide would

be an inevitable but undesirable impurity. The constituents controlling the colour obviously include copper oxide but probably also antimony and tin. Extensive experiments on modern copper ruby glasses suggested that the behaviour would not be sensitive to small variations in any of the major constituents but might be very sensitive to variations in copper, antimony or tin. A standard composition was therefore selected for this work (see Table 1). Only the last three constituent oxides (copper, antimony and tin) were varied, by simply adjusting the amounts added to a standard batch producing 400g of glass.

Raw materials

The alkalis, lime, alumina and silica were always supplied by soda ash, potash, limestone, hydrated alumina and sand. Antimony was added as the oxide (Sb_2O_3) and tin as finely divided metal (Sn), but alternative sources were tried for lead (red lead, litharge or lead silicate) and copper (cuprous oxide, cupric oxide or cupric carbonate). Graphite (C) was also sometimes used as a reducing agent to supplement or replace tin. Tin and carbon differ in reducing action: both react with any available oxygen during the initial stages of glass-melting and are probably about equally effective at that stage. However, carbon burns to carbon monoxide or carbon dioxide and is lost from the melt whilst tin oxide dissolves in the melt where it can exist as either stannous (Sn^{++}) or stannic (Sn^{4+}) ions. Tin can therefore help to control oxidation or reduction processes within the melt later in glass-making but carbon cannot. Antimony may behave like tin because it can exist as either Sb^{3+} or Sb^{5+} ions.

Melting conditions

The carefully mixed batches were melted in good quality clay (mullite) pots in a gas-fired furnace which permitted control of both temperature and furnace atmosphere. Although the atmosphere could be controlled the oxygen partial pressures involved are not known accurately. Melts were made in strongly reducing conditions (probably $<10^{-7}$ atm O_2) at temperatures between 1010 and 1250°C. Strongly reducing conditions are usually needed to avoid the production of colours due to Cu^{++} ions. Most melting was done with the furnace at constant temperature, the hot pot being lifted out to be filled with cold batch, but a few used various programs of time and temperature to be described later. Melting time was generally 5h but some melting schedules extended to 12h. Sets of four or five melts could be made at the same time; valid comparisons could thus be made between those melts even if either temperature or furnace atmosphere were not maintained as accurately as desired.

At the end of melting the pots were generally lifted out of the furnace and stood on the furnace room floor to cool. The difference in thermal expansion between glass and pot usually made the glass crack in several places, the cracks radiating more or less centrally from the axis. Tapping generally made the pot split neatly producing several wedges of glass adhering to pot revealing a vertical section through the melt from centre line to pot wall. These were examined with a hand lens and, when required, photographed immersed in a liquid of similar refractive index thus avoiding extensive grinding and polishing. Small sections were also prepared for microscopic examination.

Results

The choice of batch materials had very important effects on the glass produced. The section shown in Fig.2 is typical of many melts made using red lead (Pb_3O_4) and cuprous oxide (Cu_2O). The melt shows very clear horizontal layers: at the bottom there is a layer of bright red opaque glass, very like the original Nimrud glass; above it is a thinner band of opaque yellow glass like the small yellow regions in the Nimrud glass. This becomes a muddy brown and fades away into the bulk of the transparent green (due to cupric ions) and seedy melt above. A thinner layer at the top is an opaque brownish red typical of precipitated cuprous oxide. The surface in contact with the atmosphere shows extensive patches and pimples of metal oxides.

The layering of the melt is due to segregation during the early stages of melting. This is a common problem when some of the batch constituents react together much more easily than others; if the first liquid formed is denser than the final product and also very fluid it easily runs to the bottom of the pot and remains there. This problem is likely to affect glasses of significant lead content, as noted long ago by Faraday (1830). Measurement of the densities of samples from several melts confirmed that this was the main source of the large scale inhomogeneity (Table 2); all the melts suffered bad density stabilized segregation. The density of the original Nimrud glass is about 3.29 g cm^{-3} and that of cuprous oxide about 6.5 g cm^{-3}. Electron microprobe analysis has confirmed that these density differences involve segregation of the heaviest elements to the bottom of the melt. In one case the top layer had 9.9% Cu_2O, 19.9% PbO and 45.5% SiO_2 whilst the bottom had 14.6% Cu_2O, 29.0% PbO and 31.0% SiO_2. The antimony and tin also showed greater concentrations at the bottom of the melt.

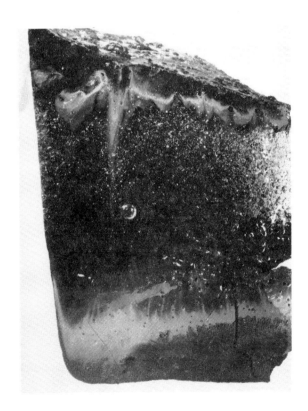

Fig. 2 A wedge of a typical melt made using red lead and cuprous oxide which shows serious melting segregation. The figure represents a width of 32mm.

Table 2

Densities (g cm^{-3}) and colours of samples taken
from different parts of several melts

Melt No.		Top	Middle	Bottom
12	colour	red brown	clear green	red
	density	2.88	3.17	3.91
55	colour	red brown	dull brown	red brown
	density	2.75	3.02	3.26
58	colour	dull red	red brown	brown
	density	2.94	3.01	3.21

The other problem revealed by these early melts was excessive oxidation of the copper. The bulk of the melt (about 60%) is transparent green, the colour being due to Cu^{++} ions; however, the intensity of the colour shows that only a small proportion of the copper present had been oxidized to cupric. Experience shows that precipitation of metallic copper is generally impossible in any glass with a detectable tint due to Cu^{++} and precipitation of cuprous oxide may also be difficult. The upper red-brown layer shows that the furnace atmosphere was sufficiently reducing to convert cupric to cuprous, permitting precipitation of cuprous oxide. The atmosphere was, in fact, able to reduce the copper and lead in contact with it to metal, not merely oxide, hence the pimples and globules on the surface of the melt.

Successful production of the desired opaque red glass thus depended on (1) preventing segregation during the early stages of melting and (2) achieving more uniform reducing conditions inside the melt without excessive reduction at the surface of the melt by interaction with the gas atmosphere. More reducing melting conditions would be achieved by replacing red lead by litharge. Red lead spontaneously decomposes to litharge at about 580°C, somewhat below the temperature at which many glass forming reactions become rapid,

$$2Pb_3O_4 \rightarrow 6PbO + O_2\uparrow \qquad (1)$$

Red lead is thus a very effective oxidizing agent in making, for example, lead crystal. Its use in this glass seemed inappropriate. Lead silicate ($PbSiO_3$) was also used in some melts. Refractory oxides such as silica and alumina are often unreactive and best avoided as batch materials. Table 3 shows the melting points of some of the metals and oxides relevant in this work; it can be seen that copper and its oxide have much higher melting points than lead and litharge. Addition of lead, copper and silica to the batch, all as oxides, would hardly ease problems involving reactivity in melting; some alternative source of copper was desirable. Replacing a cuprous compound by a cupric one would, presumably, have the same disadvantage as using red lead but very few cuprous compounds are readily available.

For reasons that will become clear later metallic copper was regarded as very unsuitable so cupric compounds had to be used. The sulphate and chloride were inappropriate for such large proportions of copper; the basic

carbonate $CuCO_3 \cdot Cu(OH)_2 \cdot H_2O$, which is the same as malachite except for its additional water of crystallization, seemed particularly appropriate and cupric oxide was also avaiable. Trials with various combinations of all these raw materials also included varying tin, antimony and copper as well as the addition of graphite. It was not likely that all the secrets of a subtle process like glass-melting would be revealed in one series of experiments. This proved to be the case but sufficient was learnt to make a summary of the main features useful.

Table 3

Melting points (°C) of metals and oxides

Metal		Oxide	
Cu	1083	Cu_2O	1235
Pb	327	PbO	886
Sn	232	SnO_2	1630
Sb	630	Sb_2O_3	656

The source of lead

Replacing red lead by lead silicate ($PbSiO_3$) decreased the amount of silica to be dissolved but did not eliminate segregation during melting. In melts where the batch was heated very rapidly to the maximum melting temperature lead silicate gave a more reduced melt (no transparent green areas) than red lead. Replacing red lead by litharge (PbO) also decreased the production of oxidized green glass but gave worse melting segregation because of its lower reactivity when all the silica was once again added as quartz.

The source of copper

When litharge replaced red lead also replacing cuprous oxide by cupric oxide had only a small oxidising effect but possibly a beneficial effect on melting segregation. With basic copper carbonate density induced segregation was definitely decreased but the melt was also somewhat more oxidised. Most subsequent trials therefore used litharge and copper carbonate instead of the original red lead and cuprous oxide. These melts were entirely opaque with only small variations in colour from top to bottom, clearly demonstrating that significant melting segregation no longer occurred.

Reducing agents

Precipitation of cuprous oxide in glasses of this type requires reduction of cupric to cuprous. Strong reducing agents are usually needed to make transparent copper-ruby glasses, but those rarely contain more than 1% copper oxide. The classic Ellingham diagram (Fig.3), shows the conditions necessary to maintain equilibrium between metals and their oxides and gives some insight into the functions of antimony, tin and carbon in these melts. It must, however, be emphasized that oxides dissolved in glass melts often behave very differently from pure oxides and that such a diagram can sometimes give very misleading predictions about glasses. Fortunately that does not seem to be true here.

This diagram yields two important pieces of information. First, each line shows the variation of the equilibrium between a metal and its own oxide with temperature; drawing a line from \underline{X} to the scale on the right shows the oxygen partial pressure needed to maintain equilibrium between metal and oxide. Thus $4Cu + O_2 \rightleftarrows 2Cu_2O$ needs about $pO_2 = 5 \times 10^{-10}$ atm at 800°C but $Sn + O_2 \rightleftarrows SnO_2$ needs about $pO_2 = 10^{-14}$ atm at 1000°C. Higher oxygen pressures permit oxidation of metal to oxide. Secondly, the order of the lines or values of free energy (ΔG), read off at any particular temperature, show which metals and oxides can oxidize or reduce each other.

Alumina and silica are extremely stable and difficult to reduce to metal. If either of these were added to a glass as metal it would be oxidized even if that could only be achieved by reducing another oxide to metal. Tin and antimony would be oxidized and reduce either Cu_2O or PbO to the metal. Below about 870°C antimony would be a more powerful reducing agent than tin but the opposite is true at higher temperatures. Copper is more easily reduced than lead below about 1230°C but the contrary is true above this temperature. Carbon is a more powerful reducing agent than tin or antimony above about 800°C. These inferences are important to the production and composition of metal globules at the surface of the melt which is discussed below.

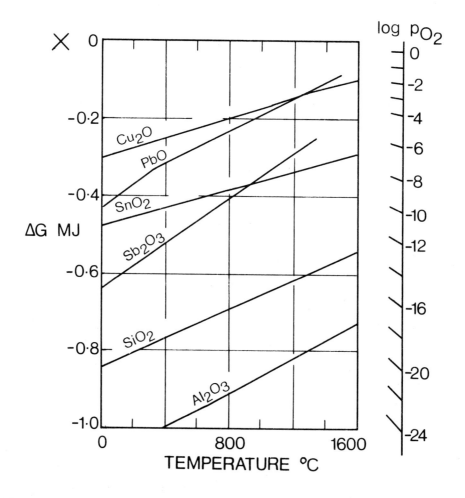

Fig. 3 Ellingham diagram for the equilibria between several metals and their oxides. The energies (ΔG) all refer to equations written to involve one molecule of oxygen gas, as in equations 1-4 in the text. Oxygen partial pressures (atmospheres) are given by the appropriate straight line drawn from X to the scale at the right.

The third vital point, about which Figure 3 unfortunately tells us little, is the chemical interaction between the ions of elements of variable valence. Our reliable knowledge about this is regrettably meagre; one of the best sets of data is that of Johnston (1965) for sodium disilicate at 1085°C. Since copper can exist in two valence states it is reasonable to assume a reaction of the form

$$4Cu^{++} + 2O^{--} \rightleftarrows 4Cu^{+} + O_2(g). \qquad (2)$$

Similar oxidation-reduction processes may occur for

$$2Sn^{4+} + 2O^{--} \rightleftarrows 2Sn^{2+} + O_2(g) \qquad (3)$$
$$\text{and} \qquad 2Sb^{5+} + 2O^{--} \rightleftarrows 2Sb^{3+} + O_2(g) \qquad (4)$$

When two or more of these elements are present in a glass they can interact so that the physical evolution of oxygen and its transport to or from the atmosphere are unnecessary. For example, combining equations 2 and 3 gives

$$2Cu^{++} + Sn^{++} \rightleftarrows 2Cu^{+} + Sn^{4+}. \qquad (5)$$

Such interactions generally tend to go strongly in one direction and the behaviour of copper, antimony and tin in sodium disilicate at 1200°C is exactly what Fig.3 implies: tin will reduce either antimony or copper to their lower valence states and antimony will reduce copper but not tin. Antimony may be a more powerful reducing agent than tin at lower temperatures but this is not certain. The assumption of such interactions indicates why the Nimrud red glass needs a reducing agent and suggests that antimony and tin together might be better than either alone, especially if crystals grow at relatively low temperatures, say below 800°C.

Several sets of melts were made with either tin or antimony omitted, sometimes with carbon added instead. Omitting tin caused little difference but omitting the antimony oxide gave more green (oxidized) glass. Adding carbon (either 4 or 8g) obviously gave a more reduced glass but omitting antimony from these batches produced a deep rather dull ruby coloured glass (either with or without tin). It thus seems that antimony is important in producing the precipitation of cuprous oxide, especially in its orange or red form, but tin could be replaced by carbon. Omission of the copper from the standard batch produces a white opaque glass in which the crystalline phase is a calcium antimonate, possibly $Ca_2Sb_2O_7$.

Reduction of oxides to metal

When melting ordinary copper-ruby glasses a few small droplets of metal are sometimes found in poured samples or in the bottom of the pot: a degree of reduction close to that needed to reduce cuprous ions to metallic copper seems necessary to produce a ruby. Much more extensive reduction of oxides to metal occurred in the present work, largely by reduction of oxides at the surface of the melt. These globules eventually sank to the bottom of the melt and coalesced to form a pool. Their weight obviously increased with melting temperature and melting time as well as the amounts of the various reducing agents used; weights of 56-62g were recorded in four instances. The compositions of these alloys were strongly temperature dependent (Fig.4) and these observations agree qualitatively with the data shown in Fig.3. The inference that lead would become the major constituent above about 1250°C clearly agrees with Fig.3. It may be noted that antimony was the second most important constituent at temperatures below about 1230°C, again suggesting that it may be more important than tin in controlling nucleation and growth of crystals. From time to time crystals

of cuprous oxide growing around metallic particles have been seen under the microscope; the possibility of metal particles acting as nuclei for growth deserves further study.

A more oxidizing atmosphere would have decreased reduction of oxide to metal but was not used in these particular experiments because the frequent production of some clear green glass due to cupric ions showed that greater reduction was needed. It might better be achieved by addition of carbon or more tin to the batch. However, this also may risk further reduction of oxides to metal.

Temperature

When melted at constant temperature, use of different melting temperatures from about 1010° to 1250°C had very little effect on the glass produced although the higher temperature naturally gave faster melting and produced a more fluid melt.

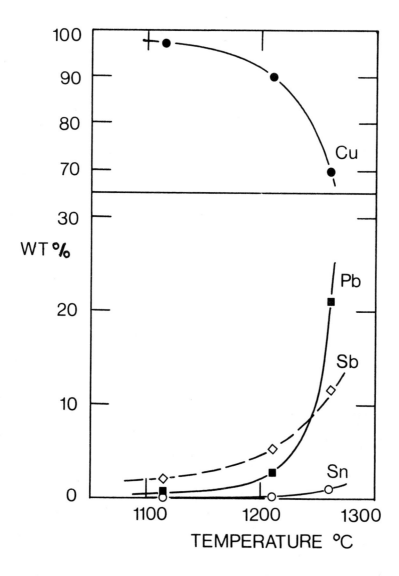

Fig. 4 Temperature dependence of the composition of the bronze alloy found in the crucibles. Note the difference in scale between the upper and lower parts of the diagram.

Programmed time-temperature cycles

A few sets of melts were made with temperature programs as follows: (1) Heat at constant rate (either 150 or 250°C/h) to 750°C, (2) Hold at 750°C for 4 hours, (3) Heat from 750°C to 1200 or 1250°C in 1 hour, (4) either remove at once or leave 2 hours more.

These melts indicate that fritting could be advantageous but this remains to be investigated in detail. In such melts litharge had no advantage over red lead because red lead released its oxygen before any significant degree of reaction had occurred. These melts showed less segregation than batches heated rapidly to the maximum melting temperature but samples taken at various stages (e.g. on first reaching 750°C, after 4h at 750°C or on reaching 1200°C) all showed the sea green colour typical of much of the copper being present as cupric ions rather than cuprous. Such melts might be sufficiently reduced when melting was complete.

Identification of the crystal phase

The bright red glass always contained large dendrites; as the colour changed to orange then yellow the crystal size became smaller and the habit octahedral or cubic. Several samples were examined by x-ray diffraction, in all of them the strongest peaks were characteristic of cuprous oxide. However, cuprous oxide can be non-stoichiometric and might also, in strongly reducing conditions, have some replacement of oxide by sulphide. Melting some glasses with deliberate additions of sodium sulphate had no obvious effect; this suggests that formation of Cu_2S was not an important factor.

The role of lead oxide

Lead oxide may be essential to produce this particular type of glass. It is sometimes said that lead 'increases the solubility of copper in glasses' but this seems to be based on little direct evidence. Comparison of the $Na_2O-PbO-SiO_2$ and $Cu_2O-PbO-SiO_2$ phase diagrams would be helpful; although the former is available the latter is not. However, a hint as to the essential function of lead oxide may be supplied by comparison of the Cu_2O-PbO and Cu_2O-SiO_2 phase diagrams which are available (Levin et al.1964). Both are of the simplest type with one eutectic and no intermediate compounds. These eutectics are at about 92% Cu_2O and 1060°C in the silica system and 18% Cu_2O and 680°C in the lead system. Addition of lead oxide thus probably extends the range of compositions having cuprous oxide as the primary crystalline phase. Addition of lead oxide probably also makes a more fluid melt, assisting particle growth, and decreases the temperature at which any second phase would form.

Discussion

It proved possible to melt glasses of the Nimrud type at temperatures from about 1010 to 1250°C but it was difficult to produce homogeneous glasses of the desired red colour. This colour was confirmed to be due to relatively large dendrites of cuprous oxide and regions very similar to the original Nimrud red glass were easily formed in the bottoms of the melts. The yellow colour of the patches in the Nimrud glass seems to be also due to cuprous oxide but is of a much finer texture. The segregation into horizontal layers was undoubtedly largely produced during melting but some

segregation of crystals after they had grown might also have occurred. These problems could probably be cured by appropriate choice of raw materials and fritting at 750-850°C before eventually melting the glass at a temperature of 1000 to 1200°C. Such a process was probably used by the original Nimrud glass-makers.

If melted without reducing agents in the batch or heated in an oxidizing atmosphere, much of the copper is present as cupric (Cu^{++}) ions which may impair precipitation of cuprous oxide. Oxidation of a proportion of the copper to cupric may not prevent production of cuprous oxide particles but leaves the transparent matrix green: this degrades the orange to a red colour due to the precipitated particles and the perceived colour tends to become a dirty brown. A considerable range of tints is possible but few are attractive. Reducing agents must be added to the batch; tin and carbon are very suitable for this purpose but carbon is only useful whilst it is burning off. Excess carbon around the crucible could maintain the reducing atmosphere needed. However, the desired red colour seems to be more influenced by the antimony and lead oxides; the latter probably ensures that cuprous oxide is the primary crystalline phase; the action of the former is important but not yet clear. An antimonate compound crystallizes out from the melt if the copper is omitted; antimony may thus play a role in crystal nucleation or growth.

From what is known about nucleation and crystal growth in other glasses this kind of glass is probably best produced by relatively slow cooling from just above the liquidus to a temperature not more than about 200°C below the liquidus, (probably about 950 to 750°C for this glass). This should give relatively few nuclei and large dendrites. Nucleation rate usually continues to increase rapidly as temperature falls but rate of crystal growth falls off so that crystals grown at lower temperatures usually show a very fine texture.

Heating the glass in air at temperatures above about 350°C produced a black surface film; x-ray diffraction confirmed that this was cupric oxide. At higher temperatures, e.g. 900°C, oxidation also occurred in the glass adjoining the surface film, the glass becoming green due to the conversion of cuprous ions to cupric. This was accompanied by dissolution of the cuprous oxide crystals. The red Nimrud glass was thus much better suited to use as a semi-precious stone than for hot shaping by normal glass-making methods.

Ahmed and Ashour (1981) discussed an interesting investigation of cuprous oxide precipitation in a glass somewhat similar to the Nimrud glass. Their glass had (wt.%) 13.7 Na_2O, 48.7 SiO_2, 14.6 Cu_2O and 19.1 PbO; it was melted at 1400°C in a gas-fired furnace but melting conditions are not recorded. No reducing agents were added to the batch and subsequent heat treatments were made in air. As a result their glass was always coloured green by cupric ions but this does not prove the absence of cuprous ions. Their results confirm that nucleation rate was a maximum at about 500°C but that maximum rate of crystal growth occurred at about 900-1000°C. Suitable heat treatments could therefore control crystal size and volume fraction. They also found the colour of the crystals to vary from yellow when very small (<5 μm) to red when of diameter larger than about 150μm. These differences could be related to temperature of growth but, as this was the most convenient way of controlling crystal size, there is little evidence that temperature itself directly influences crystal morphology or colour. Despite the absence of reducing agents in the batch and the green colour showing some (not necessarily all) of the copper to be present as cupric ions, Ashour and Ahmed sometimes found globules of metallic copper in their crucibles.

Conclusion

The particular achievements of the ancient Nimrud glassmakers were (1) to achieve a sufficiently high volume fraction of cuprous oxide crystals to produce visually uniform opacity, (2) to produce an almost colourless glass matrix containing very few cupric ions, thus avoiding degradation of the red colour, but (3) to do so without, apparently, reducing large proportions of the dissolved metal oxides to globules of metal, and (4) to avoid serious melting segregation. The authors believe that more complex time-temperature melting schedules than were used in this work would succeed in producing the desired result.

Several matters deserve further study. These include elucidation of the role of antimony in aiding formation of the red colour, the possibility that defects or impurities in the crystals as well as crystal habit might influence the colour, and the effect of changing base glass composition.

Acknowledgements

The authors gladly acknowledge the interest and assistance of Miss M Bimson and Dr I C Freestone of the British Museum and of Mr C M Wilson in making electron microprobe analyses.

References

Bachtik S and Pospichal V (1964). Zuslechtovani Skla (Decoration of Glass). Prague, State Technical Literature Publishers

Biek L and Bayley J (1979). Glass and other vitreous materials. World Archaeology 11 (1), 1-25

Faraday M (1830). On the manufacture of glass for optical purposes. Philosophical Transactions, 1-57

Freestone I C (1986). Composition and microstructure of early opaque red glass. In Early vitreous materials, M Bimson and I C Freestone, eds., British Museum Occasional Paper 56

Guido M, Henderson J, Cable M, Bailey J and Biek L (1984). A Bronze Age glass bead from Wilsford, Wiltshire: Barrow G.42 in the Lake group. Proceedings of the Prehistorical Society 50, 245-54

Johnston W D (1965). Oxidation-reduction equilibria in molten $Na_2O.2SiO_2$ glass. Journal of the American Ceramic Society 48, 184-90

Levin E M, Robbins C R and McMurdie H F (1964). Phase diagrams for ceramists. Columbus, Oh., American Ceramic Society

Mallowan M E L (1954). The excavations at Nimrud (Kalhu), 1953. Iraq 16, 59 - 163

Oppenheim A L, Brill R H, Barag D and von Saldern A (1970). Glass and glassmaking in ancient Mesopotamia. Corning, N.Y., Corning Museum of Glass

Turner W E S (1954). Studies of ancient glasses and glass-making processes. II. The composition, weathering characteristics and historical significance of some Assyrian glasses of the eighth to sixth centuries BC from Nimrud. *Journal of the Society of Glass Technology* 38, 445-56

OPAQUE RED GLASS: A REVIEW

Mavis Bimson

Research Laboratory, British Museum, London WC1B BDG

Abstract

This paper attempts to review what is now known with a fair degree of certainty of the distribution, date and general composition of opaque red glasses of the second and first millennia BC. Some statements in the archaeological literature concerning these glasses have been based on rather doubtful evidence and an attempt has been made to trace their origin.

Keywords: GLASS, ANALYSIS, RED, OPAQUE, CUPRITE, COPPER, LEAD.

Introduction

Our current knowledge of opaque red glasses of the second and first millennia BC is chiefly based on excavated material and on analyses dating back over the last hundred years. Partly because of the casual nature of much early archaeology and the hazards of subsequent storage and partly because even the simplest analytical facilities were often lacking, the archaeological literature contains data which ought at the least to be queried - though in all but a very few cases it is not possible to re-examine the original material or the original excavation reports.

Until recently silicate analysis was a lengthy process and the sources of error were numerous, especially in the separation of metallic sulphides. If the presence of an element was not suspected its precipitate was very likely to be weighed along with that of some other metal; for example, antimony was frequently missed in this way. Thus in the series of analyses carried out by students of B Neumann in the nineteen-twenties on Egyptian and Roman glass (Caley 1962), no antimony is reported in any of the samples, though our present knowledge indicates that antimony must have been present at least in the opaque white and turquoise glasses. In spite of the almost universal use of antimony compounds as opacifiers in coloured glasses of the second and first millennia BC, it seems to have been almost invariably missed until the analyses by the laboratories of the British Museum and the General Electric Company in the nineteen fifties (Caley 1962). Errors in the analyses of opaque red glasses are not so obvious but one must assume that these also occurred fairly frequently.

It would be misleading, however, to suggest that errors are only likely to be found among the earlier gravimetric analyses. Atomic absorbtion analysis enabled quantitative results to be obtained much more quickly and on much smaller samples than the classical gravimetric techniques, but again many published analyses do not include constituents which were almost certainly present, such as phosphates, sulphates and chlorides; also the questionable practice of simplifying the chemistry by estimating silica by difference meant that gross analytical errors could go undetected.

X-ray fluorescence analysis was apparently the answer to all the dreams of archaeologist and analyst for non-destructive testing, but with this technique only a thin superficial layer is analysed and, after burial, the superficial layer of a glass is rarely representative of the original composition. It is possible to polish down through the glass, analysing each fresh surface, until consistent results are obtained which indicate that unaltered glass is being analysed. Thus it has been found that even if a glass appears unweathered to the eye it still may have undergone a significant loss of alkali.

The microprobe is arguably by far the most powerful tool that has yet been devised both for speed and in the completeness and accuracy of the analysis. Even more important is the ability to analyse different phases of a glass and to determine whether a crystalline phase, such as an opacifier, has crystallized out of the melt or is present as undissolved material. Even this technique has weaknesses, such as the inability to analyse boron and inherently high detection limits of the order of 0.1% for most elements, thus leaving unrecorded important minor constituents such as cobalt. However, because of the small size of the sample required and the number of samples that can be analysed in a reasonable time, we are now able to investigate groups of these extremely complex glasses on a sound scientific and statistical basis and the odd rogue result or misidentified sample should be quickly recognized.

Opaque red glass

Two main types of opaque red glass were employed in antiquity; both owe their colour and opacity to copper but are differentiated on the basis of their lead content. These glasses can generally, but not invariably, be identified by their colour. The low or lead-free glasses are typically of a dull liverish or rather dark red while high-lead glasses are usually of a brilliant sealing-wax red, due to well-developed dendritic crystals of cuprite suspended in an almost colourless matrix (Freestone, this volume).

Opaque red glass in Egypt

Opaque red glass containing negligible lead was known in Egypt in the mid-second millennium BC. The date of the introduction of large amounts of lead into such glasses is obviously of considerable significance in the history of glass-making. Petrie commented in his manuscript catalogue of the glass and glazes in the Petrie Collection (Arkell 1956) that:
> 'From the 26th to the 30th Dynasty (between 664 and 341 BC), it is almost impossible to date glass with certainty ... though glass was so little used, a step was made by adopting a red glass loaded with red oxide of copper, in place of the duller red paste ... of the earlier periods.

> This copper glass is very heavy (S.G. 3.44) and has a fracture closely like that of red jasper, which it also imitates in colour. It usually decomposes green on the surface and the red may be unsuspected if not broken'.

This statement, particularly the last two sentences, shows the characteristic acuteness of Petrie's observation. There can be no doubt, therefore, that Petrie considered that an opaque red glass containing sufficient lead to give a specific gravity of 3.44 was not introduced into Egypt before the first millennium BC.

Oddly enough it was Dr W E S Turner, whose word is usually law in glass matters, who was responsible for introducing the belief that high-lead, high-copper cuprite glass was already known in Egypt in the Eighteenth Dynasty. In his article on the glass finds from Nimrud, Turner referred to a lump of high-lead, high-copper glass which was among the finds from Tel el Amarna in the Petrie collection. This was literally true, but the obvious inference was not since it should not have been there.

A short time later A J Arkell published a 'Brief Communication' in the *Journal of Egyptian Archaeology* (Arkell 1956) in which he pointed out that this piece of glass was described in Petrie's notes as coming from Memphis:
> 'It was certainly among the specimens believed to come from the Tel el-Amarna glass factory when Professor Turner carried out his study on them; but we later discovered that with the Tel el Amarna specimens were others of later date, ... This confusion was presumably due directly or indirectly to the bombing of University College in 1941. That the lump of red glass mentioned by Professor Turner also probably came from Memphis ...is indicated by the recent re-discovered manuscript catalogue... written by the late Sir W M Flinders Petrie'.

Turner (1956) did not dispute the redating of the glass but unfortunately instead of simply admitting that a mistake had been made, he utterly confused the issue by stating that the redating:
> 'does not essentially effect the correctness of the statement I made, that sealing-wax red glasses were well known in the Egyptian XVIIIth Dynasty ... There is plenty of other evidence. Petrie himself included red-coloured glasses in his list of opaque glasses found at Tel el Amarna'.

True, but as we saw, Petrie specifically stated that the high-density opaque sealing-wax red glass did not occur until the mid-first millennium.

In support of his statement, Turner (1956) went on to refer to eight opaque red glasses from Tel el Amarna, five of which contained no lead, two a trace of lead and one contained lead but with a specific gravity of 2.80 this cannot have been a high-lead glass. It is unfortunate that the general impression of refutation leaves a superficial impression that Turner believed high-lead red cuprite glass occurred in the Eighteenth Dynasty, whereas he was in fact redefining and enlarging the term 'sealing-wax red glass' possibly to avoid admitting that he had not spotted the anomaly of finding such a glass at Tel el Amarna. Even as late as 1984, one finds an example of Turner being quoted without any reference to Arkell's correction. (Guido *et al.* 1984).

We have not been able to find any sealing-wax red, high-lead, high-copper glass of the Eighteenth Dynasty in the British Museum collections. At one time two strips of dark red glass, which were surface finds at Tel el Amarna, were found to contain cuprite as colourant, and it seemed that these might provide contrary evidence. However, our analysis of these pieces (see Freestone Table 2) showed that the lead content was below detection. The copper content, on the other hand, was about ten per cent, one of the first indications we had that a high-copper glass did not also

necessarily contain a significant amount of lead. The magnesium and potassium values were relatively high, typical of ordinary Egyptian glass of that period. This type of rather dull, low-lead opaque red glass was used in the second millennium BC for inlays, for beads, as a substitute for cornelian in jewellery, but does not often occur as marbling on core-formed vessels, though it was used on some small polychrome dishes.

Towards the end of the second millennium BC a series of barbarian invasions led to the collapse of the earlier civilizations, and the centuries which followed both in Egypt as well as in the Mediterranean area and the Near East were 'dark ages' from which almost no glass has been recovered. In the first millennium BC, as glass gradually reappeared, there was a series of changes in glass-making technique, including the addition of lead to opaque red glasses, changes in the material used for making cores and in the source of alkali as well as in glass-forming. A dull opaque red glass continued to be made, frequently containing small amounts of lead but differing from the earlier glass in that the copper content was usually low. It continued to be manufactured into the first millennium AD and was used in glass mosaic of the Roman Period and in millefiori. On present evidence it seems that the high-lead, high-copper, sealing-wax red glass came into use in Egypt in the earlier part of the first millennium BC. Petrie, as quoted above, considers the date to be probably between the twenty-sixth and thirtieth Dynasty. It was used for moulded inlays and other small objects and in the Roman period blanks were treated as a substitute for red jasper and were turned on lapidary wheels to make small dishes. A number of similar dishes from the Hellenistic period were found at Kush (Sudan) although no analyses are given in the paper in which they were published (Stern 1981).

Opaque red glass in the Near East and Europe

The Department of Western Asiatic Antiquities possesses several samples of red glass from Alalakh (in Anatolia) dating from the fifteenth century BC. The two samples which were analysed here contained between six and eight per cent of copper oxide and the lead content was below detection, thus in general type they resemble the fourteenth century BC Tel el Amarna samples. At this point one would naturally be expected to refer to the opaque red glass bead recently published as having been found in a bronze-age cist barrow at Wilsford in Wiltshire (Guido et al. 1984). However, not only is it of a most unusual type of glass found only as yet in the late Middle Ages but its so-called provenance is extremely weak. It is based on an early nineteenth-century manuscript containing a copy of a letter describing a grave group excavated by an eighteenth-century barrow digger, which contained 'a stone bead which had been stained red'. A glass bead is not mentioned until later, and there must have been many opportunities in the subsequent centuries for the sort of mistake to occur which happened with Petrie's Memphis glass. Until more products of this unique British glass industry are found in modern excavations it would be as well to leave out the Wilsford bead from any consideration of second-millennium opaque red glass.

In the Near East and the eastern Mediterranean, as in Egypt, the first major period of glass-making came to an end in the late second millennium BC and glass does not occur on excavated sites for several centuries. As more first millennium sites are excavated it may be possible to state with some certainty where and when large amounts of lead were first introduced into opaque red glass. The earliest examples of high-lead opaque red glass which we have analysed are circular inlay pieces from Toprak Kale, which Barag (1985) dates as eighth to early sixth century BC. Completely weathered inlays from Arslan-Tash, whose lead content suggests that they

were originally high-lead opaque red glass, were dated by Barag to the eighth century BC. This suggests that the addition of large amounts of lead may have occurred first in the Near East rather than in Egypt, but much further evidence is needed.

In 1952 Professor Max Mallowan deposited at the Research Laboratory circular ingots of opaque red glass then covered with a thin green weathered layer which had been found in Room XXIII of the Burnt Palace at Nimrud. Associated with the glass were runnels of bronze metal, fragments of magnetic iron oxide mixed with lead alloy and ferric oxide, a sintered cake of iron oxides and siliceous material and some charcoal. The remains of furnaces were also found. These ingots were of a high-lead, high copper cuprite glass containing about four per cent of antimony oxide. The working floor was originally dated by Professor Mallowan to the sixth century BC, but he later redated it to a reuse of the palace area in the second century BC. The presence of associated charcoal enabled radiocarbon dating to be carried out in the British Museum Research Laboratory, this gave a date of c.425 BC for the wood (Burleigh 1985). Since the wood itself was of uncertain age, this gives only a *terminus ad quem* for the manufacture of the glass. In spite of the uncertainty about the date, this is still a site of great importance since we have certain evidence of the manufacture of a high-lead, high copper glass and not merely its use.

As early as the sixth century BC this glass was being employed by the barbarians north of the Alps to decorate their metalwork (e.g. the Basse Lutz flagons) and continued to be used as late as the eighth century AD (Hughes 1972). It is interesting to note that both types of opaque red glass occurred in the Anglo-Saxon ship burial at Sutton Hoo (c. 620 AD): the high-lead cuprite glass on the hanging bowl escutcheons and the low-lead glass in the millefiori (Bimson 1983). When it occurs in a Late Iron Age-Roman-Dark Age context, high-lead cuprite glass is often referred to as 'red enamel', though it is not possible to use it for enamelling in the ordinary manner. Unlike almost all other glasses it cannot be remelted when once formed without destroying its colour; if heated in air the red cuprite is oxidised from the cuprous to the cupric state and the result is a dark dirty green glass.

However, experiments by the author have shown that if the glass is merely softened and quickly pressed onto the metal, while maintaining a reducing atmosphere as far as possible, it can be employed to give an effect very much like enamelling. There is considerable physical evidence that this technique was employed and the metal surface under red high-lead cuprite glass is usually found to have been hatched to assist the glass to adhere. This can be seen on the studs of the Thames helmet (Brailsford 1975), and the waste fragments of glass from Mont Beuvray (Smith 1925) bear the impressions of the hatched metal surfaces on which they failed to adhere.

Conclusions

The overall picture which we have at the moment is of an opaque red glass with negligible lead content being introduced some time about the middle of the second millennium BC for inlays, beads, and as a substitute for cornelian in jewellery. Later, some time in the first half of the first millennium BC, a high-lead, high-copper, sealing-wax red cuprite glass was introduced and was employed contemporaneously with a low-lead, low-copper glass. Further excavations may well change the details of this picture, and further analyses on a much more liberal scale are needed to enable the technology of these very complex glasses to be more fully understood.

References

Ahmed A A and Ashour G M (1981). Effect of heat treatment on the crystallisation of cuprous oxide in glass. Glass Technology 22, 24 - 33

Arkell A J (1956). Ancient glass at University College, London. Journal of Egyptian Archaeology 43, 110

Ball V (1893). On a block of red glass enamel, said to have been found at Tara Hill. Royal Irish Academy Transactions 30, 277-281

Barag D P (1985). Catalogue of Western Asiatic glass in the British Museum. London, British Museum Publications

Bateson J D and Hedges R E M (1975). The scientific analysis of a group of Roman-age enamelled brooches. Archaeometry 17, 177-190

Bimson M (1983). Coloured glass and millefiori in the Sutton Hoo grave deposit. In The Sutton Hoo Ship Burial Vol.3 London, British Museum Publications

Bimson M and Freestone I C (1985). Scientific examination of opaque red glass of the second and first millennia BC. In Catalogue of Western Asiatic glass in the British Museum. London, British Museum Publications

Brailsford J (1975). Early Celtic masterpieces from Britain in the British Museum London, British Museum Publications

Brill R H (1967). Lead isotopes in ancient glass. In Annales du 4e Congrès des Journées Internationales du Verre, 255 - 261, Liège

Brill R H (1970). The chemical interpretation of the texts. In Glass and glassmaking in Ancient Mesopotamia, 105-124. Corning N.Y., The Corning Museum of Glass

Brill R H and Moll S (1961). The elecron-beam probe microanalysis of ancient glass. In Recent Advances in Conservation, G Thomson ed., 145-151. London, Butterworth

Burleigh R J F (1985). A radiocarbon date for wood charcoal from a glass workshop at Nimrud. In Catalogue of Western Asiatic glass in the British Museum. London, British Museum Publications

Caley E R (1962). Analyses of ancient glasses 1790-1957. Corning N.Y., The Corning Museum of Glass

Guido M, Henderson J, Cable M and Biek L (1984). A Bronze Age glass bead from Wilsford, Wiltshire: Barrow G.42 in the Lake Group. Proceedings of the Prehistoric Society 50, 245 - 254

Hughes M J (1972). A technical study of opaque red glass of the Iron Age in Britain Proceedings of the Prehistoric Society 38, 98 - 107

Matson F R (1957). Analyses of various substances from Persepolis. In Persepolis II, Oriental Institute Publication 69, E F Schmidt, 127-132

Oppenheim A L et. al. (1970). *Glass and glassmaking in Ancient Mesopotamia.* Corning N.Y., The Corning Museum of Glass

Petrie W M F (1926). Glass in the early ages. *Journal of the Society of Glass Technology* 10, 229 - 234

Pliny (1929). In *The elder Pliny's chapters on chemical subjects* part II, K C Bailey, ed., p151. London, Arnold

Sayre E V (1967). Some materials of glass manufacturing in antiquity. In *Archaeological Chemistry*, 279-311. Philadelphia, Univ. of Pennsylvania Press

Smith R A (1925). *British Museum guide to the Early Iron Age antiquities* London, British Museum

Stern E M (1981). Hellenistic glass from Kush (modern Sudan). *Annales du 8e Congrès de l'Association Internationale pour l'Histoire du Verre, Londres 1979*, Liège

Tress H J (1962). Ruby and related glasses from the standpoint of the chemical potential of oxygen in glass Part 2: Gold and copper glasses. *Glass Technology* 3, 95-106

Turner W E S (1954). Studies of ancient glasses and glass-making processes. Part II: The composition, weathering characteristics and historical significance of some Assyrian glasses of the eighth to sixth centuries B.C. from Nimrud. *Transactions of the Society of Glass Technology* 38, 445-456

Turner W E S (1955). Glass fragments from Nimrud of the eigth to the sixth century B.C. *Iraq* 17, 64

Turner W E S (1956). Ancient sealing-wax red glasses. *Journal of Egyptian Archaeology* 43, 110-112

COMPOSITION AND MICROSTRUCTURE OF EARLY OPAQUE RED GLASS

Ian C Freestone

British Museum Research Laboratory
London WC1Q 3DG

Abstract

A small group of opaque red glasses dating to the first and second millennia BC has been analysed using the electron microprobe and scanning electron microscope. The colour of the glass is a function of the size of the cuprite particles which in turn depends on the concentration of cuprous oxide. The advantages conferred by the addition of lead, antimony and iron oxide to the batch are discussed. On the basis of lead and copper contents, three categories of opaque red glass are recognised: a second millennium BC group with negligible lead, which is followed by a high-lead, high-copper group and a duller group with lower lead and copper concentrations.

Keywords: GLASS, OPACIFIER, RED, CUPRITE, LEAD, COPPER, ANTIMONY, SEM, MICROPROBE, EGYPT, NEAR EAST

Introduction

The opaque red glass of antiquity has generated considerable interest due to the high level of technical achievement its production implies. However, published compositional data are sparse, particularly for glasses dating from before the Roman period. Furthermore, available analyses are often incomplete and do not include details of the microstructure and phase composition of the glasses. Such information is essential if we are even to understand the development of their colour and opacity, let alone deduce the raw materials used to produce them. Earlier work on opaque red glasses is summarised by Bimson (this volume).

In the present study, a small group of opaque red glasses dating to the first and second millennia BC have been characterised in detail. Examples from Egypt and the Near East are included and details of the glasses are summarised in Table 1. Included in the sample is one of the widely cited glass 'ingots' from Nimrud, another of which was originally analysed by Bimson and included in Turner (1956). Chemical compositions of several of the glasses are also included in the catalogue by Barag of Mesopotamian Glass in the British Museum (Bimson and Freestone 1985).

Methods

Millimeter-sized fragments of glass were removed from the objects, embedded in epoxy resin and polished, using diamond pastes down to 1μm. They were examined by reflected light and by scanning electron microscopy (SEM), to determine the crystalline phases present and their microstructure. Their chemical compositions were determined with a Cambridge Geoscan electron microprobe fitted with a Link Systems energy dispersive spectrometer. Analysis of standards from Corning (Brill 1968), European Science Foundation (Newton 1977) and the Society of Glass Technology (1950, 1955) indicated mean relative errors i.e. for SiO_2:0.5%, Na_2O:3%, CaO:2%, K_2O:5% Al_2O_3:30%, Cl:10%, Sb_2O_3:20%, Cu_2O:10%, and for FeO above 2 wt.% the relative error was 5% and below 0.5% FeO it was 50%. Phosphorus was analysed, but at the low concentrations found in the glasses the errors can be so great as to make it unwise to quote this element. A consistent error of 8% relative was observed for lead oxide (PbO), so this was routinely adjusted to bring it in line with Corning Standard C (Brill 1968). The microprobe was operated at 15kV accelerating potential, 5nA specimen current and the beam was defocussed to 100μm spot diameter to minimise loss of alkali due to specimen damage. At least three 100μm areas were analysed on each sample and the results averaged.

Results

Chemical composition

Compositions of the glasses are given in Table 2 with standard deviations for repeat analyses on each sample. The second millennium glasses (nos.1-5) are typical of the period in that they are soda-lime-silica compositions with negligible lead and relatively high magnesium and potassium contents (cf. Sayre and Smith 1961). The high magnesium and potassium are generally thought to indicate the use of plant ash or possibly evaporated river water as a source of alkali (Sayre and Smith 1967, Brill 1970). Also of interest are the high antimony (Sb_2O_3) concentrations in several of the glasses. Copper, the colourant, is present as 5-10 wt% Cu_2O and iron approaches 3% FeO in the glasses from Alalakh (nos.4, 5) but is low in the Amarna glasses (nos.1-3).

The first millennium glasses from Nimrud (6) and Toprak Kale (7) are of a fundamentally different type, containing about 25% lead as PbO. The concentrations of SiO_2, CaO and Na_2O are depressed relative to the second millennium glasses; MgO and K_2O are again present at concentrations which suggest an alkali source other than natron. At around 10% Cu_2O, copper is similar to that in the more copper-rich of the low-lead glasses and antimony is higher, at 4% Sb_2O_3.

Microstructure

The high-lead glasses are of the classic 'sealing-wax red' variety and are characterised by the presence of abundant extensively branching dendritic crystals of cuprite (Fig.1). In addition the glass from Toprak Kale (7) contains common equant grains of calcium antimonate which may occur as individuals, as aggregates or associated with large ragged grains of cuprite which are probably relict, i.e., left from the batch materials, and occur throughout the sample (Fig.2). The Nimrud glass (6) contains common

Table 1

Details of Analysed Objects

Analysis No	Registration No	Date (Century BC)	Provenance	Description
1	EA 1894.8-16.241	14th	Amarna	Flat strip
2	EA 1924.10-11.124	14th	Amarna	Curved strip
3	EA 1984.8-16.193	14th	Amarna	Trailing rod
4	WAA 1951.1-2.115	15th	Alalakh	Core of Fragment
5	WAA 1951.1-2.115	15th	Alalakh	As 4
6	WAA 1957.2-9.10	4th	Nimrud	Crucible blank
7	WAA 118049	8th-6th	Toprak Kale	Circular inlay

Table 2 Electron Microprobe Analyses of Opaque Red Glasses

Analyses	SiO_2	Al_2O_3	FeO	MgO	CaO	Na_2O	K_2O	Cu_2O	PbO	Sb_2O_3	S	Cl	Total
1	57.79 (0.10)	1.09 (0.12)	0.62 (0.07)	4.10 (0.07)	7.84 (0.53)	14.31 (0.42)	1.70 (0.05)	9.85 (0.46)	b.d –	0.89 (0.15)	0.21 (0.03)	0.58 (0.03)	98.98
2	54.36 (0.05)	0.76 (0.15)	0.58 (0.12)	3.85 (0.32)	9.12 (0.05)	16.61 (0.04)	1.65 (0.09)	9.06 (0.40)	b.d –	1.51 (0.31)	0.18 (0.07)	0.80 (0.04)	98.48
3	59.58 (0.09)	0.47 (0.03)	0.36 (0.11)	3.32 (0.16)	8.87 (0.66)	17.15 (0.30)	1.74 (0.08)	5.18 (0.28)	b.d –	b.d –	0.17 (0.04)	1.10 (0.09)	97.94
4	53.95 (0.57)	0.37 (0.12)	2.93 (0.12)	4.98 (0.18)	7.30 (0.23)	16.83 (0.44)	2.65 (0.09)	5.65 (0.77)	0.13* –	2.44 (0.34)	0.33 (0.06)	0.90 –	98.46
5	52.61 (0.41)	0.49 (0.08)	2.73 (0.10)	4.77 (0.12)	7.04 (0.06)	16.50 (0.18)	2.44 (0.05)	7.59 (0.25)	b.d –	2.56 (0.24)	0.21 (0.06)	0.91 (0.05)	97.85
6	42.28 (0.95)	0.68 (0.07)	0.43 (0.03)	2.84 (0.27)	3.82 (0.27)	9.46 (0.25)	1.43 (0.07)	8.58 (1.25)	24.96 (2.12)	4.19 (0.11)	b.d –	0.45 (0.08)	99.12
7	41.13 (1.05)	0.56 (0.07)	0.48 (0.09)	2.18 (0.06)	3.00 (0.19)	9.10 (0.70)	2.15 (0.05)	11.00 (2.17)	23.54 (1.70)	3.89 (0.24)	b.d –	0.55 (0.02)	97.58

Notes.

Number in brackets is one standard deviation of the value given, typically a mean of three analyses.

TiO_2 and MnO analysed but below detection limits

P_2O_5 analysed and below 0.5%

*PbO in sample 4 analysed by wavelength dispersive spectrometry

relict quartz grains, occasional large copper metal droplets of uncertain origin and rare diopside (CaMgSi$_2$O$_6$), which is a devitrification product. Both high lead glasses contain occasional fine spheroidal droplets of copper about 5 μm diameter.

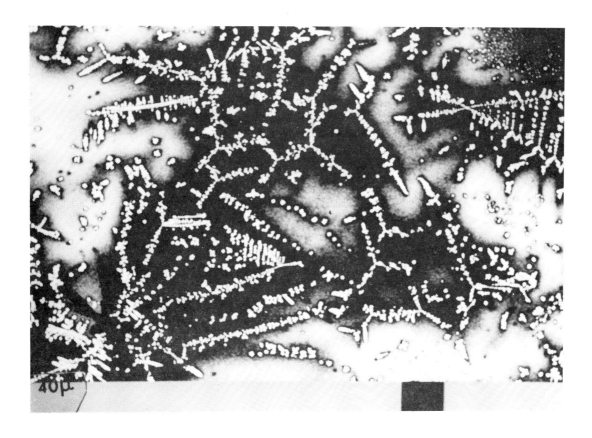

Fig. 1 Branching crystals ('dendrites') of cuprite in opaque red glass from Nimrud (no.6).

In the low-lead glasses cuprite is much less well-developed. In samples 1 and 2 from Amarna, crystallites of cuprite, typically less than 10 μm, are common (Figs. 3 and 4). Although much finer than those in the high-lead glasses, these cuprite crystals are morphologically related in that they show the incipient development of dendritic structure in the form of radiate, cruciform and limited branching patterns. Large corroded cuprite grains up to 300 μm diameter are present in sample 1; these are interpreted as relict from the batch. Occasional large rounded copper grains of a similar size are also present. In contrast to 1 and 2, glass 3, also from Amarna, contains extremely fine copper-rich droplets less than 1 μm diameter (Fig.5). The proportion of those droplets which are cuprite as opposed to metallic copper is uncertain due to their scale, but reflected light examination suggests that the coarser particles are cuprite. A characteristic of all of the Amarna samples is the presence of silicate devitrification products. Glass 1 contains abundant laths of diopside (CaMgSi$_2$O$_6$; Fig.3), glass 2 contains an extensive development of a Na-Ca-silicate which has markedly inhibited the development of cuprite (Fig.4) and glass 3, which contains the least well developed cuprite, has scattered devitrification products including Cu-Ca, Ca-Na and Ca-silicates.

Fig. 2 Large relict grains of cuprite in glass from Toprak Kale (no.7). The bright white grains are calcium antimonate.

Fig. 3 Crystallites of cuprite (white) and the devitrification product diopside, $CaMgSi_2O_6$ (pale grey) in glass from Tel el Amarna (no.1).

Fig. 4 Glass from Amarna (no.2) showing many crystallites of cuprite. The area to the left of the photograph where cuprite is poorly developed has extensive development of a sodium-calcium silicate, which is not easily resolved as its mean atomic number is close to that of the glass matrix. The large white droplet is metallic copper.

Fig. 5 Glass no.3 from Amarna, showing many very fine droplets of cuprite less than 1μm diameter. Note the darker, weathered hydrated layer at the edge of a gas bubble in the glass. The black area at the top of the photograph is the mounting medium, filling the gas bubbles.

The glasses from Alalakh (nos.4 and 5) differ from the others examined in that metallic copper is present as a significant phase. The copper occurs as equant sub-angular grains up to 10 μm diameter. Sample 4 also contains cuprite as acicular and equant grains and as rims on metallic copper (Fig.6). However, in sample 5, cuprite (also detected by XRD) is only just resolvable in reflected light as fine rims on some of the copper particles (Fig.7). Very fine droplets (c.1μm) occur in the glass and are probably cuprite, but this could not be confirmed.

Discussion

Colour, microstructure and composition

The major colourant in all of the glasses studied is the crystalline phase cuprite, cuprous oxide (Cu_2O). The fine morphology and the distribution of the cuprite in the glasses indicate that the cuprite is a phase which was grown from initially homogeneous glass; the few ragged grains of cuprite which are probably left from the batch materials (e.g.in no.7) are very subordinate to the precipitated material. Cuprite growth could have occurred as a glass was cooled, or alternatively the glass could have been held at some temperature below its melting point to encourage cuprite nucleation and growth. Such a process is known as heat-treatment and its effect on a high-lead cuprite glass has been investigated by Ahmed and Ashour (1981). The number of variables which affect the morphology of the cuprite are large and include time and temperature of heat-treatment and the direction from which the soaking temperature is approached as well as bulk composition. It is therefore difficult to place constraints on this aspect of the manufacturing process.

In the past it has been suggested that very fine-grained, 'colloidal' copper metal may be responsible for the colouration of some opaque red glasses of antiquity. Parallels appear to have been drawn with copper-ruby glasses, which transmit red light. However, coarsening of the very fine copper particles in ruby glasses to render them opaque has an adverse effect on the red colouration (e.g. Bamford 1977). Furthermore Paul (1982) has argued on thermodynamic grounds that a glass which precipitates metallic copper will also enter the field of cuprite stability, so that the colouration of even copper-ruby glasses may be due to cuprite. This conclusion is supported by recent spectroscopic work on ruby glasses by Duran *et al.* (1984). Thus the possibility that opaque red glasses owe their redness to metallic copper may probably be discounted.

The high-lead glasses (6 and 7) are the most intense and brilliant red of the group examined, closely followed by glasses 1 and 2 from Amarna which are red to bright red. The Alalakh glasses are red (4) and brownish (5) however, while sample 3 from Amarna is orange-red. This sequence follows well that of the relative grain-sizes of the cuprite in the samples, from extensive dendrites in the high-lead glasses (6, 7, Fig.1,2), through incipient dendrites (1, 2, Figs.3,4) and needles (4, Fig.6), to rims on copper (5, Fig.7) and minute droplets (3, Fig.5). The effect of grain-size on the colour of cuprite has been known for many years (e.g. Straumanis and Cirulis 1935). Concomitantly, with the changes in colour, the grain-size of the cuprite in the glasses shows a correlation with Cu_2O content, those with dendrites (1,2,6,7) containing 8.5-11 wt% Cu_2O and those with less well-developed cuprite (3,4,5) containing 5-8%. This control exercised by Cu_2O content on the size and quantity of cuprite which can be grown from

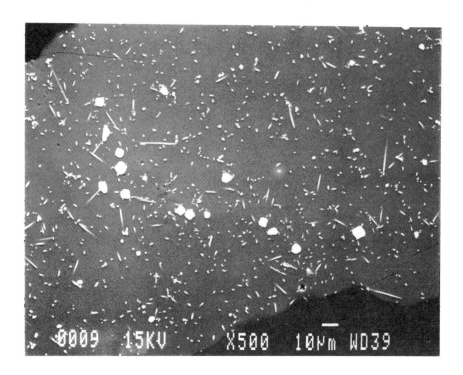

Fig. 6 Glass no.4 from Alalakh showing fine needles and minute droplets of cuprite. The slightly larger, whiter more equant grains are of metallic copper, but these are not well resolved from cuprite in the SEM, and generally reflected light was used to distinguish these phases.

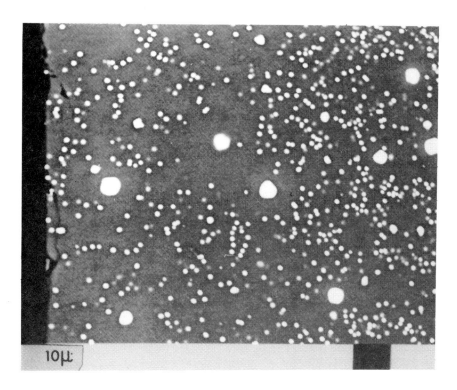

Fig. 7 Glass no.5 from Alalakh showing fine copper droplets.

the glass has been demonstrated experimentally by Ahmed and Ashour (1974). Thus the possibility was open to the craftsmen of antiquity to control the colour of their opaque red glass by varying the amount of copper oxide in the initial batch. This possibility would, of course, have depended on the degree of their control of the production process, for which we have little direct evidence.

Oxidation state of copper

Copper may occur in three valence states: metal, cuprous (Cu^+) and cupric (Cu^{2+}). In turquoise blue glass and in the glazes which are observed on much Egyptian faience, copper occurs in its oxidized cupric form. For the production of opaque red glass it is necessary that the copper should be dissolved as far as possible in the reduced cuprous state to maximise the growth of cuprite, the reduced oxide, from the glass and to avoid the discolouring effect of a blue or green glass matrix. In terms of the range of reducing conditions attainable by the early technologist, those required to produce a good cuprite glass are really quite limited, as indicated in Fig. 8 by plotting standard oxidation reactions and associated early technologies against the appropriate temperatures and partial oxygen pressures. While the fields indicated are admittedly on the conservative side, it can be seen by reference to copper and lead smelting that over-reduction of cuprite glass to produce metallic copper and lead (in the case of high lead glasses) is a danger which must be avoided in its production. On the basis of their experiments, Cable and Smedley (this volume) consider the control of the oxidation state of copper in high-lead glasses to be a major achievement of the ancient craftsmen.

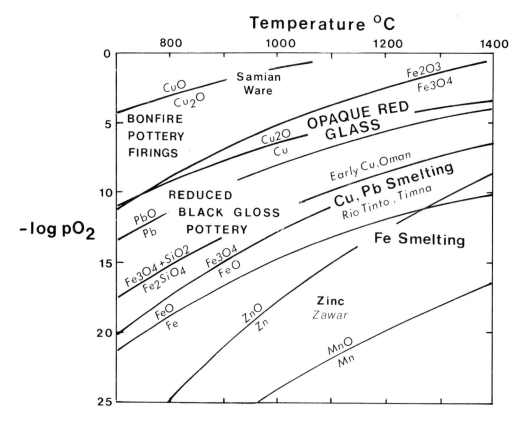

Fig. 8 Oxygen partial pressure – temperature diagram showing probable melting conditions of opaque red glass compared with other pyrotechnologies, and the curves for reactions involving various oxides, metals and oxygen.

There are, in principle, three plausible approaches to the production of a glass in which most of the copper is in the cuprous state. The first is to reduce an oxidized glass using a reducing furnace atmosphere. It is unlikely that such an approach would have been practicable for the craftsmen of antiquity, for strong redox gradients would have been set up in the glasses leading to heterogeneities and it would have been very difficult to control the furnace conditions to avoid under or over-reduction.

The second approach is to reduce the copper in the glass from the cupric to the cuprous state using an internal solid reductant which could have intimately mixed with the melt. Possibilities include carbon (charcoal) and metals such as lead, antimony and iron (see Guido et al. 1985, Cable and Smedley, this volume). Use of charcoal as an internal reductant has been demonstrated by Cable (in Guido et al., op.cit.) for a glass with 2-3% Cu_2O to produce a red-brown colour and also to reduce a high-lead glass (Cable and Smedley, this volume). There is sufficient FeO in the glasses from Alalakh (nos.4 and 5, Table 2) for it to have been added as a metallic reductant, but the fifteenth-century date of these glasses makes this less likely as knowledge of iron technology was not widespread at this time. Antimony is not present in the glasses in sufficient concentrations to have been the sole reductant, while M.Cable (personal communication) considers that metallic lead would segregate rapidly to the base of the crucible and become isolated from the glass melt and is therefore unlikely to have been an effective reductant.

The third possible approach to the production of a glass containing cuprous oxide would have been for the glassmakers to have added the copper in the cuprous state, and to have maintained the internal oxidation state of the glass as far as possible during further melting and heat-treatment. A number of features support this possibility in a circumstantial way. These include the blanket of charcoal found on some of the Nimrud ingots (Turner 1954) and the relict phases present in some of the glasses, suggesting short melting periods. Furthermore, the presence of relict cuprite in sample 1 supports the view that it was present during the early stages of the production process, although there is a reservation in that it could have been reduced/oxidized from tenorite (CuO) or metallic copper. Further support for careful control of oxidation conditions is found in the cuneiform glassmaking texts from the Library of Assurbanipal, which specify the use of crucibles with bound lids (Oppenheim et al. 1970, 45).

An approach which might have been adopted by the Mesopotamian glassmakers to produce cuprite is indicated by Oppenheim's translation and Brill's discussion of the cuneiform texts (Oppenheim et al. 1970). To produce a red glass the texts specify 'fast bronze' as a source of copper, while for a blue glass 'slow copper' was preferred. Brill has suggested that 'fast bronze' may have meant molten bronze and 'slow copper' unmelted copper. Now it happens that the stable oxide of copper in air is tenorite (CuO) until a temperature of 1067°C is reached, when tenorite converts to cuprite (Cu_2O). The melting point of copper is 1081°C, very close to this transition. Thus the melting point of copper could be used as a practical thermometer to indicate if the copper would oxidise to CuO or Cu_2O. In practice, the use of a smokey (reducing) furnace atmosphere would have reduced the $CuO-Cu_2O$ transition temperature (Fig.8), and the change from a solid (slow) to fast (molten) bronze could have served to indicate at what temperature tenorite or cuprite was likely to be produced.

Iron and Antimony

Although iron and antimony are unlikely to have been used directly as metallic additives to reduce cupric copper during melting, their concentrations are sufficiently high in some cases to show that their presence was intentional. Antimony is clearly an additive in most of the glasses and high iron may be intentional in the Alalakh glasses, where its concentration approaches 3% FeO. Both components are polyvalent and in the glasses would have formed the redox pairs $Sb^{3+} - Sb^{5+}$ and $Fe^{2+} - Fe^{3+}$. The interactions of redox pairs in glasses have been discussed by many authors, including Tress (1962), Paul (1982) and Schreiber (1980). In the first instance such redox pairs interact at constant temperature and oxygen partial pressure in the glass. Iron and antimony can be expected to interact with copper in the following ways:

$$Sb_2O_3 + 4CuO = 2Cu_2O + Sb_2O_5 \qquad (1)$$
$$2FeO + 2CuO = Fe_2O_3 + Cu_2O \qquad (2)$$
$$Cu_2O + 2FeO = 2Cu + Fe_2O_3 \qquad (3)$$

Thus more oxidized forms of iron and/or antimony occur with more reduced forms of copper. However, while the presence of iron/antimony in solution helps to maintain copper in the cuprous state, the real benefits of these oxides probably occur as the glass is cooled. According to Tress (1962) the relative rates of change with temperature of the chemical potentials of iron, copper and antimony are such that as a glass is struck the reactions above will move to the right, favouring the more reduced forms of copper. Thus the nucleation and growth of cuprite and (where iron is present) metallic copper will be enhanced by the presence of iron and antimony. In support of such a mechanism operating in early opaque red glass we note that the glasses from Alalakh which contain substantial amounts of iron are also those which have precipitated metallic copper more extensively, as expected from equation (3). Furthermore the opaque red from Toprak Kale (7) contains abundant crystals of calcium antimonate (Fig.2), in which antimony is in the oxidised, pentavalent state. The size and morphology of the antimonate crystals suggest that they were precipitated as the glass was cooled, along with the dendritic cuprite. Thus, in this case, reaction (1) may have initiated the precipitation of both phases.

Hence the role of iron and antimony was not as colourants or opacifiers in these glasses, but they aided the reduction of the copper oxides and the striking of cuprite. The calcium antimonate in glass 7 is an unintentional by-product of this mechanism and is not essential to the properties of the glass. High iron contents have been reported in a number of opaque red glasses by Sayre and Smith (1967). In one case the copper content was only 0.71% Cu_2O and the iron content 4.7% FeO. However, x-ray diffraction confirmed that the colourant in this case was cuprite plus copper and no trace of the red oxide of iron, haematite, was found (Sayre and Smith 1967). Thus care should be taken in identifying the colourant of glass purely on the basis of chemical composition as, in this case, iron would have been suggested, whereas in fact the glass is a cuprite red.

Categories of opaque red glass

Although there are few published complete analyses of opaque red glass, we are fortunate in that a large body of data on lead and copper in these glasses has been published. Fig.9 shows PbO and Cu_2O contents of some eighty samples (predominantly from Hughes 1972; also from Caley 1962, Brill and Moll 1963, Bateson and Hedges 1975, Sayre and Smith 1967, Henderson and

Warren 1982, Cowell and Werner 1973, Vandiver 1982, as well as the present study). Glasses dated to the second millennium BC are shown as squares, those to the first millennium BC or later as circles. The data are heavily weighted towards later, Western European finds, but a consistent picture does seem to emerge. The second millennium glasses group away from the others in that they are essentially free of lead and contain moderate to high concentrations of copper, 3-12% Cu_2O. The later glasses appear to form two distinct groups: a high-lead, high-copper group with PbO typically above 15% and Cu_2O typically above 5%, and a low-lead, low-copper group with PbO typically less than 15% and Cu_2O typically less than 5% (Fig.9). The groups appear well-differentiated on the basis of these two elements, with little overlap.

There are one or two anomalies; for example point A (Fig.9), from a Roman mosaic plaque (Brill and Moll 1963), totals to 101.3% without allowing for Na_2O and must be regarded as a suspect analysis. A further anomaly is point S, an Egyptian glass dated by Sayre and Smith (1967, no.819) to the seventh-sixth centuries BC but which groups with the second millennium glasses. This sample may merely be misdated or may reflect the artificial nature of the first-second millennia boundary which has been chosen. As has been pointed out (Barag 1985) the earliest high-lead glasses are from Arslan-Tash and dated to the eighth century BC, so that the chronological boundary probably lies in the early first millennium. It is of some interest that the probable date for the introduction of lead into opaque red glasses is only slightly earlier than the dates for other important changes in glass composition, such as the introduction of the use of antimony as a decolourant in colourless glasses and the introduction of low-magnesia ('natron') glass (Sayre and Smith 1961, 1967, Sayre 1963,

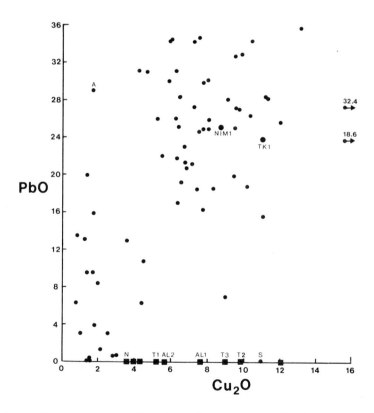

Fig. 9 Lead and copper contents of opaque red glasses. For sources, see text. Squares represent second millennium BC glasses, circles later glasses. T1-3 are glasses from Amarna, AL1-2 from Alalakh and NIM1 and TK1 from Nimrud and Toprak Kale (present work). N is from Nuzi (Vandiver 1982).

Bezborodov and Ostroverkhov 1978). However, it is noted that the high-lead opaque red glasses studied here (nos.6 and 7) are of the earlier high-magnesia type.

Previously opaque red glasses have been considered as only two groups either as lead-bearing and lead-free or as high and low copper (e.g. Brill in Oppenheim et al. 1970; Hughes 1972). The chronological development has been uncertain, but it has been tacitly assumed that glass composition evolved from lead-free through small additions of lead to the high-lead type. Fig.9 suggests a different model. Second millennium opaque reds were essentially free of lead. Sometime in the first millennium the benefits of lead additions were discovered and two types of glass were produced: high-lead high-copper and low-lead low-copper types. Given the good separation of these groups (Fig.9) it is probable that they represent two intentionally produced types rather than a single continuum. The low-copper low-lead group are duller and more brownish in colour due to the development of much finer-grained cuprite (Hughes 1972), as might be expected from the results of the present study of second millennium glasses.

Advantages of lead

Finally, we turn to the underlying reasons for the introduction of lead. Once the value of lead was recognised, its use in the production of opaque red glass appears to have been ubiquitous (Fig.9) in spite of the practical disadvantage of the corrosive nature of the lead silicate glass melts. The advantages must therefore have been substantial.

It has been suggested in the archaeological science literature that the advantage of lead was to increase the solubility of copper in the glass (Brill 1963, Sayre and Smith 1967). However, this concept has not been well formulated and is at best a simplification, for as seen in Fig. 9, the copper contents of lead-free opaque red glasses may be as high or higher than high-lead glasses. Lead does, however, affect the relative solubilities of cuprous and cupric oxides in the glass, so that with additions of lead Cu_2O/CuO increases. Extrapolating in a very approximate way the data of Edwards, Douglas and Paul (1972), who investigated this effect in a simplified glass-forming system, it is estimated that the addition of about 25 wt% PbO would increase the Cu_2O/CuO ratio of a glass-forming melt by an amount of the order of 30% relative. Under constant melting conditions this would increase the potential cuprite which could be precipitated from the glass, an effect observed experimentally by Ahmed and Ashour (1984). It is probable that such an effect on Cu_2O/CuO could also have been effected by manipulating the reducing conditions in the glass, so that it is not an improvement offered by lead alone.

However, it has been observed in the present study that much larger crystals of cuprite were present in the high lead glasses than in the lead-free glasses. In order to grow coarse cuprite crystals, slow cooling rates or extended heat-treatment are desirable. However, a problem that can be encountered in such situations is the devitrification of the silicate glass itself. That this was a problem in the production of opaque red glass in antiquity is clear from the Amarna glasses, where silicate devitrification products are prominent in every case (glasses 1-3; Figs. 3 and 4). In particular it is observed in Fig.4 that the devitrification of the glass has inhibited the growth of cuprite and microscopic examination indicates that the colour is much less red in this area of the sample. Relatively simple calculations show that the addition of lead to opaque red glass was

accompanied by a depression of soda and lime relative to silica; the molar concentrations of silica in the high-lead and lead-free glasses are almost identical (e.g. Bimson and Freestone 1985). Therefore the high lead glasses were much less likely to devitrify to sodium and calcium silicates. Indeed this is apparent from their microstructure, where it is seen that in spite of the more pronounced growth of cuprite, devitrification products are less common in the later, high-lead glasses than in the second millennium lead-free types.

There are at least two further advantages of the use of leaded glasses. First the high-lead glasses will have a higher refractive index and a higher dispersion ('play of colours'). These characteristics will have improved the gem-like quality of the glass, making it appear more brilliant. Second the presence of lead may have softened the glass, making it easier to cut.

The foregoing suggests that the addition of large quantities of lead to opaque red glasses had a range of advantages which lead to more easy fabrication and improved appearance of the final glass. These were so overwhelming that copper-rich, lead-free glasses analogous to the second millennium BC group do not appear to have been made after the lead-rich formulation was discovered.

An outstanding problem is the role of lead in the relatively low-copper low-lead opaque red glasses of the first millennium. Here copper is generally below 5% Cu_2O and lead may be very variable, from negligible up to 10% and, in some cases, 20% (Fig.9). Such a erratic addition could, of course, reflect uncertainty on the part of the glassmakers as to the advantages in adding lead. Most of the advantages listed above for the high lead glasses would not be appropriate for the low-copper glasses, where the cuprite size is very fine, which implies that heat-treatment was neglected as being of little benefit and that therefore devitrification was likely to have been less of a problem, and where the colour is relatively dull. In any case relatively low-lead additions of up to 10% are unlikely to offer significant advantages in the areas mentioned. It may be then, that the glassmakers added lead to the low copper reds for traditional reasons associated with the production of high-copper red glass and without conferring any real benefits. However, an alternative explanation is offered by the experimental work of Ahmed and Ashour (1974). These authors showed that additions of lead in excess of 15 wt% were needed to significantly increase the size of cuprite in glass, and these qualities are those observed in the high-copper high-lead glasses of antiquity. However, small additions of lead increase the numbers of cuprite particles which nucleate. The addition of 10% PbO increased the number of cuprite particles in the glass by a factor of six in their experiments. This effect declines in magnitude with further additions of lead up to about 20% where the number of cuprite particles are about twice that in an equivalent lead-free glass (Ahmed and Ashour 1974). Thus opaque red glasses with PbO contents of 2-15% (Fig.9) will contain more cuprite particles than those of equivalent lead-free glasses melted under identical conditions. These more numerous particles will be of approximately the same size as those in the equivalent lead-free glass, so that the colour of the glass, which depends on cuprite size, will not become more red. Rather, the increased number of cuprite particles will improve the opacity of the glass and the intensity of its (orange or brownish-red) colour. These low-copper low-lead duller opaque red glasses are likely to have been produced because their manufacture was much easier and cheaper than that of the copper-rich glasses. The fine cuprite produced probably formed during cooling without heat-treatment and less careful control of the oxidation state will have been required.

Conclusions

The colour quality of ancient opaque red glass depends on the size of the cuprite crystals precipitated, which in turn is a function of the amount of cuprous oxide (Cu_2O) in the glass. The higher the Cu_2O, the coarser the cuprite and the more red the colour. Opaque reds of the second millennium BC have high Cu_2O (3-12%) and negligible lead. The quality of the glasses was improved by the introduction of a substantial concentration of lead oxide in the early part of the first millennium. Lead oxide had the effect of increasing the size of the cuprite particles and reducing the tendency of the glass to devitrify, thus improving the colour and facilitating manufacture. At about the same time or later, a second glass type with less lead and copper was introduced which was a less brilliant red. In this type of glass the role of the lead was probably to increase the number rather than the size of the cuprite particles, improving the opacity and intensity of the colours. Antimony and/or iron oxides are often present and promoted the formation of cuprite when the glass was struck.

Extrapolation has been possible from the rather small number of glasses analysed by incorporation of previously published data, of early written evidence and modern technological information, allowing a number of general statements on the technology of the early glasses and their development. However, one should not lose sight of the very small number of complete chemical analyses of ancient opaque red glasses that are available, and those which are combined with adequate information on the phase composition cannot number more than about ten. Therefore the conclusions are very tentative and require testing in the light of further work which will undoubtedly reveal that, at best, modifications and refinements are required. In particular data for pre-Hellenistic red glasses from Egypt and the Near East are required so that the dating problems associated with the introduction of lead may be more definitively resolved. Also there is undoubtedly more than one compositional sub-group within the second millennium glasses, but there are too few analyses to resolve them.

Finally, it is emphasised that much of the present interpretation rests on a combination of microstructural information along with the more commonly obtained chemical analyses. While this necessitates removal of a sample from the glasses, only a cubic millimeter or so is required, and where a broken surface is already present damage need be minimal. The technological information which such an examination yields is far more comprehensive and more reliable than that which would have been obtained by the more commonly performed non-destructive surface analysis of the heavier elements in the sample, and where possible and appropriate it is strongly recommended.

Acknowledgements

Mavis Bimson initiated this project and her advice and encouragement throughout have been invaluable. I thank M S Tite, M Cable and L Biek for helpful discussions. The Departments of Western Asiatic Antiquities and Egyptian Antiquities kindly allowed the sampling of objects in their care. I am grateful to the Department of Mineralogy, British Museum (Natural History), for the use of their microprobe.

References

Ahmed A A and Ashour G M (1974). The effect of glass composition on the crystallisation of copper and cuprous oxide in glass. Proceedings of the Tenth International Congress on Glass vol.3, 34-38. Kyoto, Japan

Ahmed A A and Ashour G M (1981). Effect of heat treatment on the crystallisation of cuprous oxide in glass. Glass Technology 22, 24-33

Ahmed A A, Ashour G M and El-Shamy T M (1977). Effect of melting conditions on the crystallisation of cuprous oxide and copper in glass. Proceedings of the Eleventh International Congress on Glass vol.2, 177-187. Prague

Bamford C R (1977). Colour generation and control in glass. Amsterdam, Elsevier

Barag D (1985). Catalogue of Western Asiatic glass in the British Museum Volume I. London, British Museum Publications

Bateson J D and Hedges R E M (1975). The scientific analysis of a group of Roman-age enamelled brooches. Archaeometry 17, 177-190

Bezborodov M A and Ostroverkhov A S (1978). A glassmaking workshop in the Northern Black Sea region in the sixth century BC. Glass and Ceramics 35, 109-111

Bimson M (1987). A review of some previous studies of opaque red glass. (This volume)

Bimson M and Freestone I C (1985). Scientific examination of opaque red glass of the second and first millennia BC. In Catalogue of Western Asiatic glass in the British Museum, Barag D, 119-122. London, British Museum Publications.

Brill R H (1963). Ancient glass. Scientific American 209, 120-130

Brill R H (1972). A chemical analytical round-robin on four synthetic ancient glasses. Proceedings of the Ninth International Congress on Glass, Artistic and Historical Communications, 93-110, Paris, l'Institut du Verre

Brill R H and Moll S (1963). The electron beam probe microanalysis of ancient glass. In Advances in glass technology Part 2, F R Matson and G E Rindone eds., 293-302. New York, Plenum Press

Cable M and Smedley J W (1987). The replication of an opaque red glass from Nimrud. (This volume)

Caley E R (1962). Analyses of ancient glasses 1790-1957 New York, Corning Museum of Glass

Cowell M R and Werner A E (1973). Analysis of some Egyptian glass. Annales du 6me Congres de l'Association Internationale pour l'Histoire du Verre, 295-298, Cologne

Duran A, Fernandez-Navarro J M, Garcia Sole J and Agullo-Lopez F (1984). Study of the colouring process in copper ruby glass by optical and

ESR spectroscopy. *Journal of Materials Science* 19, 1468-1476

Edwards R J, Paul A and Douglas R W (1972). Spectroscopy and oxidation-reduction of iron and copper in $Na_2O-PbO-SiO_2$ glasses. *Physics and Chemistry of Glasses* 13, 131.

Guido M, Henderson J, Cable M, Bayley J and Biek L (1984). A Bronze Age glass bead from Wilsford, Wiltshire: Barrow G.42 in the Lake group. *Proceedings of the Prehistoric Society* 50, 245-254.

Henderson J and Warren S E (1982). Analysis of prehistoric lead glass. *Proceedings of the 22nd Symposium on Archaeometry*, 168-180. University of Bradford.

Hughes M J (1972). A technical study of opaque red glass of the Iron Age in Britain. *Proceedings of the Prehistoric Society* 38, 98-107

Newton R G (1977). Simulated Medieval glasses. *Corpus Vitrearum Newsletter* 25, 3-5

Oppenheim A L, Brill R H, Barag D and Von Saldern A (1970). *Glass and Glassmaking in Ancient Mesopotamia*. New York, Corning Museum of Glass

Paul A (1982). *The Chemistry of glass*. London, Chapman and Hall

Peters T (1983). Equilibrium fugacities of the Cu_2O-CuO and $Cu-Cu_2O$ buffers. *Schweiz.Mineral.Petrogr.Mitt* 63, 7-11

Sayre E V (1963). The intentional use of antimony and manganese in ancient glasses. In *Advances in glass technology Part 2*, F R Matson and G E Rindone eds., 263-282. New York, Plenum Press.

Sayre E V and Smith R W (1961). Compositional categories of ancient glass. *Science* 133, 1824-1826

Sayre E V and Smith R W (1967). Some materials of glass manufacturing in antiquity. In *Archaeological Chemistry*, M Levey, ed., 279-311. Philadelphia, University of Pennsylvania Press.

Schreiber H D (1980). Properties of redox ions in glasses: an interdisciplinary perspective. *Journal of Non-Crystalline Solids* 38, 175-184

Society of Glass Technology (1950). The chemical analysis of a soda-lime-silica-magnesia glass. *Journal of the Society of Glass Technology* 34, 257-272

Society of Glass Technology (1955). Chemical analysis of a potash-lead oxide-silica glass, described as Standard Glass No.3. *Journal of the Society of Glass Technology* 39, 57-66

Straumanis M and Cirulis A (1935). Yellow cuprous oxide *Z.Anorg.Allgem.Chem* 224, 107-112 (from Ceramic Abstracts (1938) 17, 87)

Tress H J (1962). Ruby and related glasses from the standpoint of the chemical potential of oxygen in glass. Part I, *Physics and Chemistry of Glasses* 3, 28-36; Part 2, *Glass Technology* 3, 95-106

Turner W E S (1954). Studies of ancient glasses and glassmaking processes. Part II. The composition, weathering characteristics and historical significance of some Assyrian glasses of the eighth to sixth centuries BC from Nimrud. Journal of the Society of Glass Technology 38, 445-456

Vandiver P (1982). Glass technology at the mid-second millennium BC Hurrian site of Nuzi. Journal of Glass Studies 25, 239-247